IMAGES
of America

THE
ADIRONDACKS
1931–1990

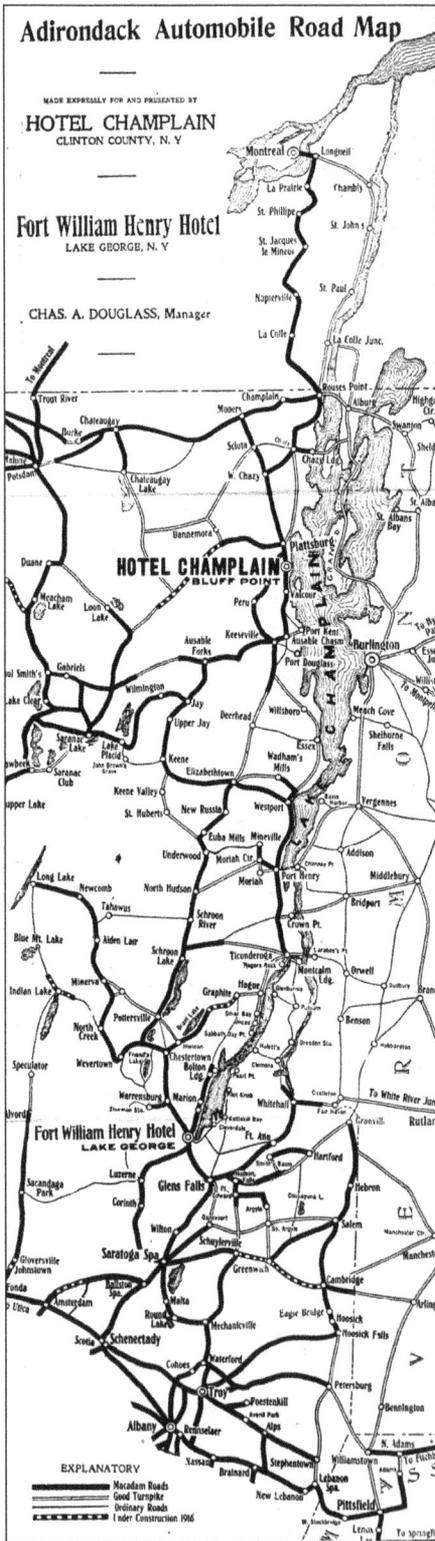

Adirondack Automobile Road Map

MADE EXPRESSLY FOR AND PRESENTED BY

HOTEL CHAMPLAIN
CLINTON COUNTY, N. Y

Fort William Henry Hotel
LAKE GEORGE, N. Y.

CHAS. A. DOUGLASS, Manager

EXPLANATORY

Macadam Roads
Good Turnpike
Ordinary Roads
Under Construction 1916

Once automobile touring of the Adirondacks caught on at the beginning of the 20th century, hotels and businesses produced maps for the tourists. Tours such as "around the little horn" and "around the big horn" became popular. Former dirt roads developed into hard-topped roads, and the Adirondack region was soon crisscrossed with passable roadways.

IMAGES
of America

THE
ADIRONDACKS
1931–1990

Donald R. Williams

ARCADIA
PUBLISHING

Published by Arcadia Publishing
Charleston, South Carolina

Library of Congress Catalog Card Number: 2002113750

For all general information contact Arcadia Publishing at:
Telephone 843-853-2070
Fax 843-853-0044
E-mail sales@arcadiapublishing.com
For customer service and orders:
Toll-Free 1-888-313-2665

Visit us on the Internet at www.arcadiapublishing.com

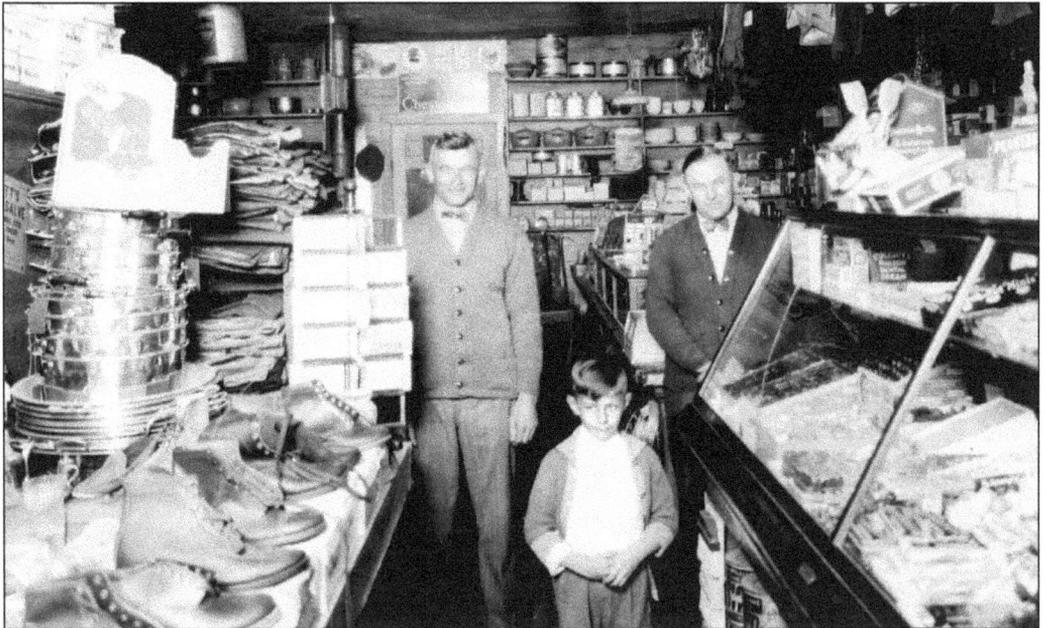

A general store could be found in each of the Adirondack hamlets during the first half of the 20th century. The store was the lifeline of the community to the outside world, bringing in the food and goods that could not be produced on a remote Adirondack homestead, along with the grain for the animals and seeds for the gardens. General stores served as post offices and social centers complete with checkerboards, spittoons, and wood stoves. Store owners extended credit when money was scarce and often wiped the debt off the books to help a neighbor. The general store shown here, L.L. Buyce and Sons in Wells, served the community for over half a century. Orra (left) and Hassan Buyce, shown with Allison, Hassan's son, maintained the business up into the 1950s.

CONTENTS

ACKNOWLEDGMENTS

The Adirondacks: 1931–1990 adds to the previous volume (*The Adirondacks:1830–1930*) with more from my 50-year collection of Adirondackia. Recording Adirondack history and lore with these photographs and captions is a culmination of collecting: collecting the photographs, collecting the memories, and collecting the information. It becomes possible through the sharing by those who lived in the Adirondacks, held on to their memories and the realia from the past, and kept the record of their experiences. I shall always be thankful for all who added to our quest for completing the quilt of the Adirondack story.

—Donald R. Williams

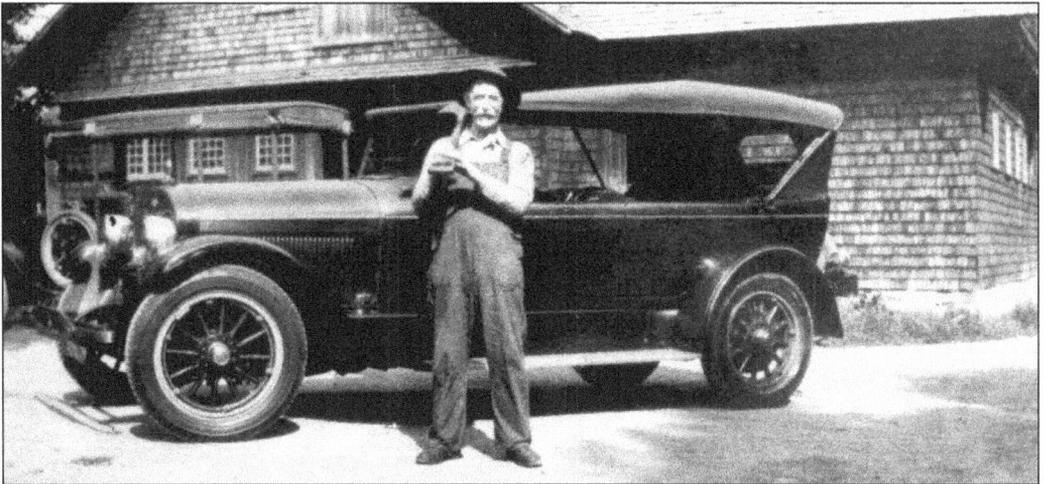

The coming of the automobile at the beginning of the 20th century was probably the greatest single factor in the opening up of the Adirondack region of New York State. It made it possible for Americans from all walks of life to reach the forested mountain country. The automobile contributed to the creation of the touring routes, the growth of roadside campsites, access to privately owned camps, and the growing tourist industry. Steamboats, railroads, stage lines, and Adirondack guides lost some of their business to the growing automobile travel. The automobile shown here is five miles back in the woods at the Santanoni Preserve near Newcomb with chauffeur Vern Pelcher.

INTRODUCTION

The 1930s, in many ways, were a turning point in the development of today's Adirondack country. The loggers, farmers, and railroad builders had had their days in the mountains. The professions of guiding, guide boat building, and hotel management had evolved. The nation's wealthy had built their "great camps." Trails and lean-tos met the needs of the outdoor lovers, and the automobile had found the Adirondacks.

The Adirondack Park, established in 1892, was becoming a people's park. Settlers found that the Adirondack hamlets had more to offer than urban areas did. Vacationists sought out the hotels, cabins, cottages, and later the growing motels. Campers pulled their cars over and camped along the early highways, along the lakes, and along the mountain streams. Formal campsites were then developed by the state and scattered throughout the mountains. New York State was acquiring additional lands to add to the Forest Preserve, established in 1885. Artists and writers were attracted to the natural offerings of the Adirondacks, and the suffering were seeking the health-giving features found in New York's Great Wilderness.

The world discovered the Adirondacks through the 1932 Winter Olympic games held at Lake Placid. Another lake almost the size of Lake George was created in the southern Adirondacks with the Conklingville Dam on the Sacandaga River. The New York State Conservation Department, now the New York State Department of Environmental Conservation, was promoting hunting, fishing, and other recreational opportunities for the growing numbers from the state, other states, and beyond who sought the Adirondack offerings.

The next 50 years brought change to the Adirondacks. The giant hotels gave way to motels, new home building, private camps and cottages, and primitive camping. The Adirondack Northway, opened in 1957, provided faster transportation to and through the Adirondacks. Regional zoning for public and private lands, administered by the Adirondack Park Agency in cooperation with others, sought to protect the character and resources of the Adirondacks. Acid precipitation, one of the Adirondacks' biggest threats, brought death to some Adirondack lakes and affected the growth of plants and animals. Abandoned railroads were being restored and reopened. Ski centers made New York State a skiing destination. Snowmobiles and personal watercraft added new uses to the mountains and lakes. Trail bikes and all-terrain vehicles took to the woods. The moose and turkeys came back to the climaxing forests of the Adirondacks.

It could be that the growing Adirondacks, approaching the 1990s, paused to catch its breath, paused to question new directions. The issues, some of which have existed since the beginning of man's intrusions, call out for our collective wisdom. How much pressure of building and people is

enough? How much of the six million acres should New York State own? When and where should new or relocated trails be built? When and how are we going to stop the deadly acid precipitation and other pollution? Where do we "motorize" the lakes and mountains? How do we assure the Adirondack education of our children? How do we manage the state-owned lands and protect the rights of private landholders? How do we police the "wandering litterbugs?" Who speaks for the original inhabitants, the creatures of the woods and waters? These and other questions cry out for answers in this new century of Adirondack stewardship.

Those who may read this book on some future day will know how well our caretaking of today's Adirondacks answered these concerns, and they will be seeking answers to the new concerns that will arise in the future. Historically, our collective wisdom, our voting pattern, and great leadership have protected New York's "crown jewels." The move to make the New York State Adirondack Park a national park in 1967 was proposed in recognition that it was a wilderness resource of national proportions. The plan met with widespread opposition but served to strengthen the resolve of New Yorkers to protect the Adirondacks at the state level. The people's park was here to stay.

Much of the 20th century saw an increase of those who turned to the Adirondacks to search for recreation and relaxation in a too-busy, stress-filled world. Using modern technology and communication, some businesses were able to relocate to the Adirondacks. Preservation of the unique architecture of the Adirondacks reached a new level of awareness. Visitor centers were established to raise up education for and about the Adirondacks. The guiding profession experienced new growth and expanded Adirondack experiences to whitewatering, rock climbing, turkey hunting, photography trips, and guided group and family experiences. Canoe routes, ski centers, and snowmobile trails multiplied. Camps, cottages, and condominiums sprouted where once only the animals roamed. Local museums and historical groups saw the need to preserve the Adirondack past. Artists and writers continued to add to the vast store of Adirondackia. Rustic furniture makers of today learned from their predecessors and produced the next level of Adirondack furniture. A four-year college was established inside the Blueline (so called for the original line drawn on a map to mark the boundary of the Adirondack Park). Improvements to the water and sewage systems became important in the Adirondack communities. New schools replaced outmoded school plants. "Outsiders" found the Adirondacks and became "natives."

Changes found their way to the Adirondacks, but in a larger sense, much is the same. The everlasting Adirondacks give us those forested mountainsides and oceans of trees. They give us those sparkling lakes and those bubbling streams and give us miles of solitude, much unbroken by man's intrusion. We can find those woodland glades for meditation, the remote streams and ponds for a cooling swim, the mountaintops for a breathless view, and the health-giving features found in the clear and quiet pine-scented atmosphere, much as our forefathers did.

Photographs and stories of those historic happenings and places with the Adirondack Blueline are found in these pages. Seek them out, add your memories, and enjoy your own Adirondack experience.

One

WATER, MOUNTAINS, AND WOODS

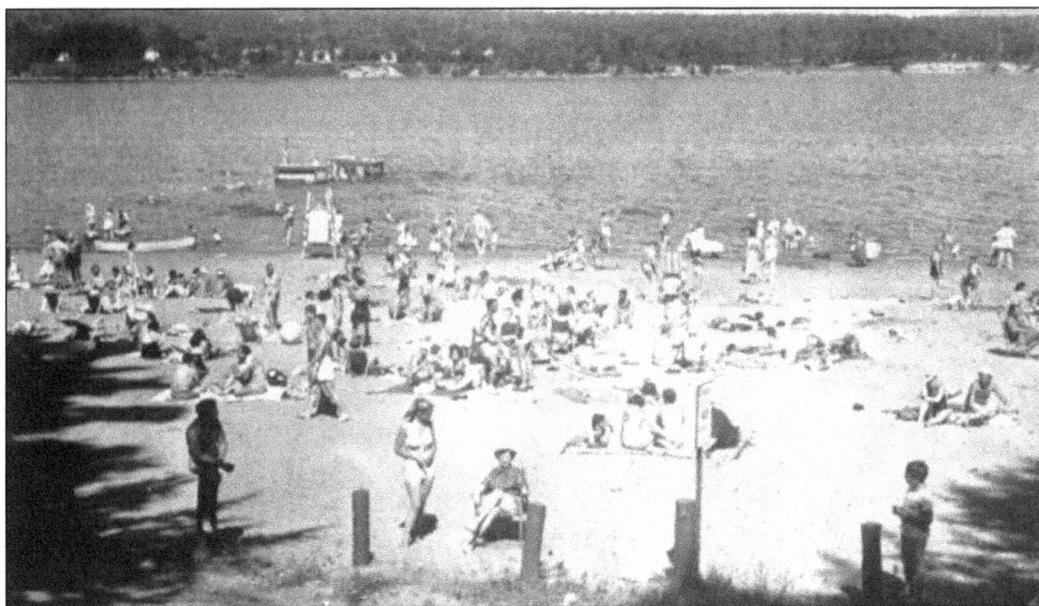

The years between 1931 and 1990 in the Adirondacks might be called the "beach growth" years. The refreshing waters of the Adirondacks had provided recreation for thousands since humankind first entered that remote wilderness. Sun-filled beaches on cool, spring-fed lakes have been developed adjacent to most Adirondack hamlets. Lake George built its "million-dollar beach" in 1951. The Sacandaga Park beach, shown here, was a benefit of the creation of the Great Sacandaga Lake and was a popular swimming spot for some 30 years.

The gates on the Conklingville Dam closed in 1930 and flooded 42 square miles of Adirondack country where hamlets, cemeteries, roads, and farms once stood. The dam helped control the water that flooded down the Hudson, including the city of Albany. The original nine streams and endless marshes of the Sacandaga Vlaie teemed with pike, pickerel, walleye pike, bass, and bullheads. Their descendants are still there today. When the dam was built, a yacht club was organized at Mayfield, and Robert Grasso, Northville garage owner, launched a 30-foot

passenger boat, *Miss Northville*. George Shepard of Gloversville added a 22-foot sailing craft. Summer homes appeared around the 125-mile shoreline, and recreation was added to the power and flood-control purposes of the reservoir. The height of the new bridge proposed to replace the old Batchellerville Bridge across the Great Sacandaga is a source of much discussion. The lake was placed under the administration of the Hudson River–Black River Regulating District in 1959, and a new office was constructed on the lakeshore in 1993.

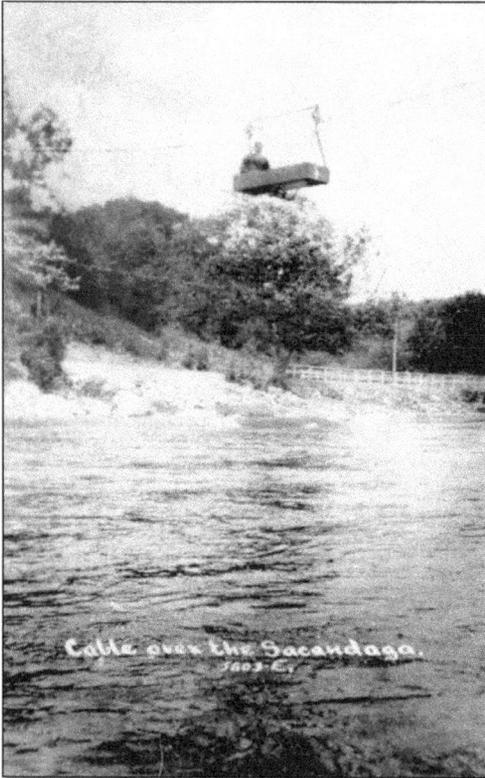

Cable over the Sacandaga.
1603-E.

The gauging station on the Sacandaga River between Northville and Wells has been measuring the water flow since the early 1900s. Half of the water that fills the 1930 Sacandaga Reservoir (known as the Great Sacandaga Lake since 1968) comes down the Sacandaga River through this station. Local cable operators have been hired over the years to ride out on the cable platform and to measure the depth and speed of the water. The records help control discharges from the dam and to maintain lake levels for power, industries, flood control, and recreationists.

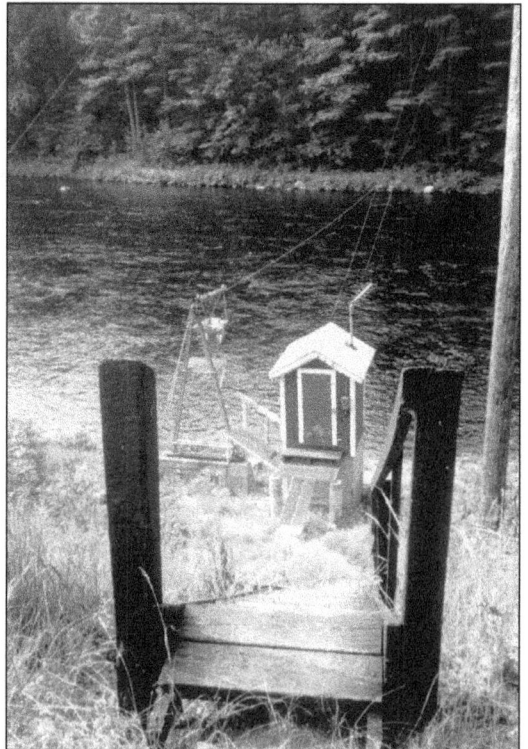

Back in the slower-paced days, an outing to the country was high on the entertainment list. This well-dressed group took a tour after church on Sunday to the newly created Sacandaga Reservoir in the 1930s. People of all ages found a visit to the newly impounded waters an interesting trip. It appears that the little girl on the stump had taken off her Sunday shoes or had gone to church without them.

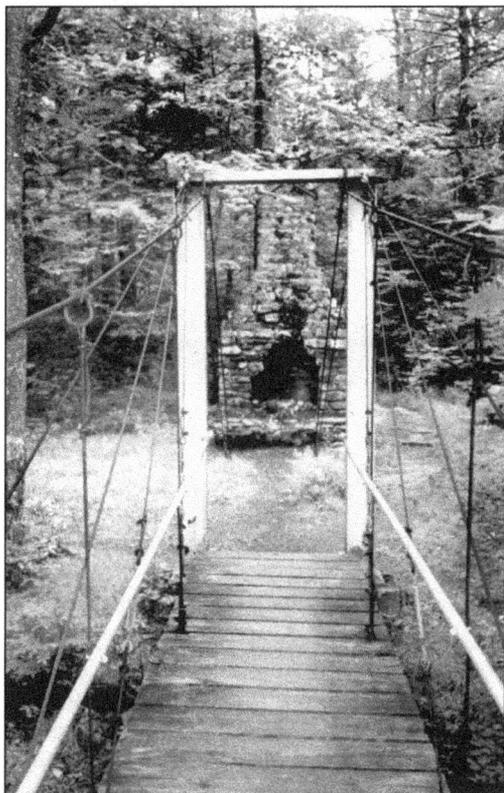

The cable bridge across the West Branch of the Sacandaga River on the Northville–Lake Placid Trail was built in the early 1960s to help hikers cross the rushing waters without calling across for a boat or wading the river. It was built by ranger Lou Simons and some local residents. The chimney still standing at the end of the bridge was once in the recreation hall of Lawrence Fountain's Mountain Trails Boys' Camp at Whitehouse.

Star Lake provides the northwest gateway to the Adirondack Park. The picturesque lake in St. Lawrence County has a far-famed reputation as an Adirondack gem. One early promotional picture booklet tells of the six-story Star Lake Inn: "Rising from the water's edge, sheer and white in the sun's strong light, the old Inn loomed through the trees, and its gayly dressed throng watched us, as we slowly passed in our little boat over the tranquil waters of this Adirondack lake."

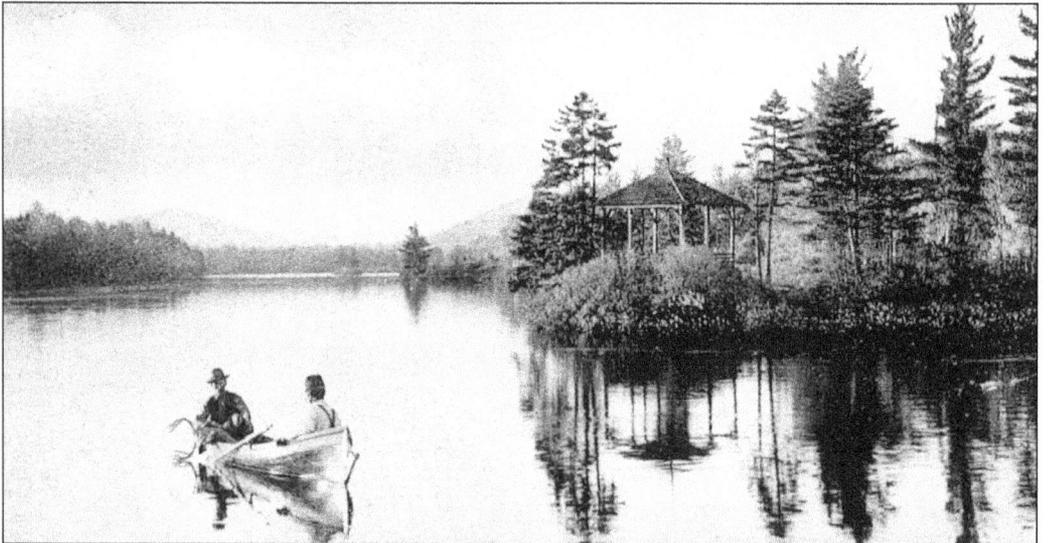

Loon Lake, "on the New York Central," is in the western part of the Adirondacks. Another popular Loon Lake is found on Route 9 in the eastern part. Loon Lake became a great resort area and, with the railroad, could be reached from major cities. One of the oldest golf courses in the Adirondacks was built at Loon Lake in 1895. In this photograph, a sport and his guide are returning from a hunt in their guide boat.

Boathouses on the Adirondack lakes come in all shapes and sizes. Some sit on the water like the one in the photograph, while others are large rustic buildings on the lakeshore. Most wanted the boathouse constructed with openings for the boats to drive directly into the building. At one time, they were built with living quarters on the second floor. Today's regulations are defining the boathouses in stricter terms and limiting what can be built on the shores of the Adirondack lakes.

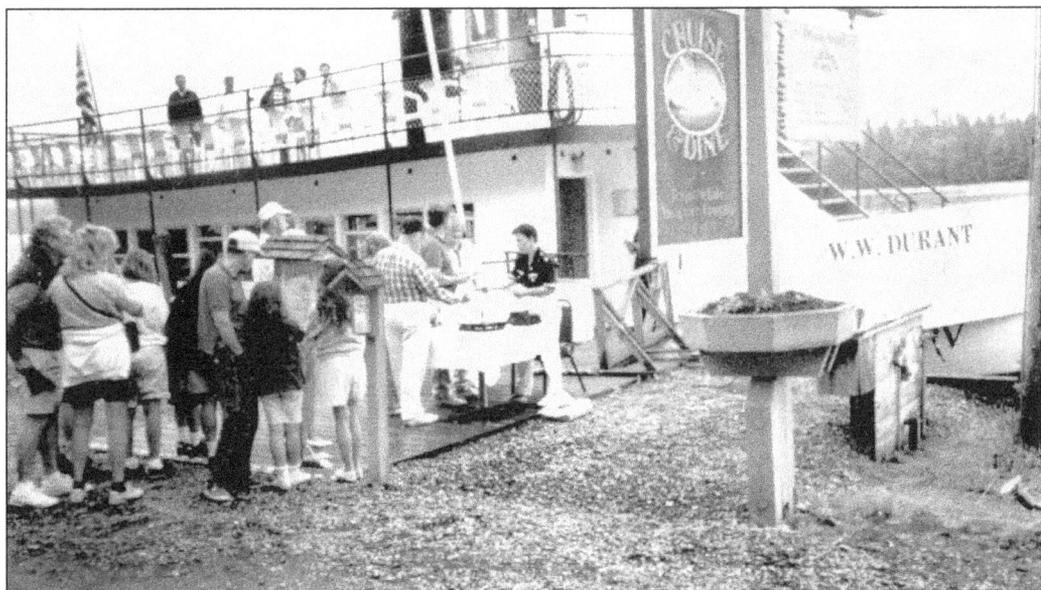

Many Adirondack lakes offered, and still offer, boat rides and transportation by large steamboats and other lake boats. Mail boats deliver mail and provide boat tours. Moonlight cruises, dinner cruises, and special event cruises are offered by the boat companies. The *W.W. Durant*, shown here, is a replica of the steamboats and provides cruises on Raquette Lake. Major boat lines are in operation on Lake George, on the Fulton Chain of Lakes, and on some of the other popular Adirondack waters.

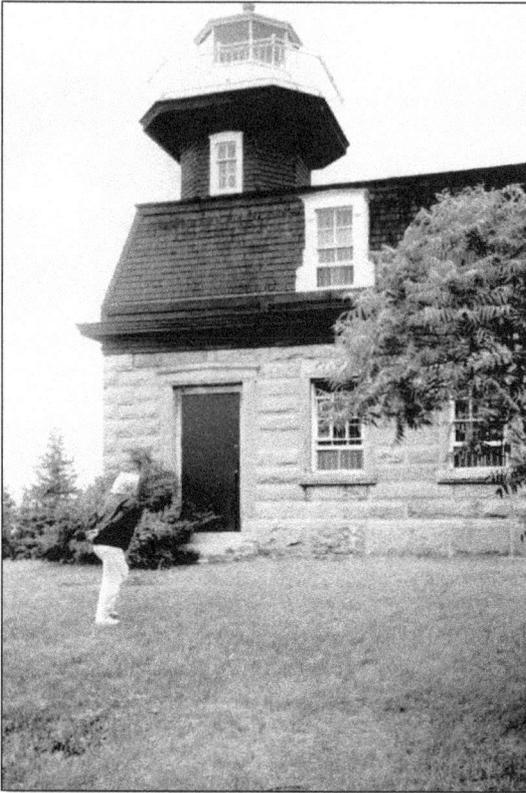

In 1972, the Adirondack Blueline, the boundary of the Adirondack Park, was enlarged to encompass Valcour Island in Lake Champlain. The land was acquired and added to the New York State Forest Preserve. The 1874 lighthouse on Bluff Point was built to aid navigation on the historic lake. It is being restored today by the Clinton County Historical Association and will help interpret the history of the lake and its role in the Revolutionary War and the War of 1812.

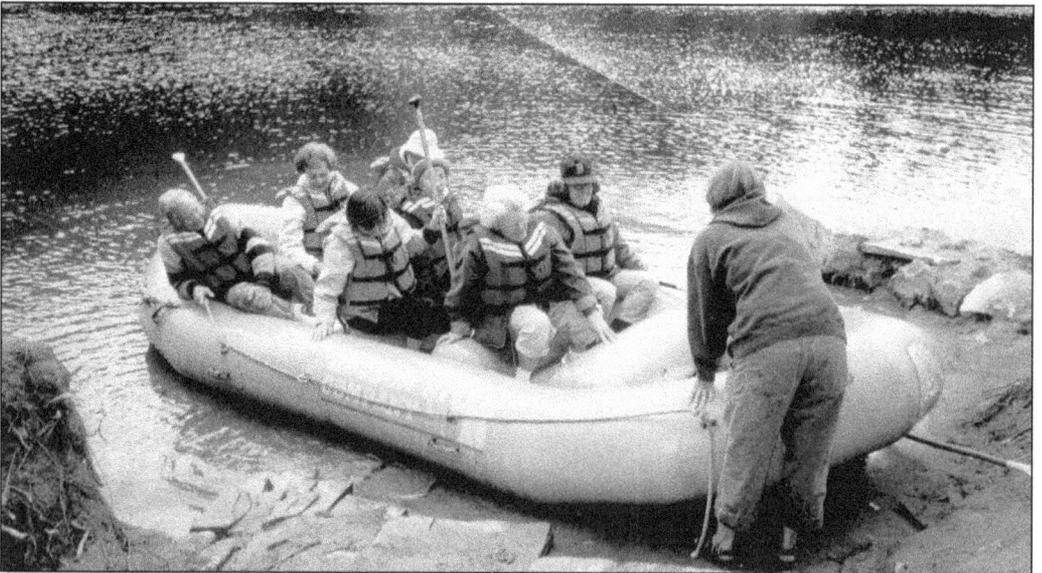

Whitewater rafting has taken hold in the Adirondacks in recent years, and dozens of rafting companies with licensed guides are making good use of the churning, tumbling rapids of the Adirondack rivers. The Indian, Hudson, Sacandaga, and Moose Rivers are used for major trips. Other waters lend themselves to smaller rafts and tubes. The raft shown here is being used to take visitors through the flume at Ausable Chasm.

The scenic waterfalls and rapids of High Falls Gorge on the West Branch of the Ausable River on Route 86 were carved millions of years ago. The spectacular 100-foot cascading waters of the narrow Wilmington Gorge plunge over slabs of pink granite for a total distance of more than 700 feet. The steel walkways and viewing platforms provide unobstructed viewing of the natural wonder of water and rocks in the Adirondacks.

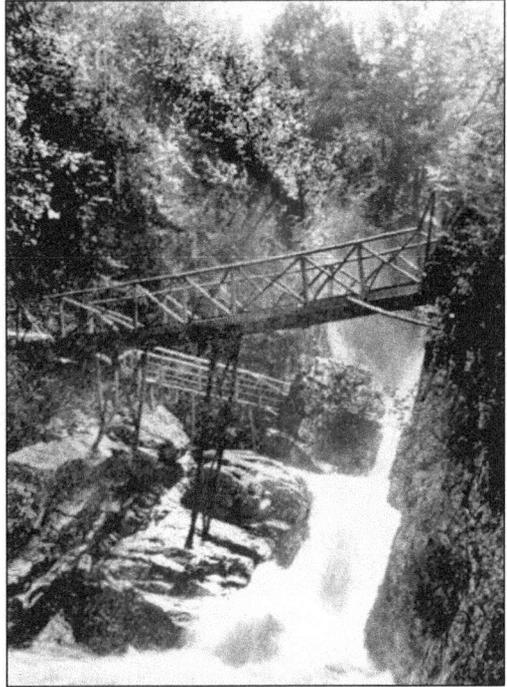

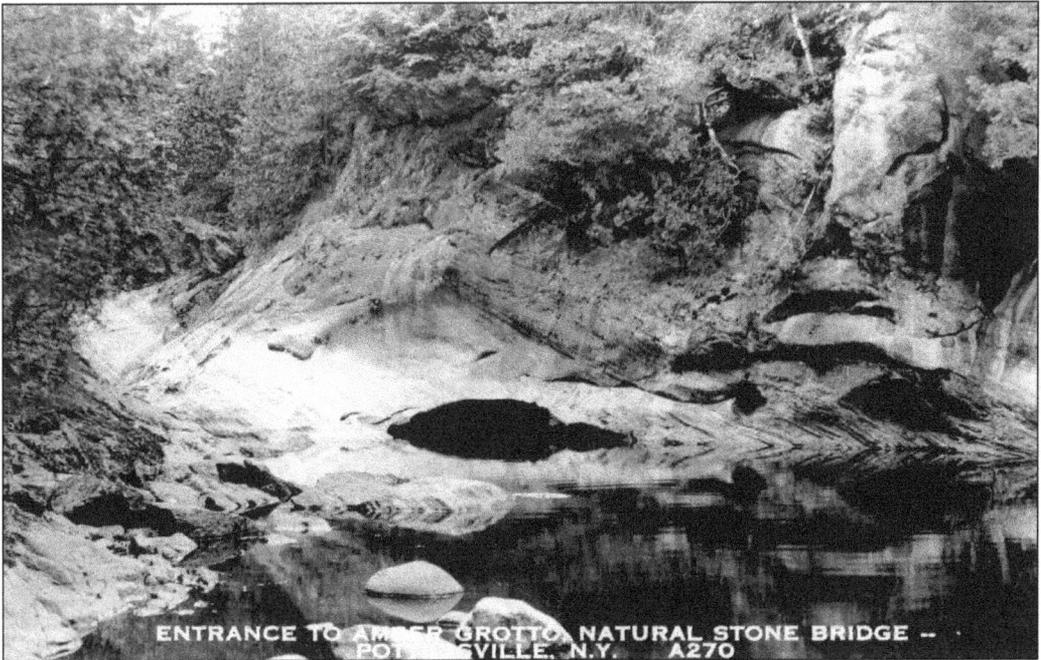

ENTRANCE TO AMBER GROTTO, NATURAL STONE BRIDGE -- POTTERSVILLE, N.Y. A270

Nature has carved out some caves, a natural bridge, and overhanging ledges in the Grenville marble on the rushing waters of Trout Brook near Pottersville. The site was described in a 1790 geography book. Some say that Sir John Johnson buried his treasure near the stone bridge on his way to Canada during the Revolutionary War. The complex of caves, grottos, waterfalls, tunnels, potholes, cliffs, ledges, crevasses, and crypts is open for visitors during the May-to-October season.

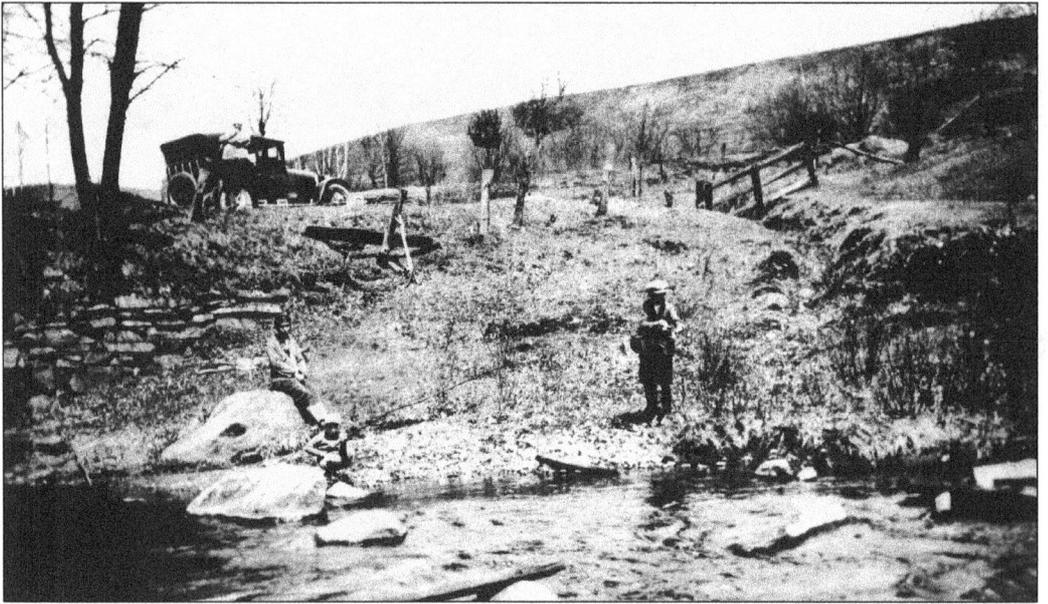

At the beginning of the century, when automobile travel provided access to the Adirondack waters, it was a part of life to put the kids in the car and take them fishing. The time on a woodland stream was far better than today's obsession with sitting with a television or computer. Walton's *Complete Angler* had its section on Adirondack fishing, and the best fishing was, and still is, a bamboo pole, a hook, line, and sinker, a few fishworms, and a good Adirondack fishing hole.

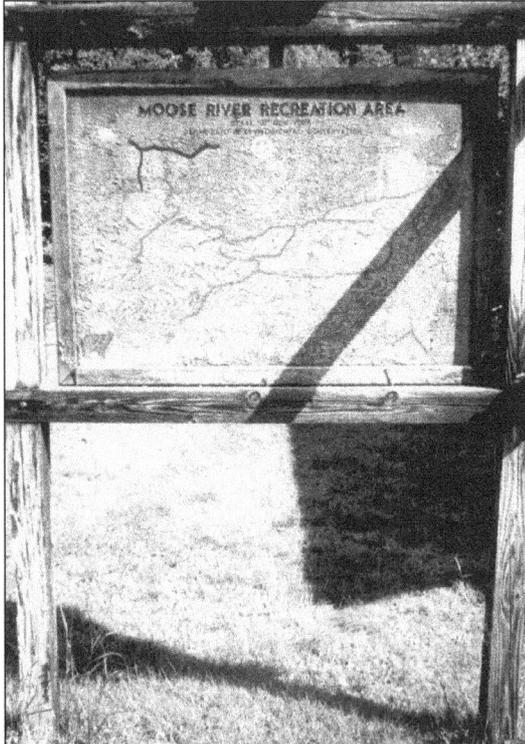

The 50,000-acre Moose River Recreation Area in western Hamilton County was purchased by New York State from the Gould Paper Company in 1963. It is also surrounded by state land and is intertwined with old log roads. Individuals and groups enjoy the wilderness camping sites, fishing, hiking, mountain biking, and hunting in the remote woodlands and along the rambling waterways. It can be entered from the east or from the west and is open to vehicles when the road conditions permit.

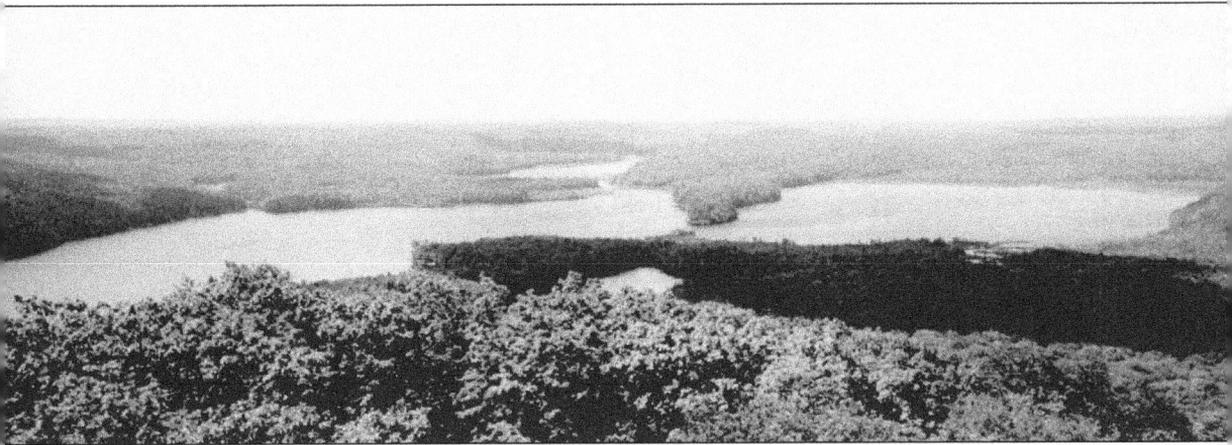

Adirondack fire towers attracted thousands each year because of the views they provided and the good hiking trails to the top the mountains. Climbing to the top of the tower got the viewers above the treetops to see the rolling forested hills and sparkling lakes off in the distance. The view from the top of Kane Mountain shows Canada Lake on the left, Lily Lake in the distance, West Lake on the right, and Mud Lake in the foreground. Fire towers had come into being at the beginning of the 20th century, when devastating fires were taking their toll on the Adirondack forests. Log towers were placed on 30 of the mountaintops by 1911, and steel towers followed until there were 57 in the Adirondacks. The state had decided by 1976 that fire towers had become obsolete and they should be removed in compliance with the "Forever Wild" constitutional protection of the wilderness. Fire observation could be done by air flights over the forest during the dry season and by modern communication technology. Supporters of the towers have joined with local town governments and Adirondack organizations to save some of the towers.

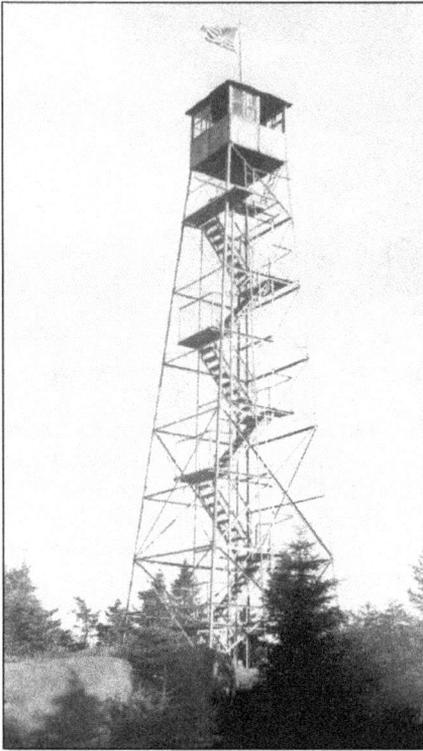

Cathead fire tower, one of the remaining towers in the Adirondacks, is now inaccessible to the public. Some parts of the trail and the tower are on privately owned land. The landowners need to cross a half-mile strip of Forest Preserve state land to get their logs out, and there is no provision in the law to allow it. The two parties have reached a stalemate on the usage; however, negotiations are under way, and a solution may soon be realized.

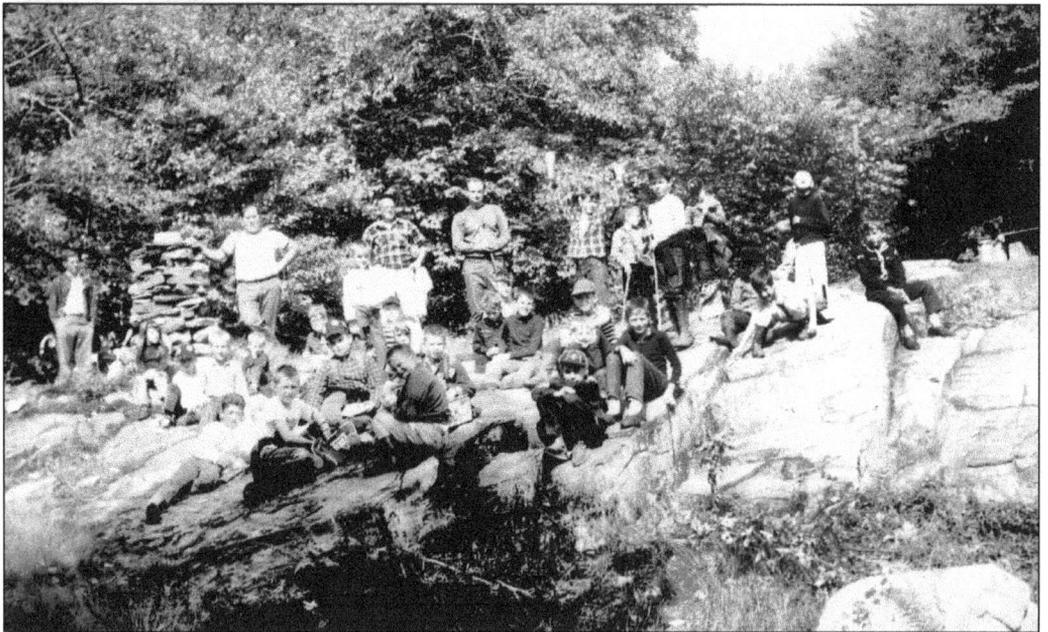

Cathead tower in Benson has long been a favorite hiking destination for Scout groups such as Gloversville's Pack 4 (shown here in 1967), hiking clubs, family groups, and others. The fairly easy mile-and-a-half hike rises a little over 1,000 feet. The view from the top, especially during the fall foliage season, is unsurpassed. Its location in the southern Adirondacks also makes it a preferred choice for communication towers.

The fire tower on display at the Adirondack Museum is from Whiteface Mountain. A combination of the towers that stood on Kempshall and West Mountains has been preserved at the Elizabethtown Museum. Life on the towers by the rangers involved isolation, being a guide for visitors, fire watching, and enough climbing up and down a mountain to last a lifetime. The experiences of a female tower ranger is the subject of *Nehasane Fire Observer*, by Frances Seaman.

There are other hikes to take in the Adirondacks besides the fire towers. The Adirondacks offer some 2,000 miles of trails for use by young and old alike. The three generations here are enjoying a section of the more than 100-mile-long trail extending from the Northville bridge to Lake Placid. Many trails have wooden walkways and bridges over swamps and streams. They provide access to the deep woodlands and majestic views from the mountainsides. Colored trail markers tacked on the trees keep the hikers from getting lost. It is a good idea to keep to the trails in the wild Adirondacks.

21

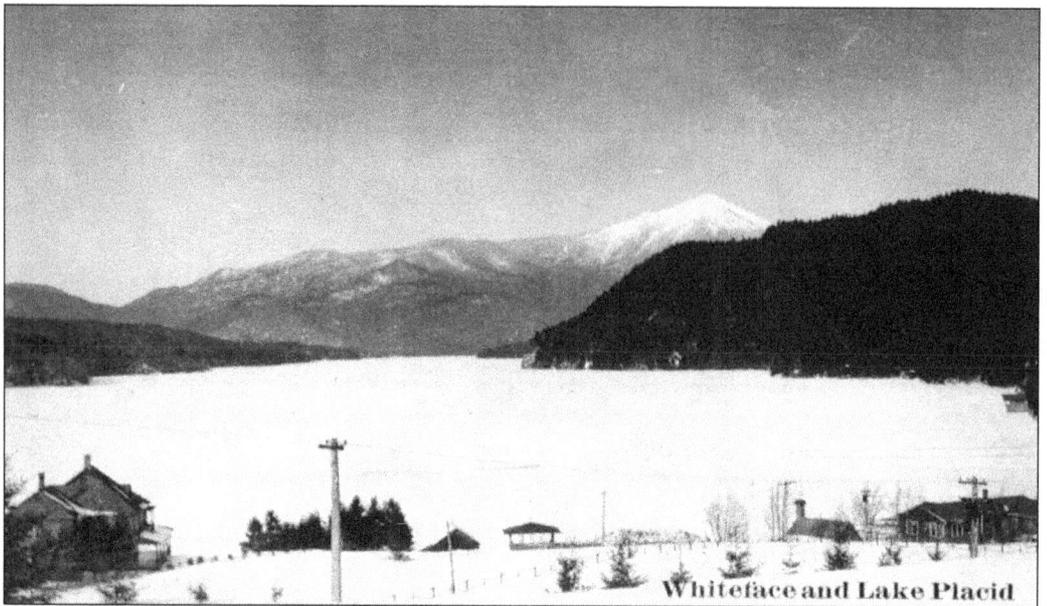

Whiteface and Lake Placid

The serene winter scene of Whiteface Mountain and Lake Placid provides only one side of the winter scene in the North Country. Skating, skiing, sliding, snowshoeing, and a wide choice of other winter sports have met the visitors and residents since they were popularized by the Lake Placid Club and the Winter Olympics early in the 20th century. Whiteface Mountain has now reached Olympic status with its winter world-class offerings.

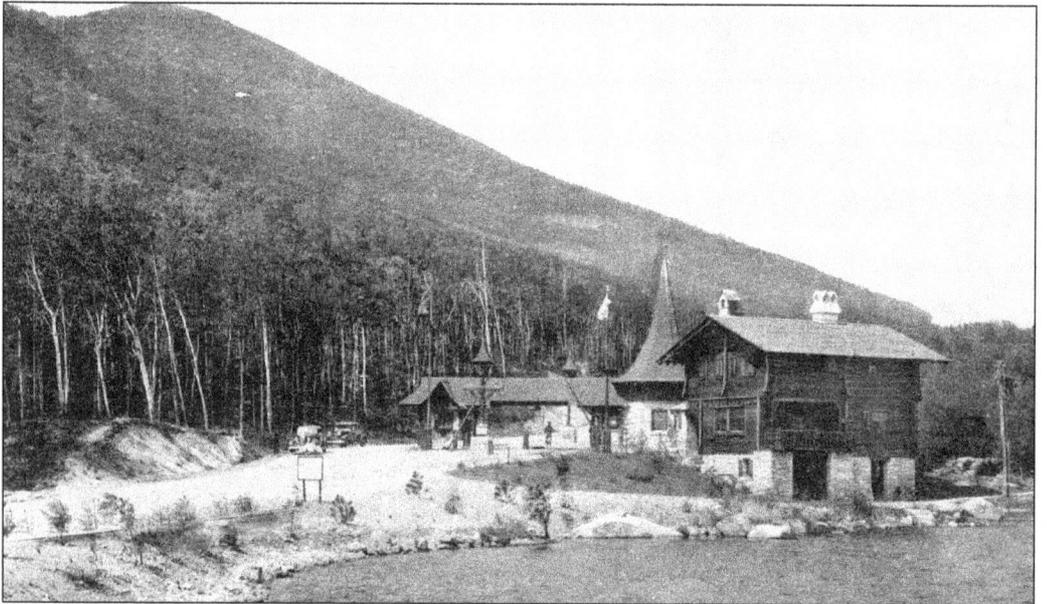

There is some history that says that the Native Americans called Whiteface Mountain *Wahopartenie*, or White Top (Whitehead); it was so named to honor white-haired King Hendrick, a Mohawk chief. New York State purchased the mountain in 1921 and built the 8.2-mile toll road to the top in the 1930s. The tollhouse is shown here. The building of ski trails commenced in 1941, and the mountain now has 65 trails. It also offers the highest vertical ski center in the Northeast and is operated by the Olympic Development Authority.

A few stands of old-growth timber, often referred to as virgin timber that predates the coming of the Adirondack settlers, can be found in the mountains. One stand, Pine Orchard, in the southern Adirondacks, includes several giant white pine trees estimated to be more than 180 years old or older. One of the giants, shown here, measures 19 feet around. Likewise, spectacular old-growth white spruce trees can be seen on the Powley-Piseco Road.

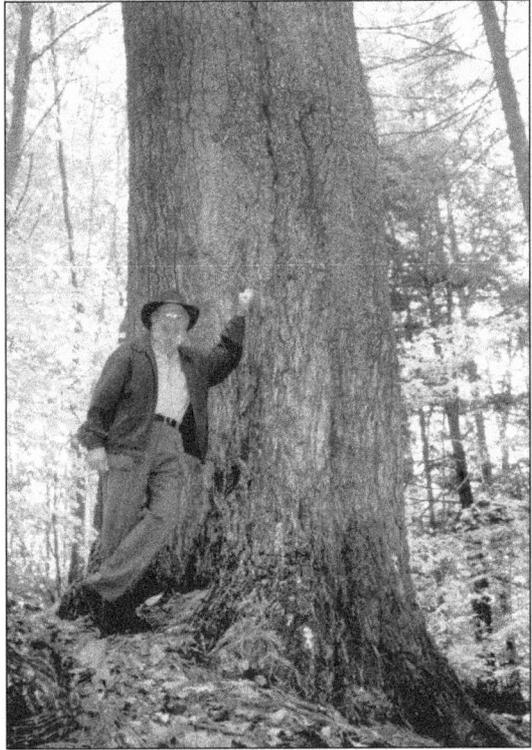

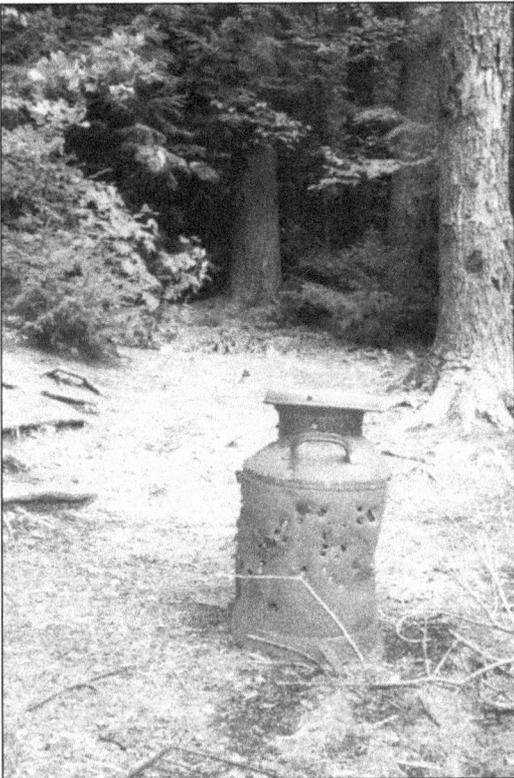

A wide variety of remnants of man's intrusion into the Adirondack woodlands can be seen along the trails and around the waterways. Old farm equipment from the days of the struggling Adirondack farms is often found rotting in the woods. The old milk can in the woods near Mason Lake has served its purpose and now appears to be a target for the riflemen. At one time, small cannons used in Revolutionary times were found abandoned on the Adirondack trails.

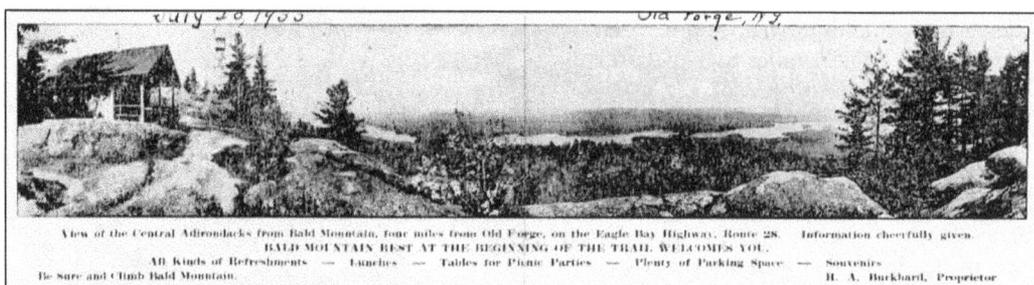

View of the Central Adirondacks from Bald Mountain, four miles from Old Forge, on the Eagle Bay Highway, Route 28. Information cheerfully given.
BALD MOUNTAIN REST AT THE BEGINNING OF THE TRAIL WELCOMES YOU.
All Kinds of Refreshments — Lunches — Tables for Picnic Parties — Plenty of Parking Space — Souvenirs
Be Sure and Climb Bald Mountain. H. A. Burkhard, Proprietor

Bald Mountain, near Old Forge in Herkimer County, claims to be the shortest, easiest climb in the Adirondacks with a great view. The two-mile round trip takes less than two hours and provides a view of the Fulton Chain of Lakes, Blue Mountain, and (in the distance) Mount Marcy. The reverse side of this long 1935 card provides "Auto Mileage Distance from Bald Mtn Rest, Third Lake, Old Forge, N.Y.," to some 120 towns, north and south, including the 874 miles to Chicago.

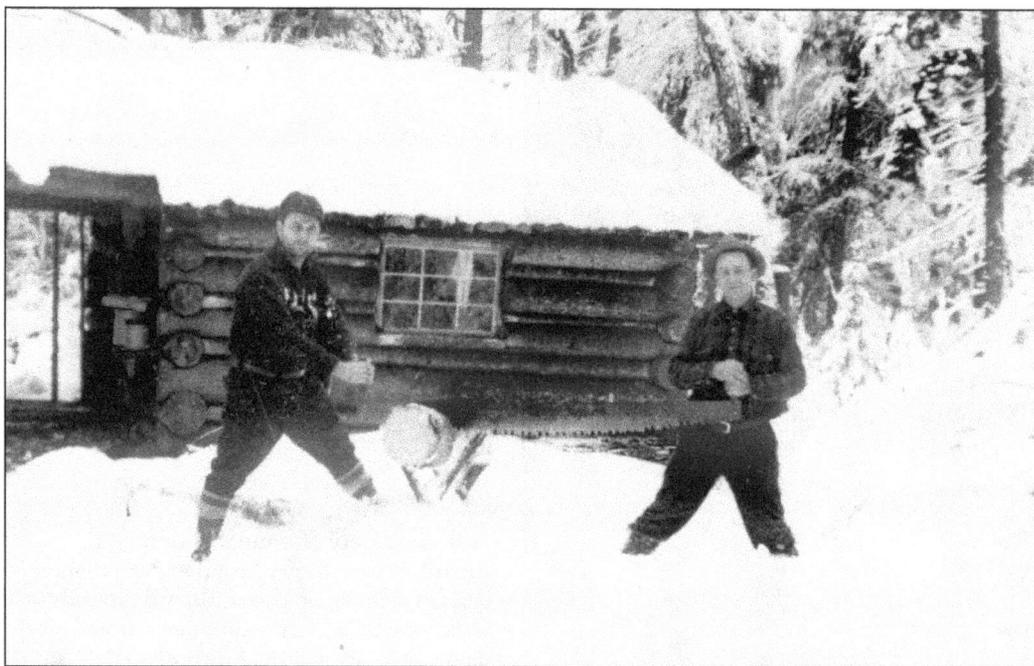

There were thousands of trees in the Adirondacks that would keep the lumber companies busy to the middle of the 20th century and beyond. They had to be cut by hand in the days before chain saws, and those who grew up in the Adirondacks felt that they were born with a crosscut saw in their hands. Young boys were put on one end of a crosscut saw as soon as they were strong enough to pull it back. There was always wood to cut for that hungry kitchen stove or fireplace, and the lumber companies were always looking for help during the cutting season.

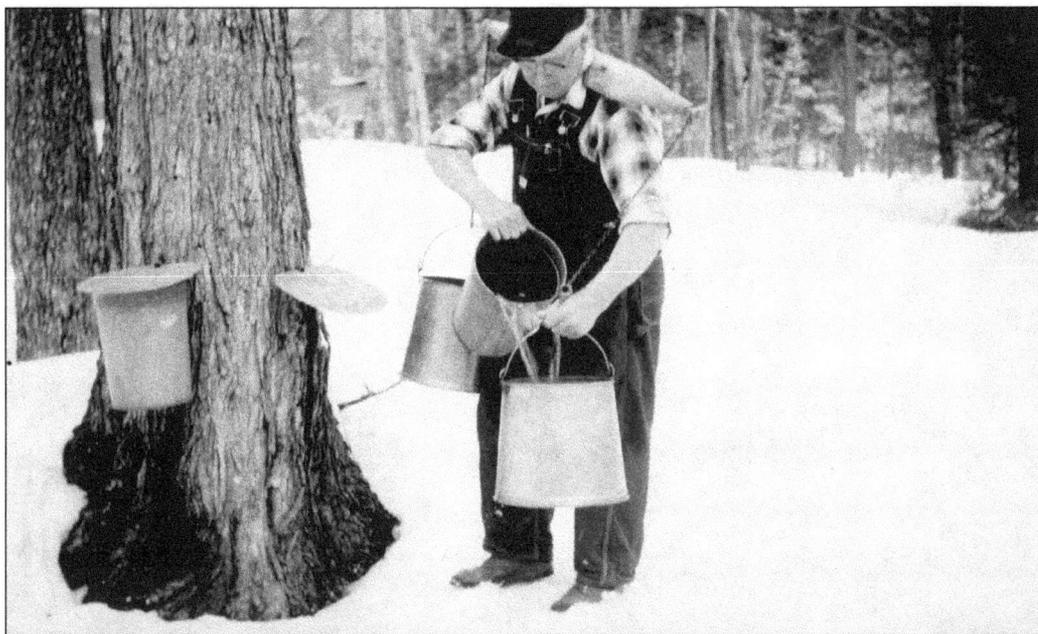

The giant sugar maple trees of the Adirondacks have supplied Adirondack settlers and others with syrup and sugar from the days of the first farms. Maple sugar bushes, as they are called, range in size from small backyard operations to those with thousands of taps. Sumac sap spiles are placed in drill holes in the trees, and 30 to 40 gallons of sap drip out into the buckets to boil down for each gallon of syrup. Jim Rieth is gathering sap at his bush in Bleecker.

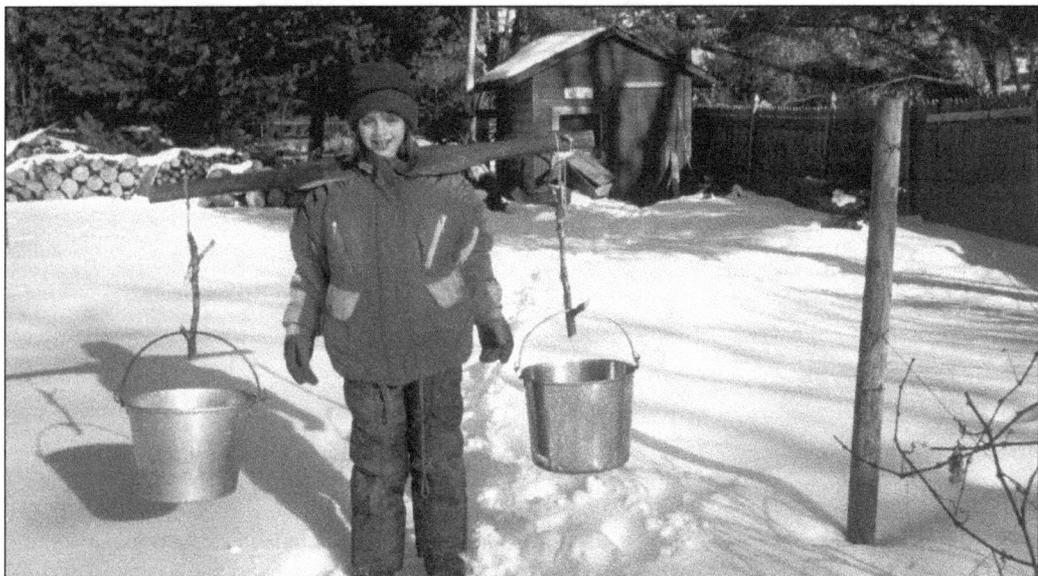

The entire family helped in the sugar bush during the few weeks in the spring when the sap runs. Wood has to be chopped, the fire needs to be tended for endless hours, and the sap must be gathered from the trees. Jennifer Williams is using her great-great-great-grandfather's homemade sap yoke to carry the sap to the sugarhouse for boiling. Some bigger operators are using plastic tubes today to transport the sap to the holding tanks and using a special machine to take much of the water out of the sap before boiling.

25

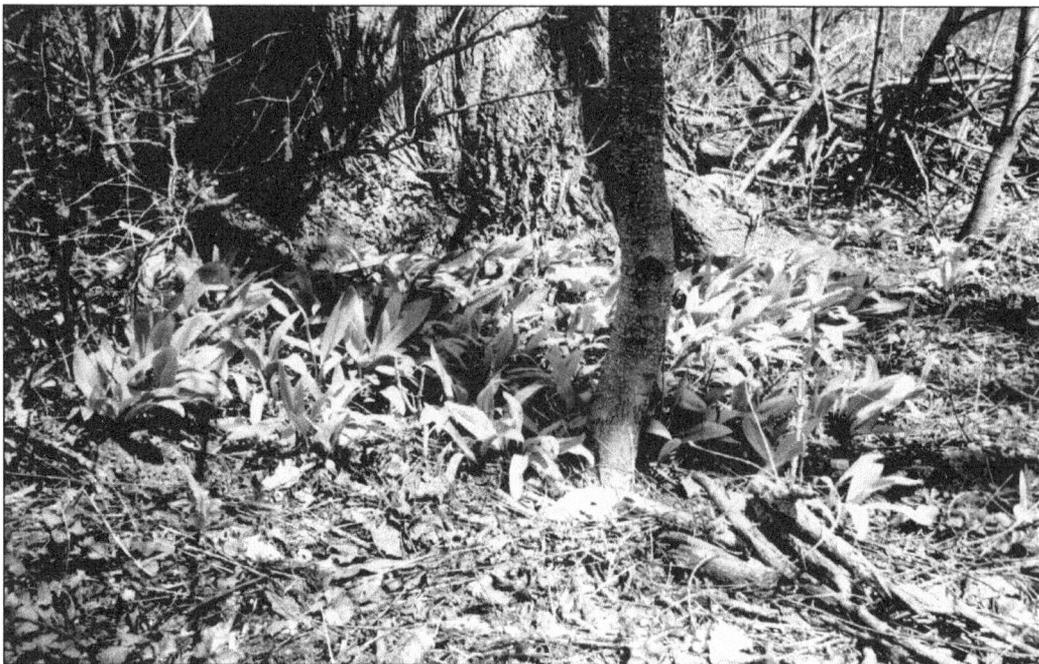

The Adirondacks are a garden of food if you know what to look for. Native Americans and early settlers learned to "live off the woods" and passed down much of their woodland knowledge to those who followed. The patch of leeks, with their strong-flavored onionlike bulbs and leaves, can be used in soups, salads, and sandwiches. They leave a strong flavor on your breath. One old guide's dog used to eat the leeks, and his "bark became worse than his bite."

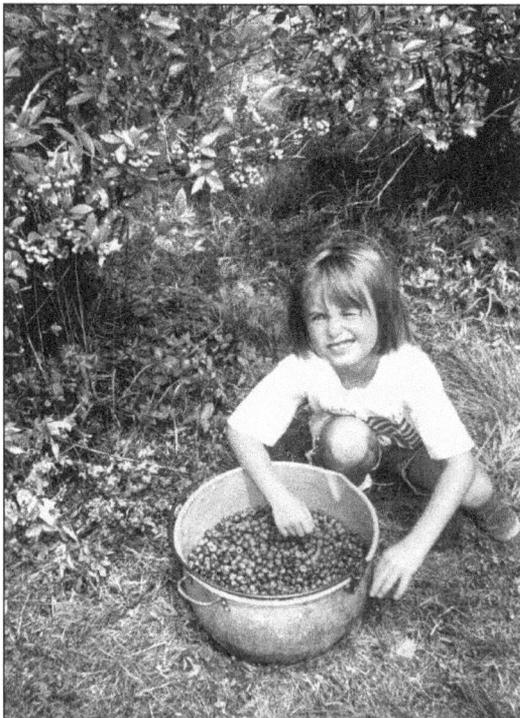

Berry picking was, and is, a part of the lives of many who grew up in the Adirondacks. Wild raspberries, blackberries, strawberries, bill berries, high bush cranberries, and blueberries were picked each year to add to the larder of the Adirondack families. Jams, jellies, pies, and muffins were produced in the Adirondack homes. The blueberries shown here with Taylor Williams were picked at the Timberline Blueberry Patch near Caroga Lake.

Butternut trees were sought out in the woodlands of the Adirondacks, and when fall arrived, it became time to pick up a year's supply of the butternuts. The oily nuts are sweet and tasty and could be used in candy, cakes, pies, and ice cream. Some unripe nuts were pickled, and the husks of the nuts were widely used for making a brown dye. They were dried on the barn or attic floor and cracked open with a heavy hammer or vise.

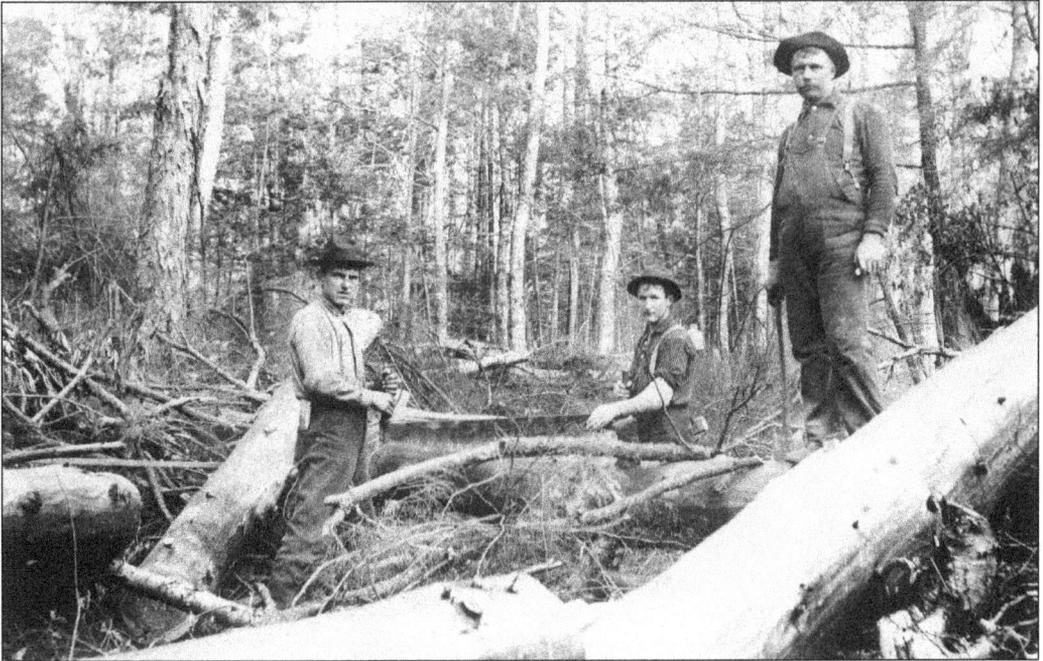

The Big Blowdown of 1950 created the biggest cleanup problem in the Adirondacks of all time. It was caused by a 125-mile-per-hour destructive windstorm. It destroyed some half-million acres of forest land, and it took five years to clear the trails and remove the tangle of downed trees. Much of the cleanup was leased to private contractors to salvage some of the wood and get the job done. The storm also forced Adirondack hermit Noah John Rondeau to leave the woods, never to return.

Look up at the Adirondack mountainsides. On occasion, one of the forested, steep mountains becomes the victim of the weather, and a slide occurs. The layer of soil that holds the growing vegetation to the rocky surface becomes water soaked or loosened, causing the tons of trees, rocks, and soil to slide down the mountain. Many slides have been seen on the mountains for years, and some have been given names, such as horse's head, by their shapes. The slide here, near Snowy Mountain, occurred during a wet streak a few years ago.

In 1985, the state held several events to celebrate the centennial of the Forest Preserve, a pattern of preserving our forests that spread from New York to other states. At a centennial dinner in Albany, hosted by Gov. Mario Cuomo, each diner received an evergreen seedling, a double balsam, as a dinner favor. The tree shown here, planted on the author's property and now 17 years old, reminds us of our precious Forest Preserve and those who had the wisdom to make it happen.

Two

CAMPS AND CABINS
AND CLUBS

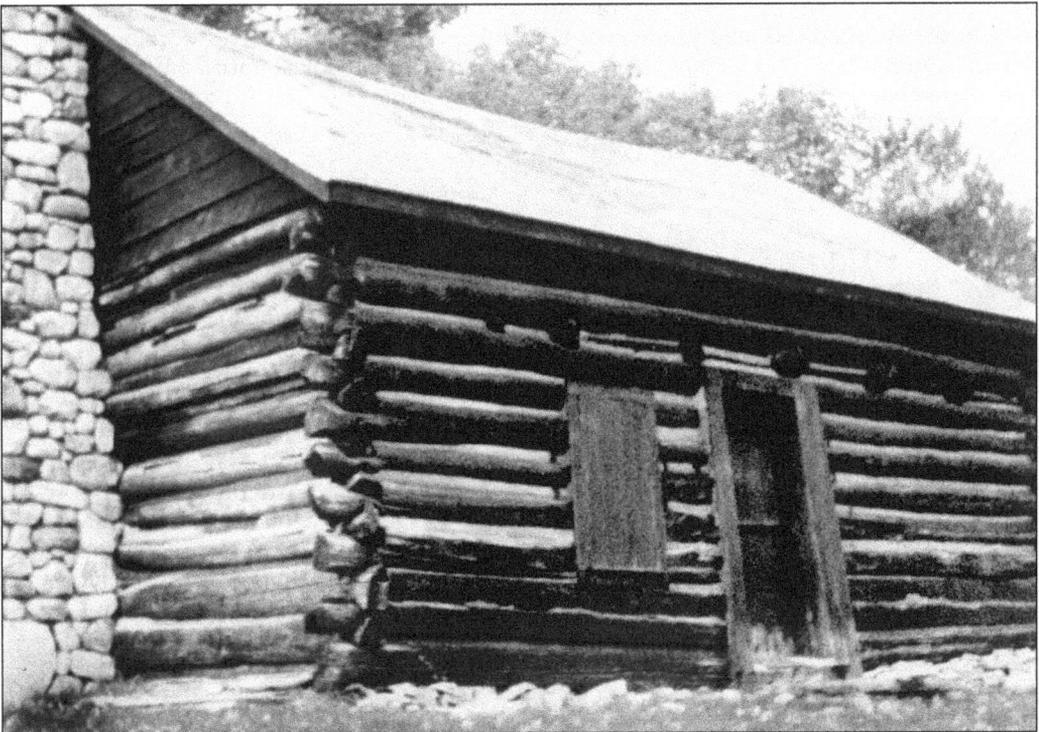

One of the oldest preserved and restored log cabins in our country can be found at Willsboro. The oak log cabin, built in the 1790s by Revolutionary War veteran Samuel Adsit and now owned by the town, is open to the public on summer weekends. It is maintained and staffed by volunteers with the Willsboro Heritage Society. Fortunately, the cabin had other structures built around it in the past, forming a protective shield from the weather.

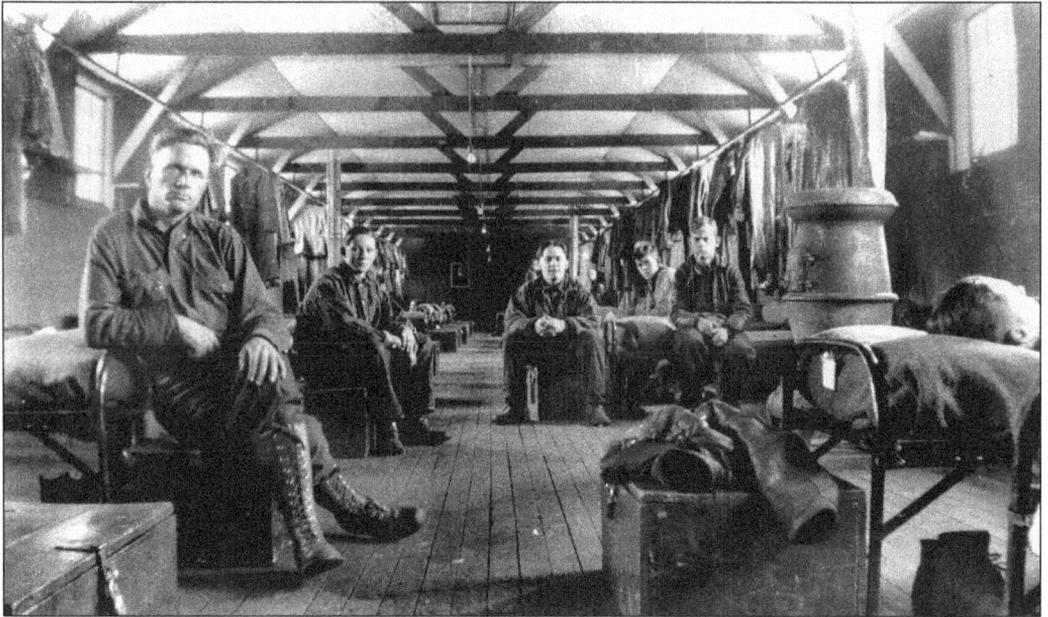

The Civilian Conservation Corps (CCC) was born in the Great Depression to help families through the bad times by providing work on worthwhile projects. Many of the work projects were in the Adirondacks, and young men from the cities found themselves working in one of the nine Adirondack CCC camps. They were provided with a booklet entitled *Woodworking* to help them cope with the conditions of living and working in the rural Adirondacks.

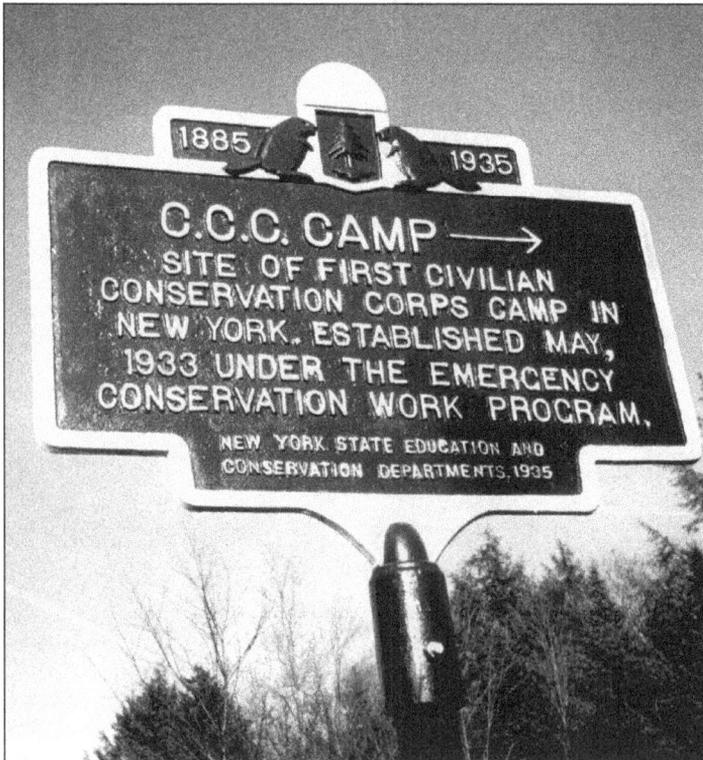

The first CCC camp in New York State was established in May 1933 on the road from Arietta to Piseco. Corps members were paid $30 a month to work on stream improvements, dams, campsites, trails, weed and pest control, and fire control. They became known as "Roosevelt's Tree Army." Many CCCers settled in the Adirondacks, and today's generations are still benefitting from the CCC Adirondack projects.

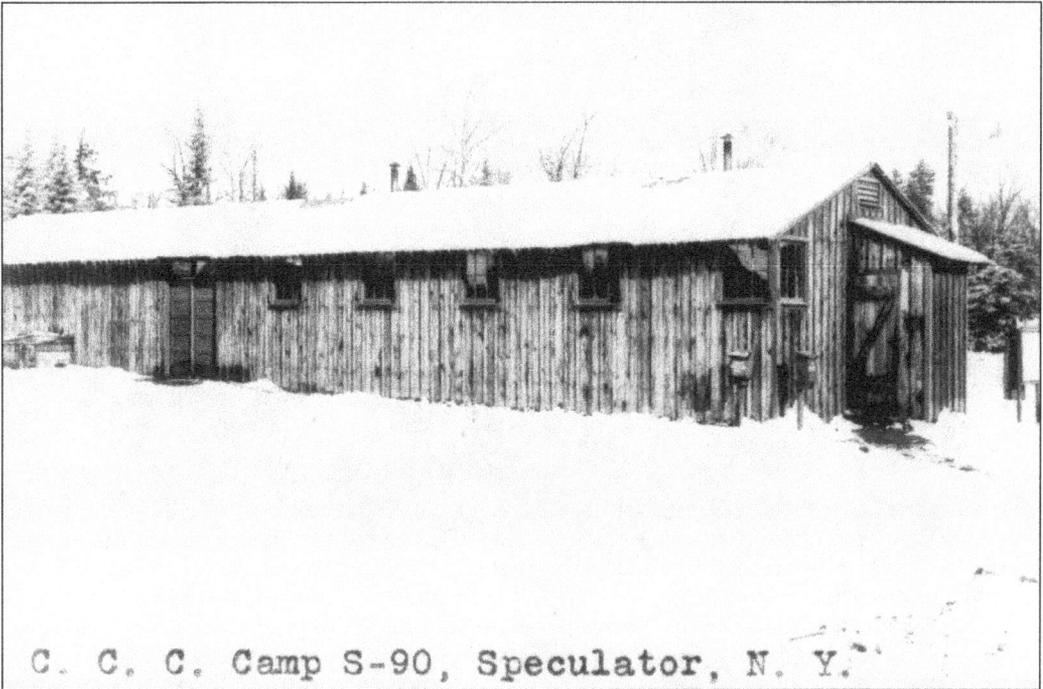

C. C. C. Camp S-90, Speculator, N. Y.

The CCC camp at Speculator was constructed in 1934 and is used today for a 4-H summer camp. It was in the headlines in April 1989 when one of the rare CCC-commissioned murals was removed from the wall of the 4-H recreation building and transported to the Adirondack Museum at Blue Mountain Lake for preservation. It was replaced on the camp wall with a wooden photograph of the original work.

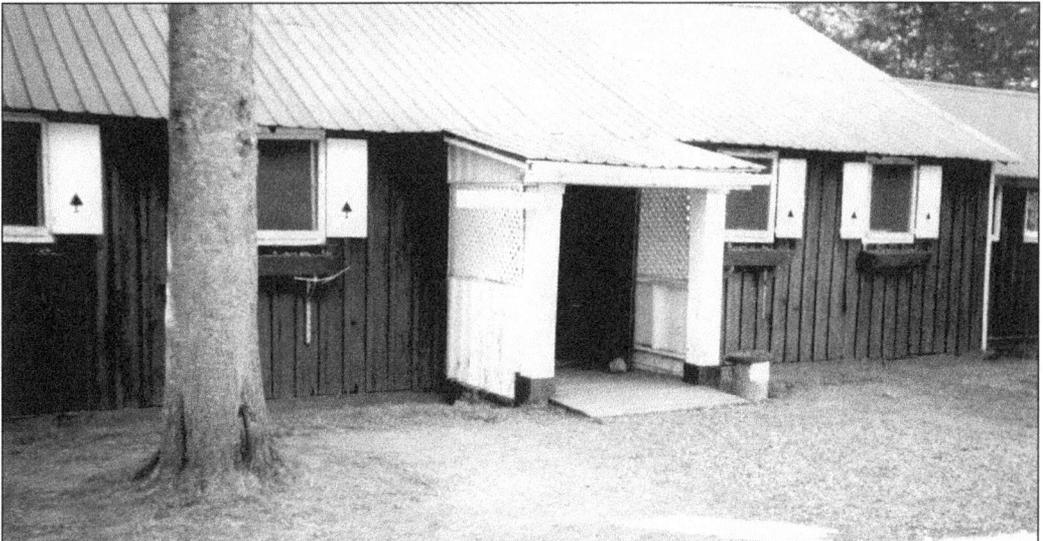

The 4-H camp, Camp Sacandaga, at the 1934 CCC site, makes use of the old CCC camp buildings for the summer program. Near Moffitts Beach on the Sacandaga Lake, the camp, owned and operated by Cornell Cooperative Extension of Fulton, Montgomery, Oneida, and Warren Counties, is in its 58th summer of camping. It is open for all boys and girls, not just 4-H members, from ages 5 to 19.

31

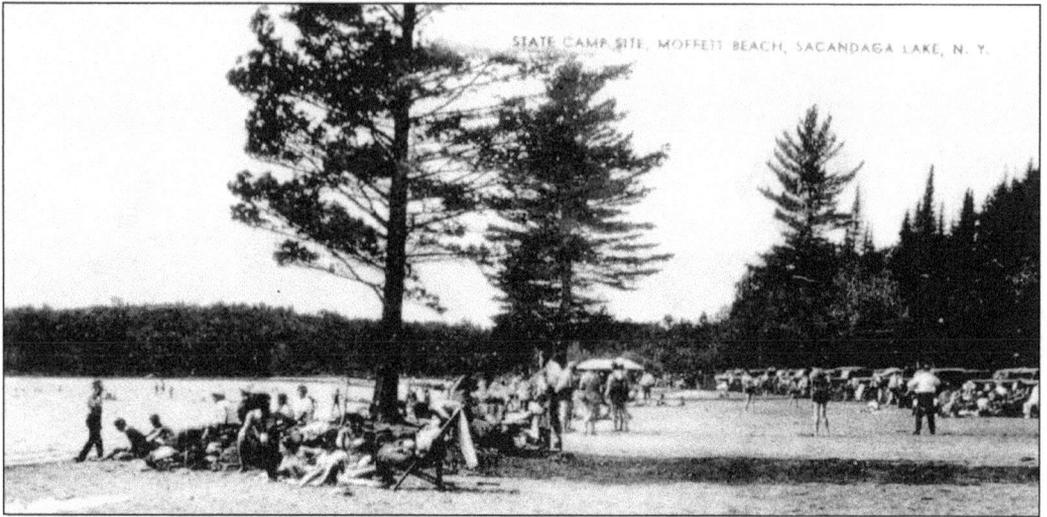

The Moffitts Beach Campsite, adjacent to the old CCC camp on Sacandaga Lake, was erected on the farmlands of Ephren Moffitt and his brother Charles. Ephren was a good mason and built the old sections of the Hamilton County Jail and the Hamilton County Courthouse. The family graveyard can be found on the site of this popular campsite. Note the automobiles lined up at the beach and the large crowd enjoying the swimming in this clear Adirondack lake.

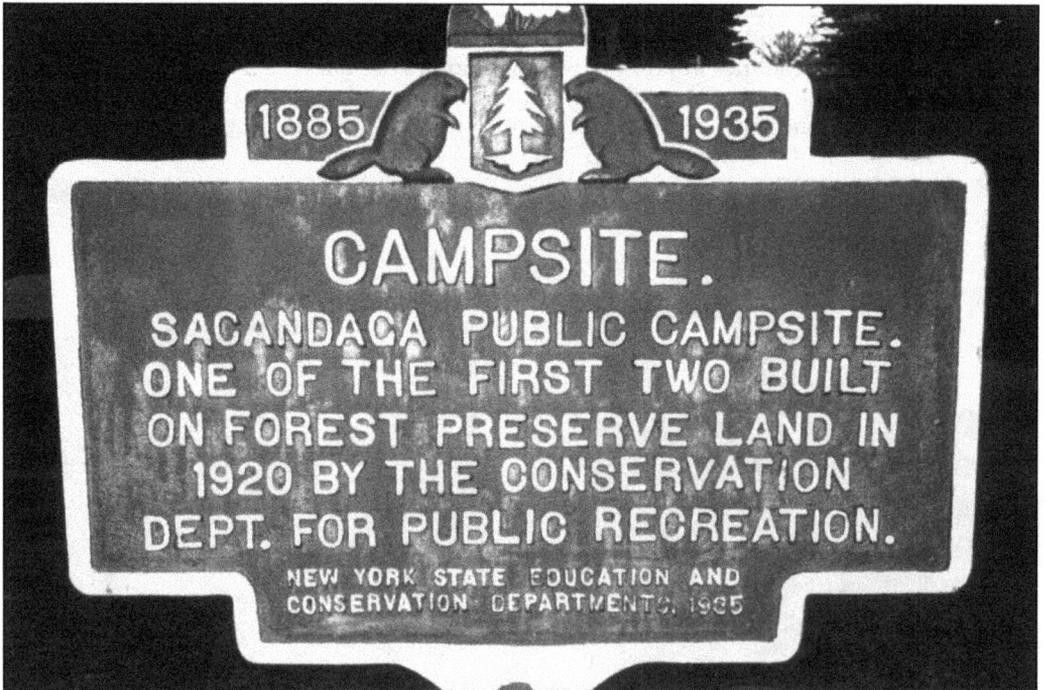

1885 1935

CAMPSITE.

SACANDAGA PUBLIC CAMPSITE.
ONE OF THE FIRST TWO BUILT
ON FOREST PRESERVE LAND IN
1920 BY THE CONSERVATION
DEPT. FOR PUBLIC RECREATION.

NEW YORK STATE EDUCATION AND
CONSERVATION DEPARTMENTS, 1935

The first two campsites were built in 1920, and by 1930, nine others were opened for campers. They could be found on the Schroon River at North Hudson, Wilmington Notch, Lewey Lake, Meadowbrook near Raybrook, Cross Clearing near Tupper Lake, Third Lake Creek on the Fulton Chain, Piseco Lake, Connery Pond, and Hatchery Brook. Today's campsites have a reservation service for planning ahead, and they are well maintained by the New York State Department of Environmental Conservation for tents, campers, trailers, or recreational vehicles.

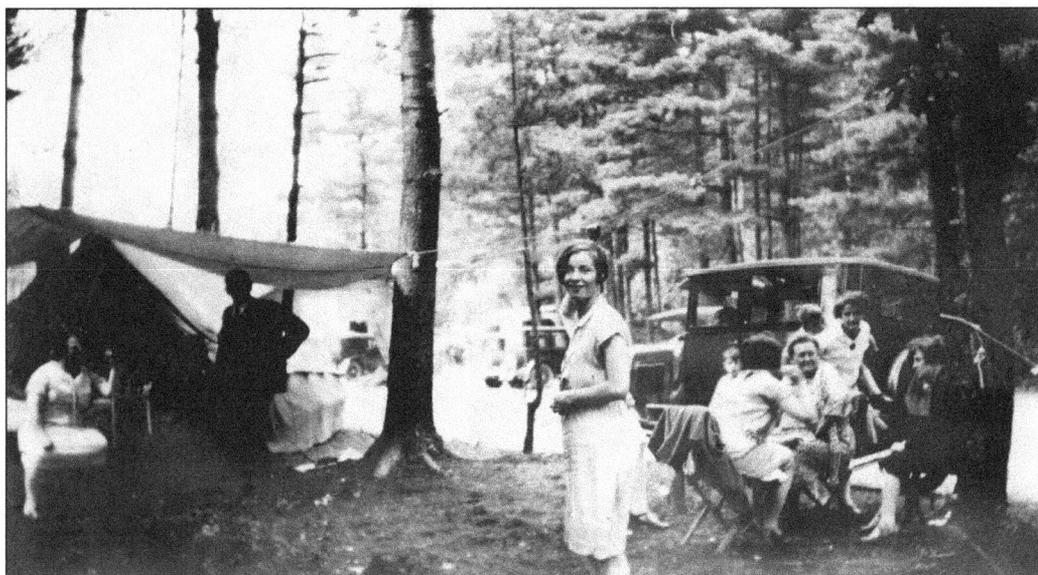

The traveling public found the Adirondacks soon after automobile touring became popular. Roadside pull-offs, usually along a river or lake, became overnight camping sites. Before the state government erected the first campground in the state at the Forks on the Sacandaga River, campers had begun to make use of the pine grove for summer recreation.

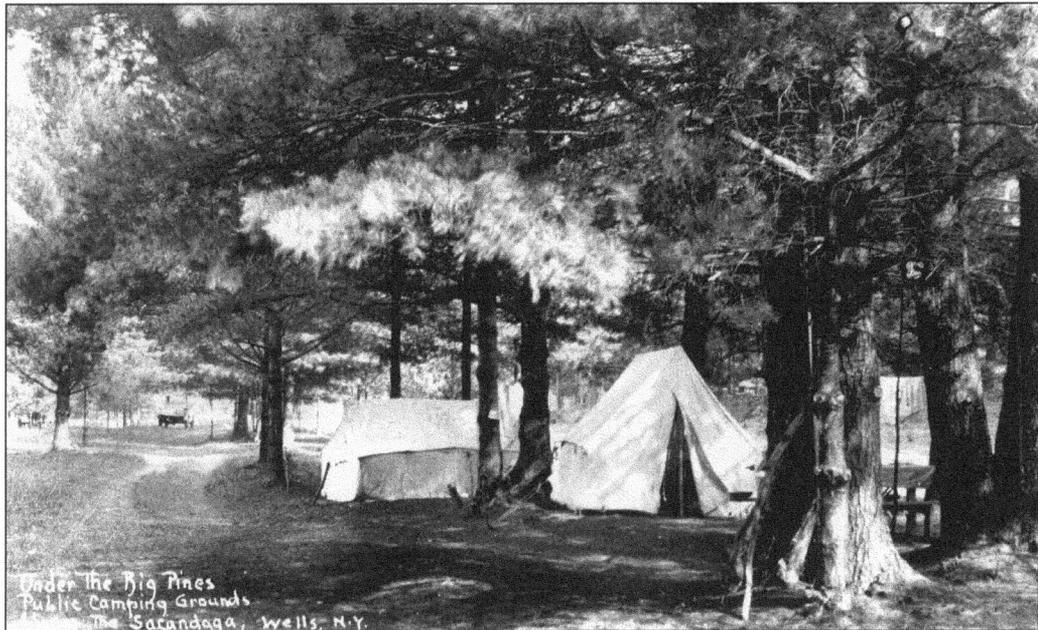

Under the Big Pines
Public Camping Grounds
The Sacandaga, Wells, N.Y.

The Forks became a public campground in 1920 and continues to this day. It was a popular site from the beginning with its small dam and beach on the refreshing Sacandaga River. The giant white pine trees provided the perfect setting for camping. Today, the dam has been removed, but the site still attracts campers to the Sacandaga solitude under the stately pines.

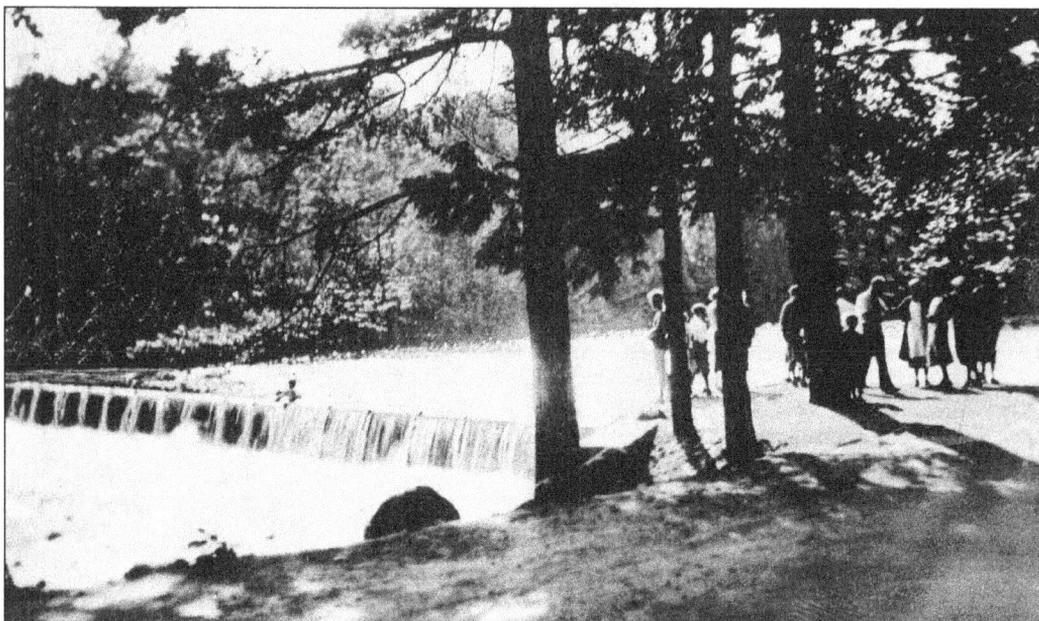

The CCC workers did much of the work at the Sacandaga Campgrounds and other public campsites. They constructed a bridge across the river below the dam to create additional campsites on the other shore. The dam shown here has been discontinued but was once a challenge to young children who walked out and sat behind the cascading waters.

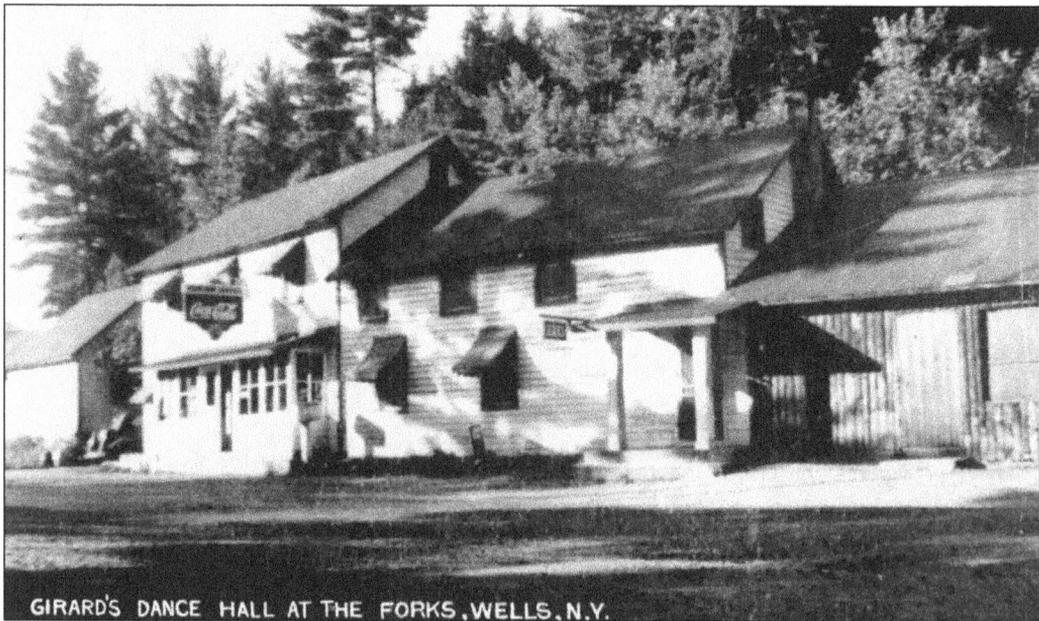

GIRARD'S DANCE HALL AT THE FORKS, WELLS, N.Y.

For the first half of the 20th century, a dance hall and variety store was operated by the Lashers and later the Girards at the Sacandaga Campground. The "Dancing Every Saturday Nite—Girards at the Forks" brought girls from the city and boys from the mountains together. Friendships were developed and weddings followed. When the square dances attracted a full house, the building, sitting on blocks, would bounce up and down to the beat of the music. The dance hall succumbed to fire in the 1950s and was not rebuilt.

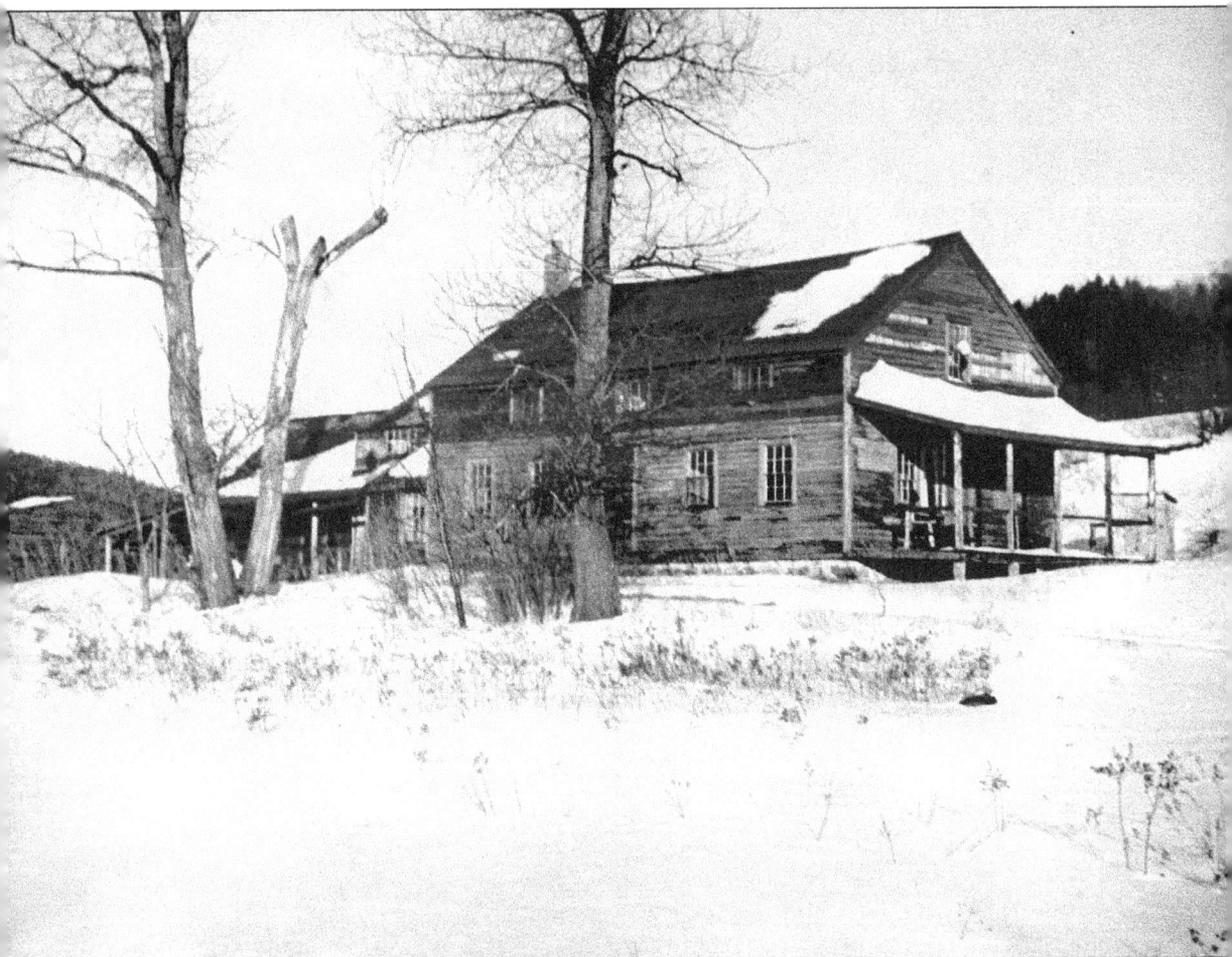

The Adirondack Shakers, part of a religious group, came to the mountains c. 1910 to make furniture, baker's peels (a wooden "shovel" tapered on the edge and used to take bread from the oven), and other wooden products from the forest trees. They found the ash, cherry, and birch trees they needed and built the house shown in this 1948 photograph on the road between Johnstown and Piseco on the West Branch of the Sacandaga River. Within 10 years, they were gone. No one knows where they came from and where they went when they left the Adirondacks. It raises the questions of how they found the Adirondack site and why they gave it up. Some say that the moose chased them away by destroying their gardens. In 1920, when Eli Rudes moved in the old house built by the Shakers, he complained that he had to move because the moose would not leave his haystacks alone; they tipped them over and ate the hay. The Shakers, Ann Lee and her followers, had come to New York State in 1774 and settled at Watervliet; it is possible that the Adirondack Shakers came from there. The Shaker Place, as it was known, has had its share of tenants over the years, including Bradford Fountain and his wife (who lived there while working for Albert Brown), Lyman Avery (who used it for a boardinghouse), John Fisher, and the Hosley family.

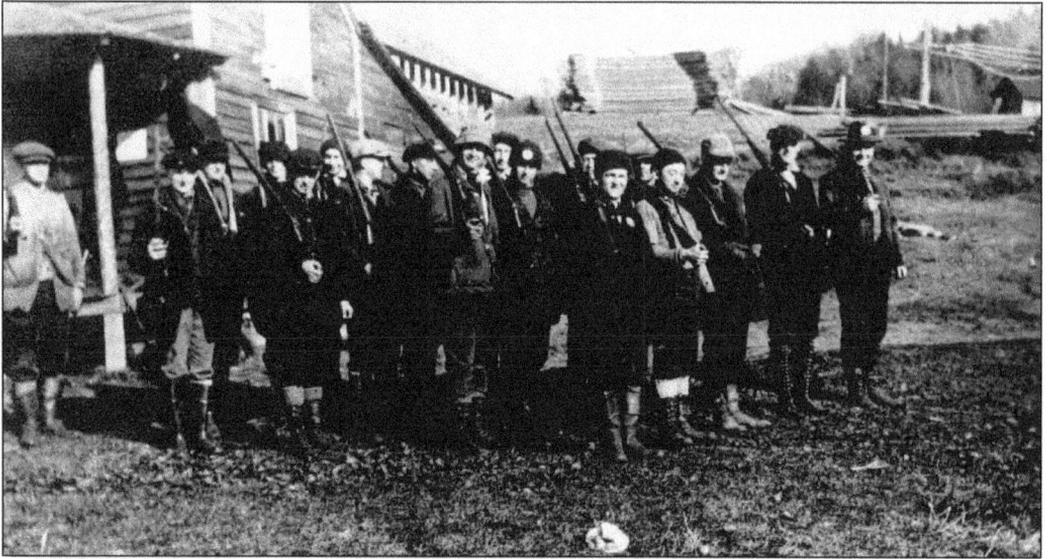

After the Shakers left their Adirondack home, the old Shaker Place continued to be used by others up into the 1940s. This hunting party, "Shaker Place Guards," appears to be ready to go off to war. Once the building was abandoned, the old house deteriorated and was gone by the 1950s. In 1997, the property was purchased by a large company that may develop the property on the meandering West Branch of the Sacandaga for other uses.

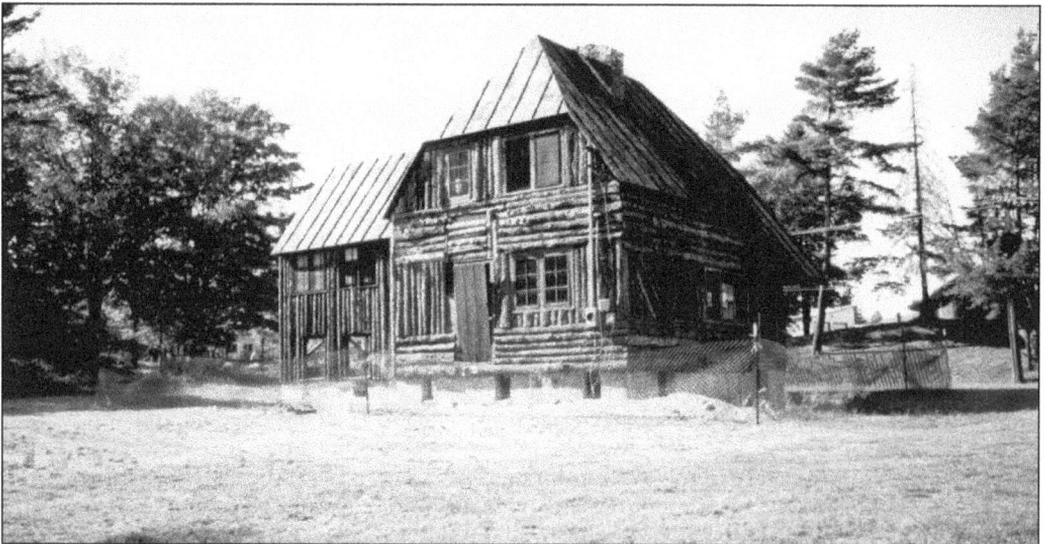

Bernard Hemmer of Syracuse came to the Adirondacks in 1919, much like others, to recuperate from tuberculosis. He also needed healing from the effects of serving in World War I. In 1932, he built Cottage Kent at Old Forge as a honeymoon cottage for his sister and her husband. Later, he and his wife, Mary (a schoolteacher in the town of Webb), lived in the cottage. He went on to build 14 other cottages, each reflecting a unique European style. Today, the architecturally unique cottage is being restored.

Once the automobile entered the Adirondacks, cabin colonies grew up on the highways and byways to provide shelter for the traveling and vacationing public. Tourists often stayed for a week, especially if the cabins were on the shores of an Adirondack lake. The lack of indoor plumbing in many of the cabins required a row of outhouses (privies) placed inconspicuously behind the main buildings.

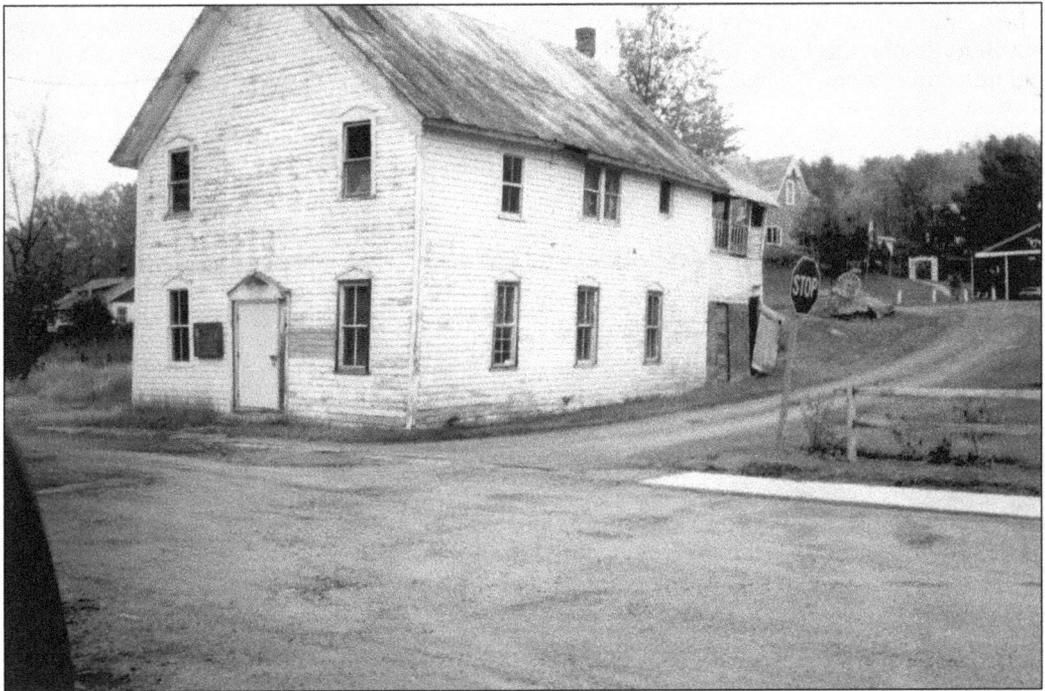

The Hudnut estate, on Route 8 between Wells and Weavertown, was once the site of a boys' camp. A sign reading, "Fox Lair, Police Athletic League" marked the location of the Adirondack summer camp for 600 boys from New York City. Opened in 1938 with a lease from Winifred Hudnut, the Police Athletic League purchased the property in 1942 and kept the camp going until the 1960s. The only remaining building from the Hudnut days is this large building that was transported to nearby Bakers Mills and used for a church. Today, the property is opened for camping as part of the New York State Forest Preserve.

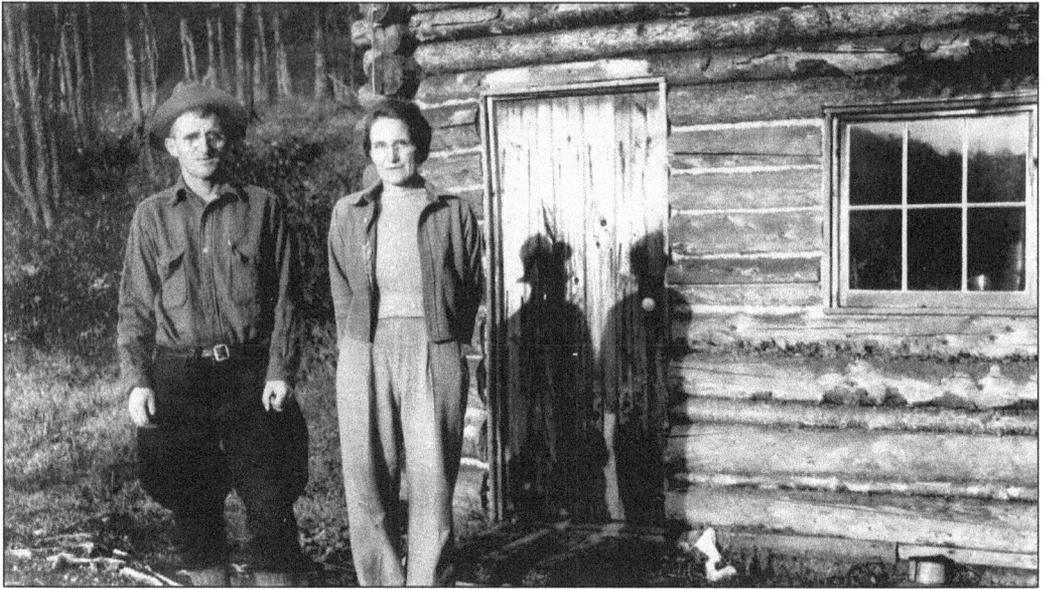

From 1926 to the 1960s, Harry Wilber, one-time mayor of Speculator and Adirondack guide, and his wife, Myrtle, ran a hunting camp that they built back in the woods on the Kunjumuck River. The only access to the camp was by foot or horse-drawn wagon until 1930, when roadways were put in for lumbering. Some remember Harry Wilber using tamarack (hackmatack) wood in the old iron stove; it crackled and sparked in a special way while burning.

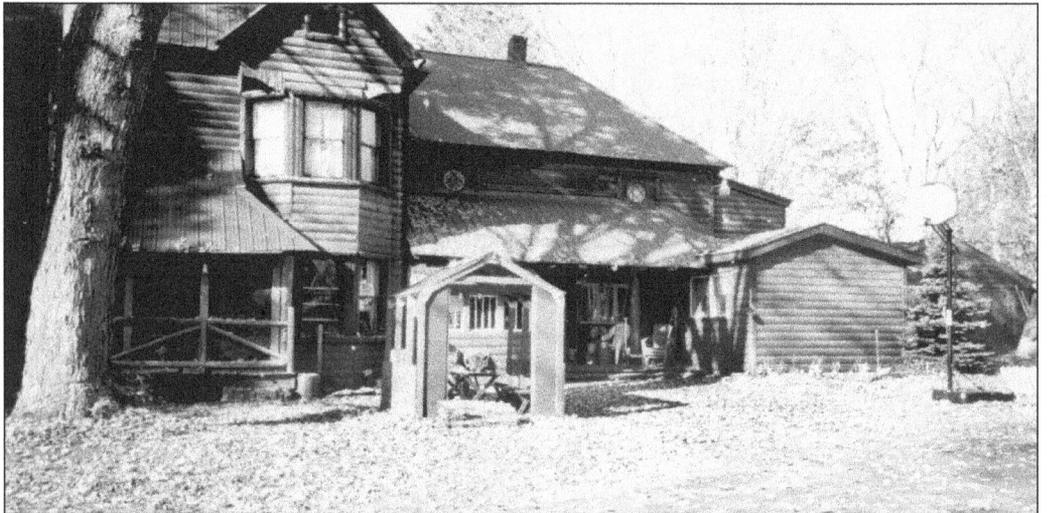

The camps, cabins, and clubs built in the Adirondacks before and during the 20th century have had their influence around the country. National parks, the log buildings built by Walt Disney, and others have adopted the Adirondack style of architecture. The author's home, shown here, is an eclectic example of Adirondack building features. Once a 22-room Victorian mansion, it has been reborn as an Adirondack great camp.

Three

ADIRONDACK STYLE

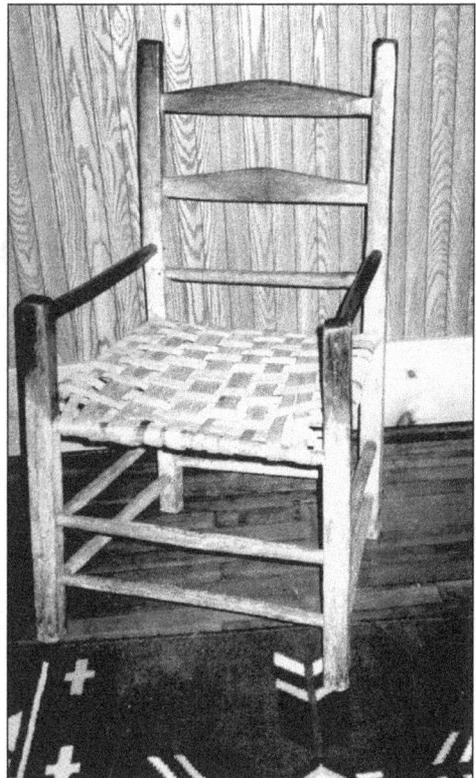

The old guides at the Whitehouse hunting camp near Wells had their own chairs to use while waiting to go out on the hunt. The strong, somewhat rustic chair was made by Adirondack furniture maker Lee Fountain and can still be used today. Note the polished hand grips on the front of the arms where years of use preserved and polished the wood.

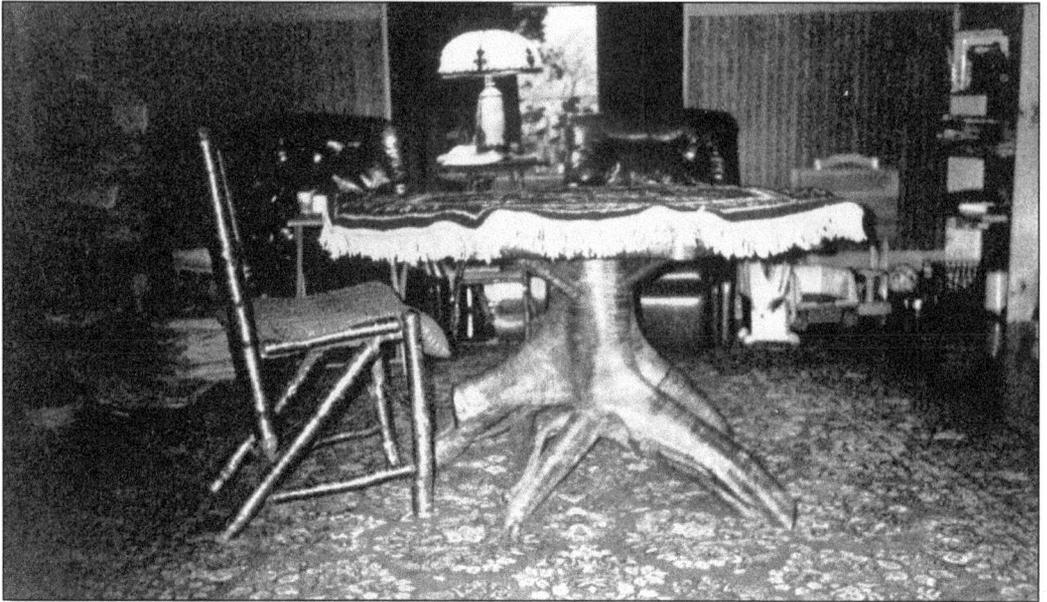

Great birch stumps were used to support the Adirondack rustic-style tables made by the Adirondack craftsmen. The stumps were set in a giant maple syrup pan of water, taken out, and then cut on the water line to make a level base. The tabletops were often ringed with more than 100 pieces of split yellow birch to decorate the edges. Lee Fountain made this stump table during the first half of the 20th century.

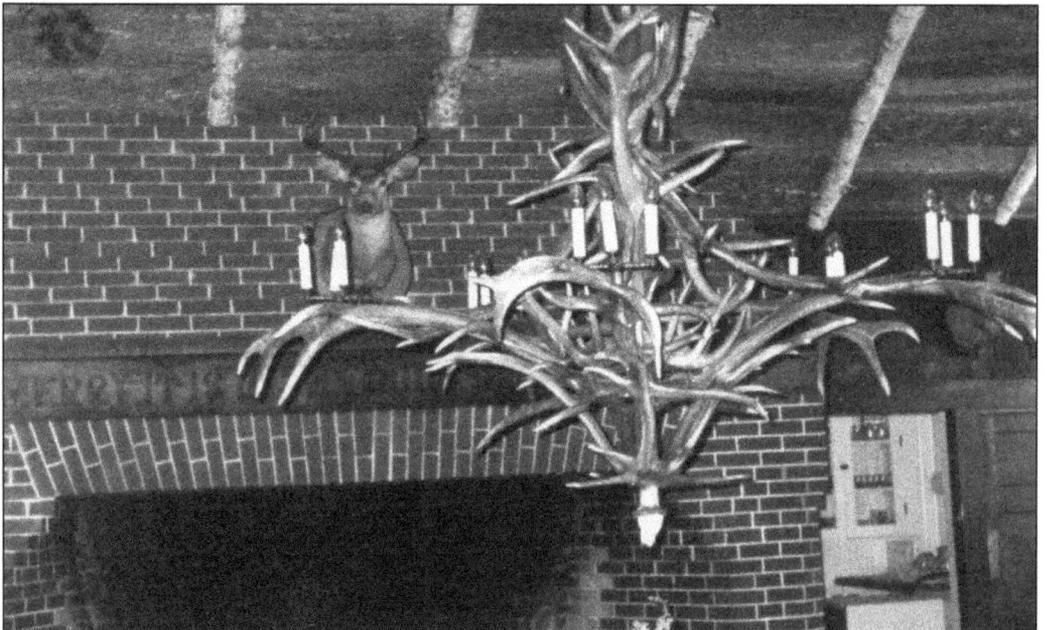

The privately owned Camp Kildare, near Tupper Lake on the shores of the Jordon, boasts a large antlered chandelier in its dining room. Antlered lighting fixtures, made of moose and deer antlers that are shed each year by the animals, have grown in popularity in recent years. The original hunting and fishing Kildare Club was founded in 1882 and has been in the same family since they bought it in 1896. The 10,000-acre tract is well cared for today.

The gatehouse designed by Delano and Aldrich at the Santanoni Preserve at Newcomb is now open as a visitors' center for those who come to visit the great camp complex. Once owned by the Robert Pruyn family, the extensive Adirondack camp complex is now owned by the people of the New York State and is being preserved. Guides are on duty during the good weather to interpret life at the camp during its heyday. Camp Santanoni has been classified as a historic area within the Adirondack Forest Preserve so that it can legally be preserved. It has been designated as a National Historic Landmark and is the subject of a well-researched book. An organized group, a project of Adirondack Architectural Heritage, Friends of Camp Santanoni are supporting the preservation efforts to save the camp for public education, recreation, and inspiration. The main camp combines Japanese architecture with the Adirondack log style to create a one-of-a-kind building. It has a great roof that connects six buildings with a continuous porch, and if seen from the air, it resembles the Japanese bird in flight, the phoenix. Well-known visitors, including Theodore Roosevelt, often traveled to Newcomb and the four miles back into the camp. The complex has three groupings of buildings to visit, including the gate lodge complex, the farm complex, and the main camp on the shore of Newcomb Lake.

The main building at Camp Santanoni is being restored along with several other buildings at the main camp complex. The camp was built in 1892 by Albany banker Robert C. Pruyn and sold to New York State in 1972 by the owners at the time, the Melvin family of Syracuse. The rustic entranceways on the buildings are unique and once had iron door handles made by the blacksmith at the camp.

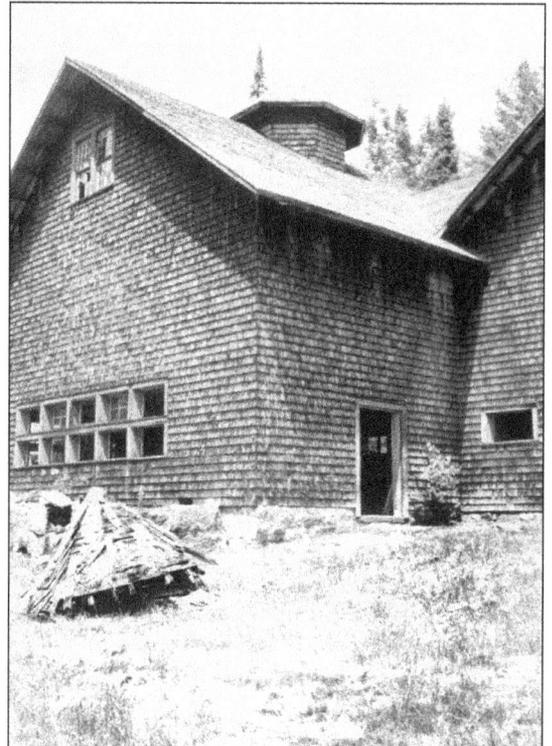

The Santanoni estate consisted of several support buildings, including a model farm at the farm complex. The farm supplied vegetables, meat, and dairy products for the Pruyn family and some to sell. It was in use up through the early 1930s, raising cows, horses, pigs, chickens, pigeons, turkeys, ducks, and prize sheep. The barns are under restoration today.

Lester "Buster" Dunham, shown here with his son Stanley, was the camp boss at Camp Santanoni from 1921 to 1931, when Pruyn retired. The six-foot four-inch guide and woodsman loved animals and allowed no hunting within three miles of the camp. He once rescued some orphan foxes and spent years making them oatmeal when they returned to visit. On another occasion, he removed a jagged tin can from the head of a skunk, and the skunk rewarded him by not spraying.

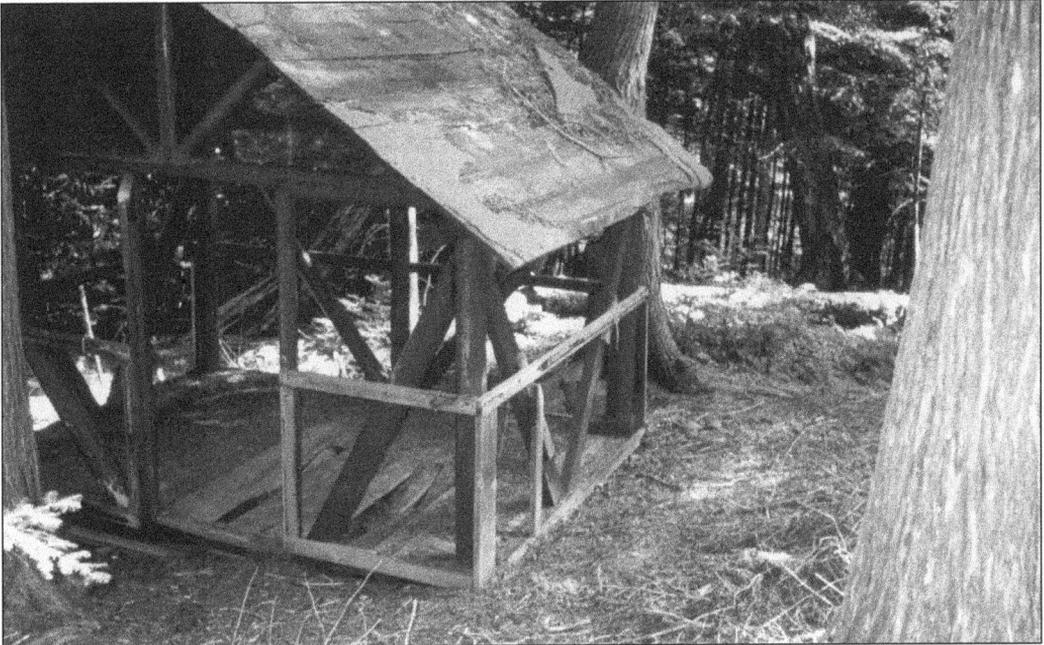

Most Adirondack woodland estates had a gazebo, or summerhouse. The small 7- by 10-foot screened gazebo at Santanoni is log braced and log supported. Anna Martha Williams Pruyn, a lover of nature, enjoyed her retreats to the little red getaway in the woods. She shared a reverence for the land and for nature with her husband, and her guidance kept Santanoni from being a replica of city life and helped retain its woodland character.

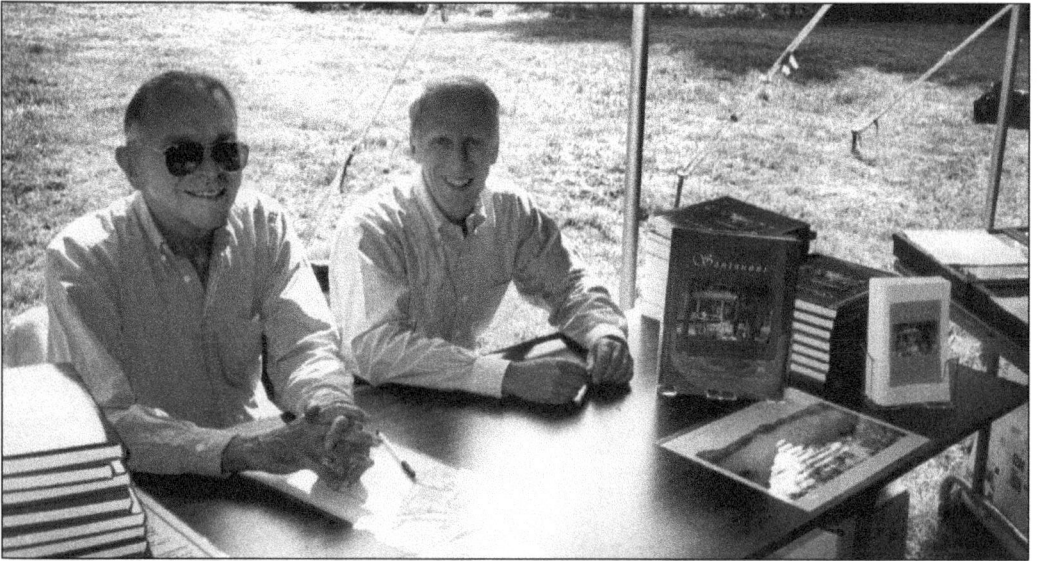

Paul Malo (left) and Howard Kirschenbaum (right), along with Robert Engel, are the authors of a definitive work on Camp Santanoni. Published in 2000 by Adirondack Architectural Heritage, it provides a complete story of the state-owned Santanoni complex, along with rare photographs from the past. Kirschenbaum is a recognized expert on Adirondack great camps and has spent a lifetime seeking and working on their preservation on the sites and in the written record.

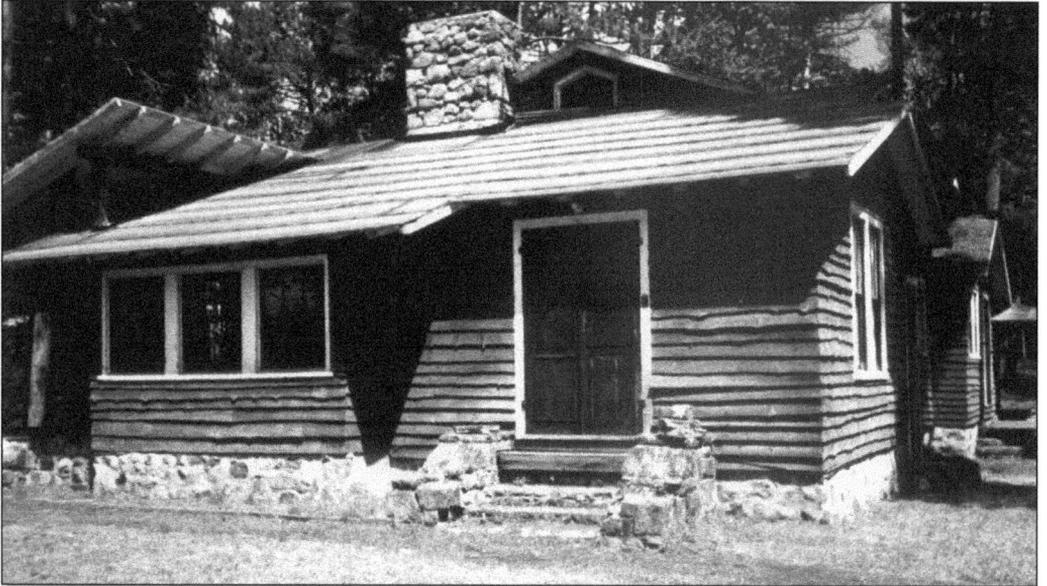

Ben Muncil, Adirondack camp builder, is credited with designing and using "brainstorm" siding, shown here on Howard Kirschenbaum's White Pine Camp. It can also be found on Camp Hutridge, which he built. The architect called for clapboards on the camp, but Muncil wanted an Adirondack-style siding, so he used wide planks with the bark still clinging to the exposed irregular edge. The word *brainstorm* came from the insanity defense being used at that time in a fatal shooting case. White Pine Camp is open for visitors today, and the siding can be observed there.

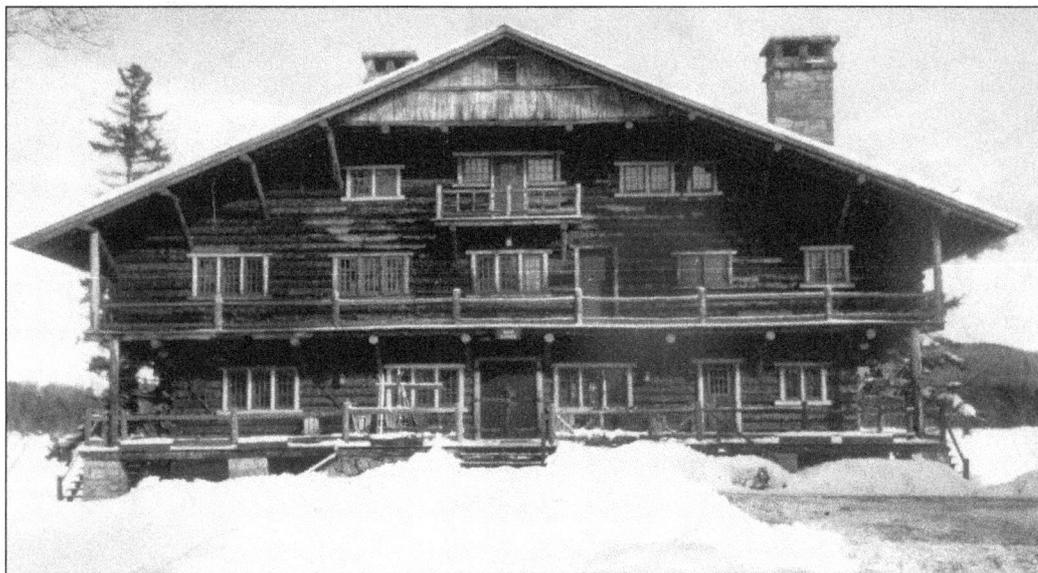

Sagamore is a Native American word meaning "chief" or "the oldest and highest in rank." It has been used to name a lake, hotels, lodges, and camps. Sagamore Lodge, an Adirondack great camp near Raquette Lake, was built in 1897 by William West Durant and sold to the Vanderbilt family. In the 1950s, it was taken over by Syracuse University and, in 1975, was sold to the National Humanistic Society. It is now preserved and is used for educational and conference activities. It is open to the public for tours, accommodations, and organized conferences.

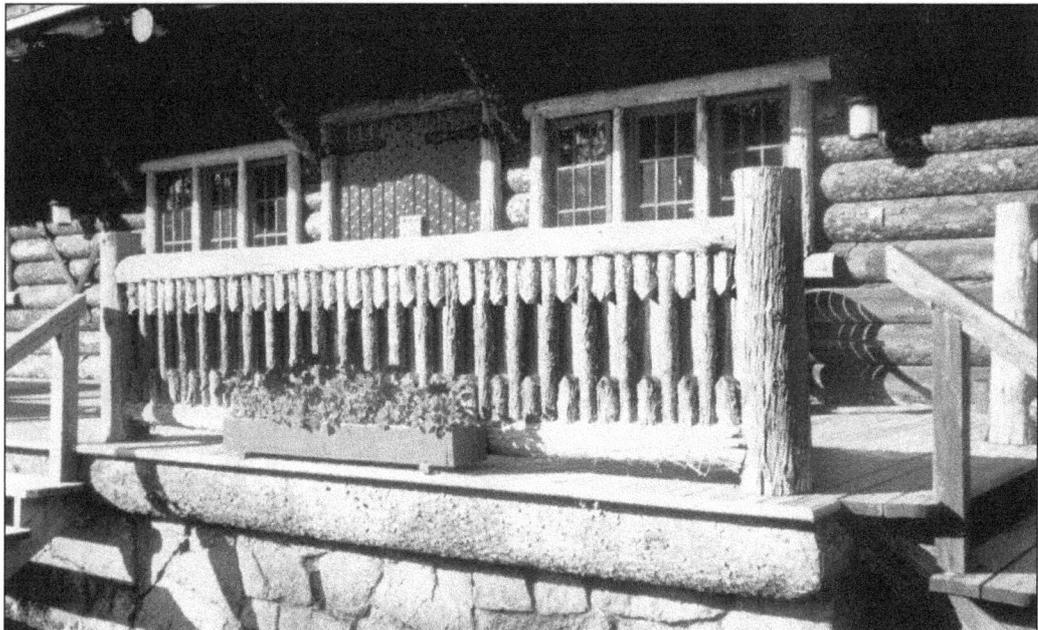

The railings on the main lodge at the former Vanderbilt great camp have been painstakingly restored. Four different designs could be seen at one time on the porch railings. The small log work shown here is unique and highly decorative. A backing kept the snow from blowing on the porches.

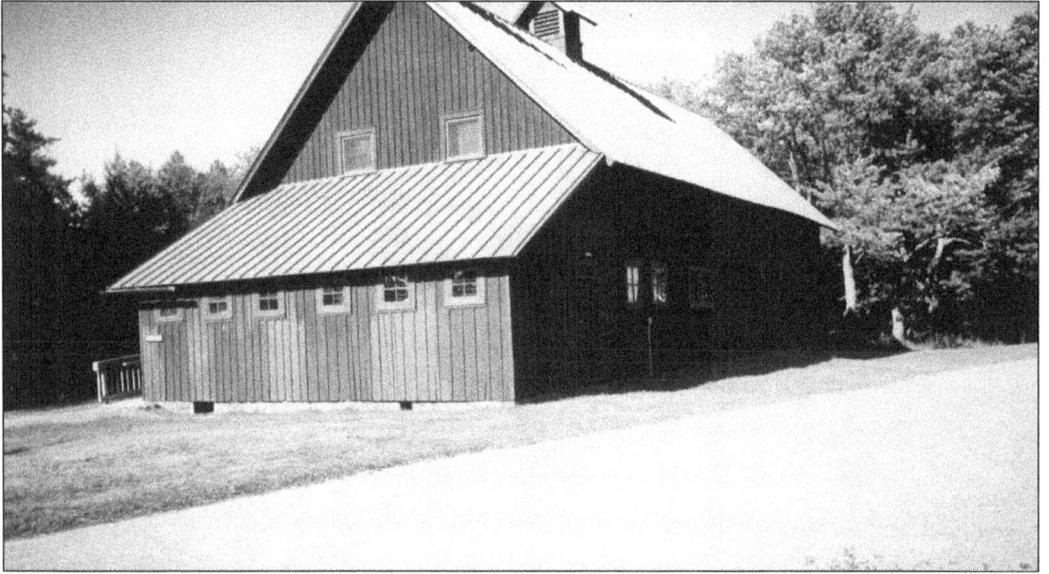

The 1898 barn at the supportive complex at the Sagamore Institute, saved by the voters in 1983, has been restored as a recreation and assembly hall for programs and barn dances. The nonconforming concrete floor that was added in the past when it became an automobile garage was jack-hammered out, and the wooden floor was restored.

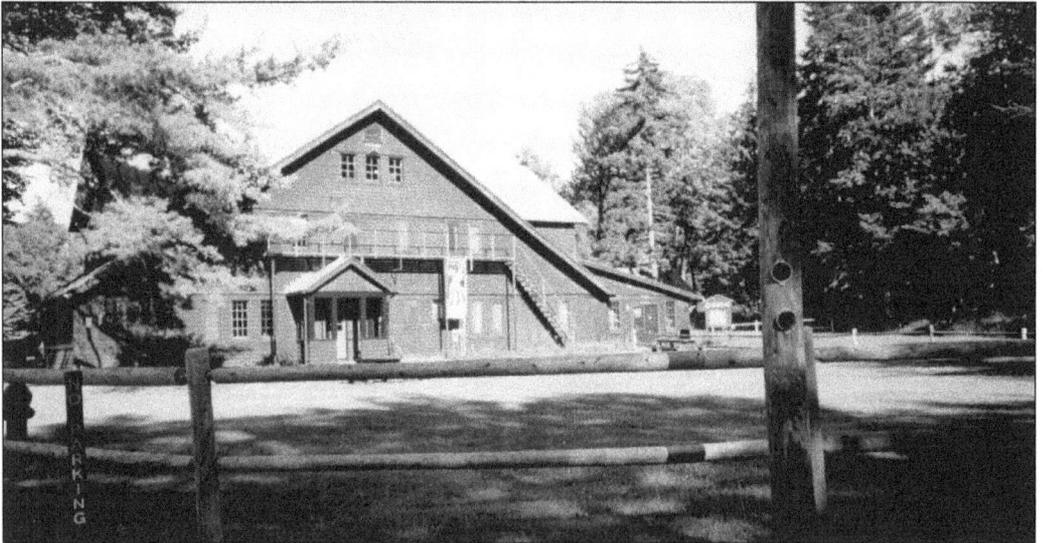

The large A-frame chalet building at the Sagamore Institute has been restored for use as a store and dormitory at the support complex. Once used by those who worked for the wealthy camp owners, the Vanderbilts, the building was one of the 11 buildings added to the preserved property in the 1983 land exchange with the state by a voter-approved constitutional amendment.

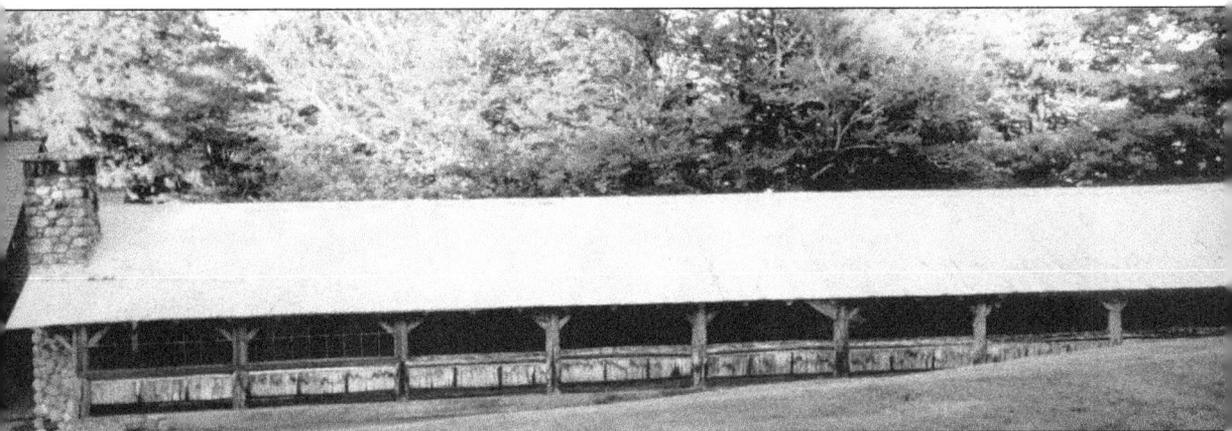

Have you ever seen a bowling alley in the Adirondack woods? Those who visit the Sagamore Institute at Raquette Lake will see the long building housing the two-lane alley built by Alfred Vanderbilt at the great camp in 1914. It had heavy canvas curtains and a large stone fireplace to warm it during cold weather, and it was built on a six-foot-deep concrete block to keep the floor from warping. It is complete with a ball return track and can still be used today. The Vanderbilts also had a "playhouse" designed by architect William Coulter, built to house their games. It was complete with a billiards table, a rustic Ping-Pong table, a roulette wheel, and other games. Margaret Emerson Vanderbilt loved to play croquet and became a champion player. She once said that she liked every game there is, and they played 50 a day at Sagamore and more at night.

Camp Wild Air on St. Regis Lake, one of the Adirondack great camps, is the summer place of the Reid family. Whitelaw Reid, publisher of the *New York Herald Tribune*, and his niece Ella Spencer Reid established the camp in the late 1800s. It was destroyed by fire in 1917, possibly set by an arsonist who disliked his newspaper, and was rebuilt in 1920. It is another fine example of the use of native stone and logs to build a structure in harmony with the forested surroundings.

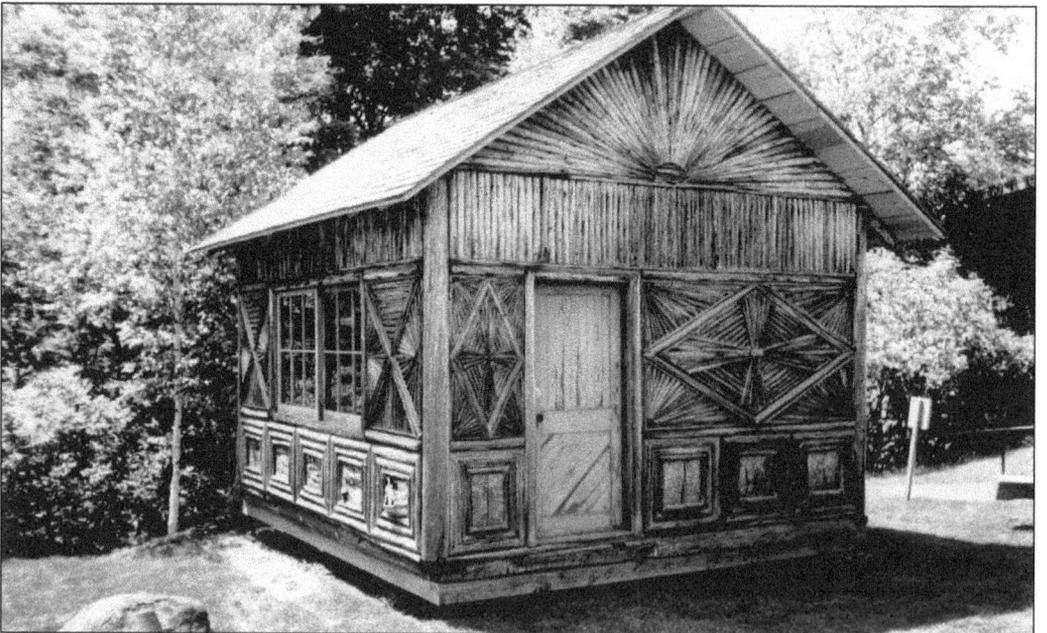

Natural twigs and branches were used not only to make rustic Adirondack furniture but to add an Adirondack touch to buildings. Sunset Cottage, now on the grounds of the Adirondack Museum at Blue Mountain Lake, started out at Camp Cedars, built in 1880 for Frederick C. Durant. All other Camp Cedars buildings were destroyed in the Big Blowdown of 1950. The cottage was moved to Camp Deerlands to use as a beach house. Mrs. C.V. Whitney donated it to the museum in 1995 in memory of her late husband.

Four

HAMLETS, VILLAGES, AND SETTLEMENTS

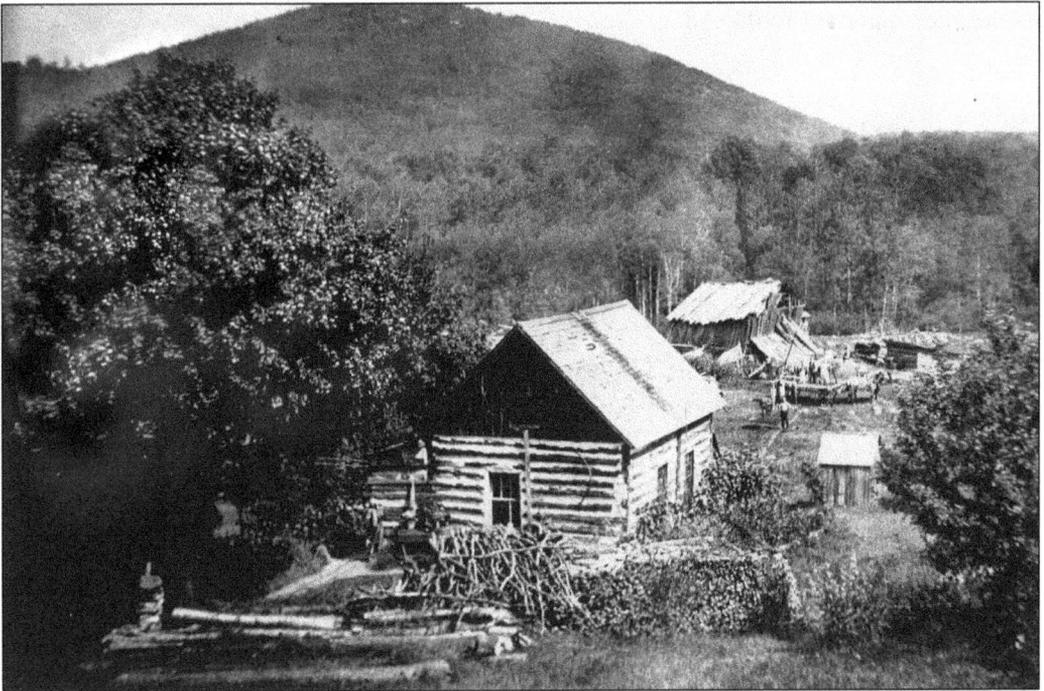

Ham Whitman's farm, much like most of the Adirondack farms, was located back in the Adirondack forest at the end of a dirt road. Farming was tough in the Adirondacks, where the frost came early in the fall and stayed late in the spring. Land once laboriously cleared for farming is now being reclaimed by forest growth. Note the rustic barn building and the privy behind the house. Attempts at farming declined as the hamlets grew and summer camps and homes multiplied during the last half of the 20th century.

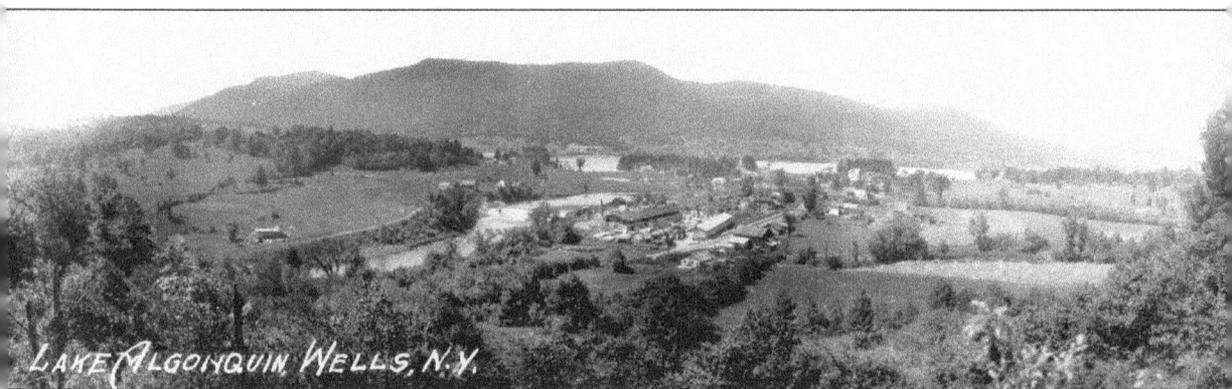

LAKE ALGONQUIN WELLS, N.Y.

Adirondack settlements sprang up in the valleys surrounded by the mountain peaks from the beginning of the 19th century on. Some made use of nearby water power to create an industry to support the residents. The lakes became tourist attractions, and dams were used to create beaches and to increase water activities. Lake Algonquin on the Sacandaga River at Wells was created by a dam in 1929 and serves the community today for recreation and the production of electric power. Adirondack communities are made up of permanent and seasonal residents. Over the years, voters in the hamlets have been supportive of good schools and maintaining services, as well as supporting the continuation of the dams that create the lakes. Yearly events, such as old home days, reunions, festivals, and carnivals, are scheduled in the settlements for the enjoyment of residents and visitors alike. Libraries, museums, churches, and medical services are important to the Adirondack communities.

The Adirondacks have their ghost towns, and one such place in the once thriving McIntyre Iron Works mining town of Adirondac. Founded in the 1840s, it now is a collection of dilapidated buildings that have their own story to tell. Part of larger acreage that was once part of the mining enterprise, it may someday be developed or added to the New York State Forest Preserve.

Remains of old tannery sites are scattered throughout the Adirondack woodlands. The hemlock trees, with their tannic acid–laden bark, attracted tanneries to the forests. Enterprising entrepreneurs began opening tanneries as early as the 18th century. The tanning site shown here on the East Canada Creek was the location of the first tannery in the town of Stratford, opened in 1812 by Daniel Cross. The old building still standing at the site was once used as a dance hall with a "spring floor" for dancing.

A special vehicle is equipped with train wheels to traverse the railroad tracks at Beaver River. The remote woodland community is landlocked with transportation limited to and from their homes and camps by planes, snowmobiles, or boats on the Stillwater Reservoir. Plans are being made to reopen the railroad from Utica to Lake Placid, with trains stopping at Beaver River once again.

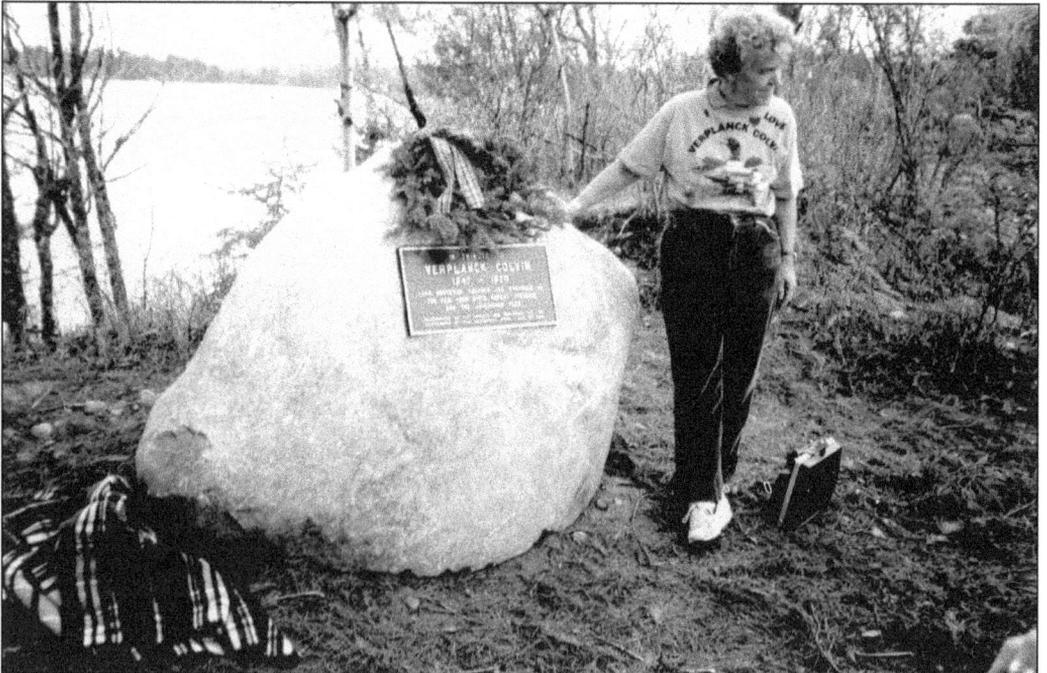

The Verplanck Colvin Memorial Stone at Beaver River was unveiled on May 16, 1992. Nina Webb, an admirer and biographer of Colvin, unveiled the tablet at the ceremony conducted by writer Anne LaBastille. Tributes were given by forest ranger Terry Perkins, Charles Hartnett of the Professional Land Surveyors, and Robert Glennon, then executive director of the Adirondack Park Agency.

52

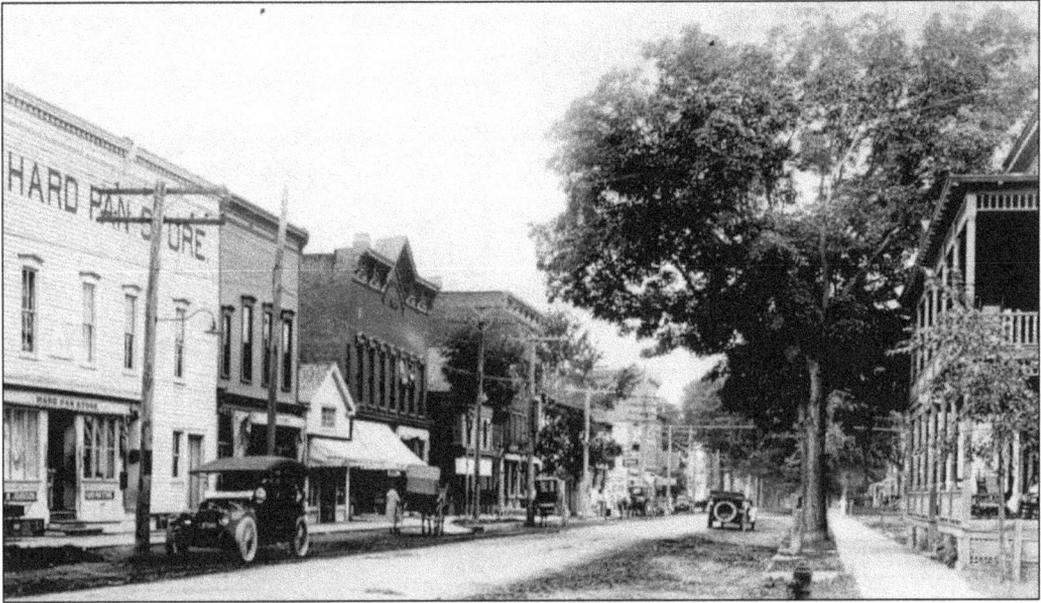

Many of the buildings in this early photograph can still be seen on Main Street in Northville today. The large building on the right, the Northville House (or Hotel), became Denton and Lipe's Furniture Store in 1957 and serves as a business complex today. A Kitchenette stands today next to the big brick 1885 Allen and Palmer Hardware Store. Note the horse-drawn buggies sharing the street with the horseless carriages, the new vehicles invading the highways during the first quarter of the 20th century.

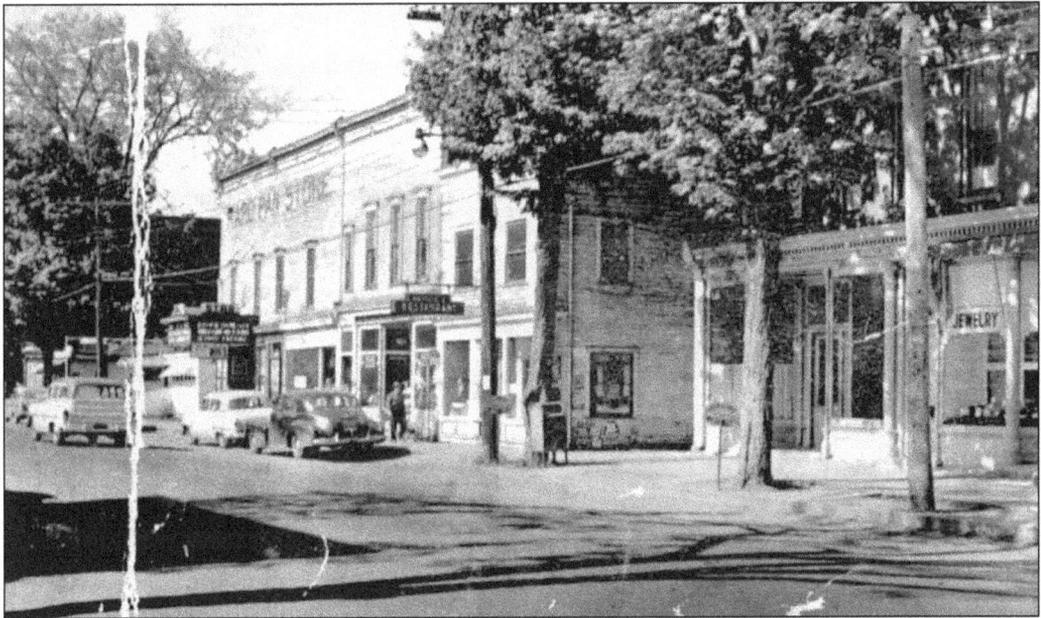

Northville, first settled in 1788, still retains some of its old character. This 1940s photograph includes Bradt's Jewelry Store, the post office, Berge's Restaurant, the hardware store, the Star Theater, and the Alhambra Restaurant. The businesses are gone today (with the exception of the hardware store), and the post office has moved across the street.

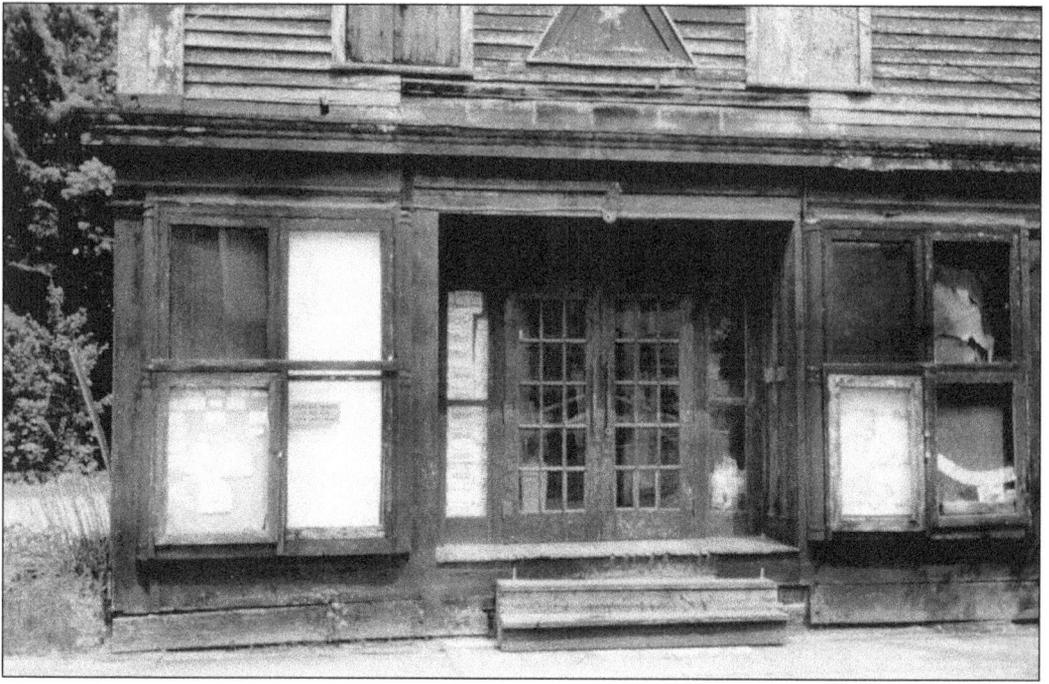

Most Adirondack hamlets had their local movie houses for early live performances and, later, silent and sound movies. Some have been restored and are still in use, including the Carol Theater in Chestertown, the Lake Theater at Indian Lake, Lake Placid's Palace Theater, and the Strands at Old Forge and Schroon Lake. The old Star Theater at Northville, built in the "hard pan" building in 1916 by D. Grant Palmer, is in need of restoration.

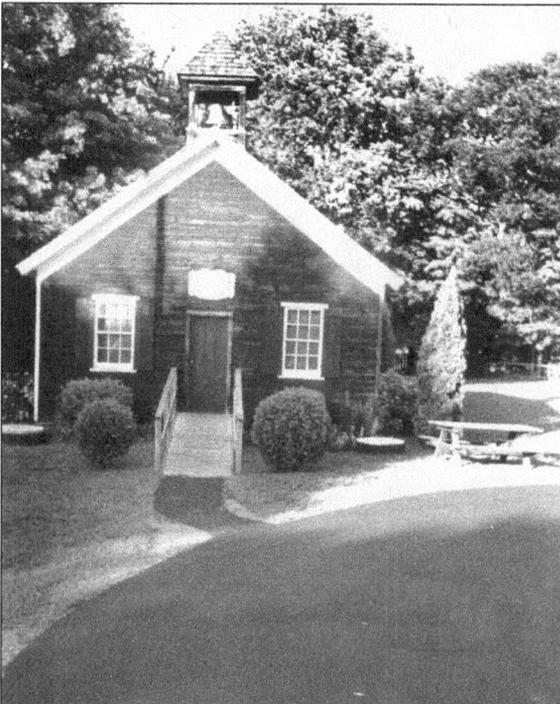

One-room schools could be found throughout the Adirondacks; they were the first buildings constructed when the residents got settled. New centralized schools developed in the 1930s and, one by one, the one-room schools were closed. The Giffords Valley School was built in the 1880s and was used until 1930. It stood empty until 1990, when it was moved to Northville and restored to house the museum of the Northville-Northampton Historical Society.

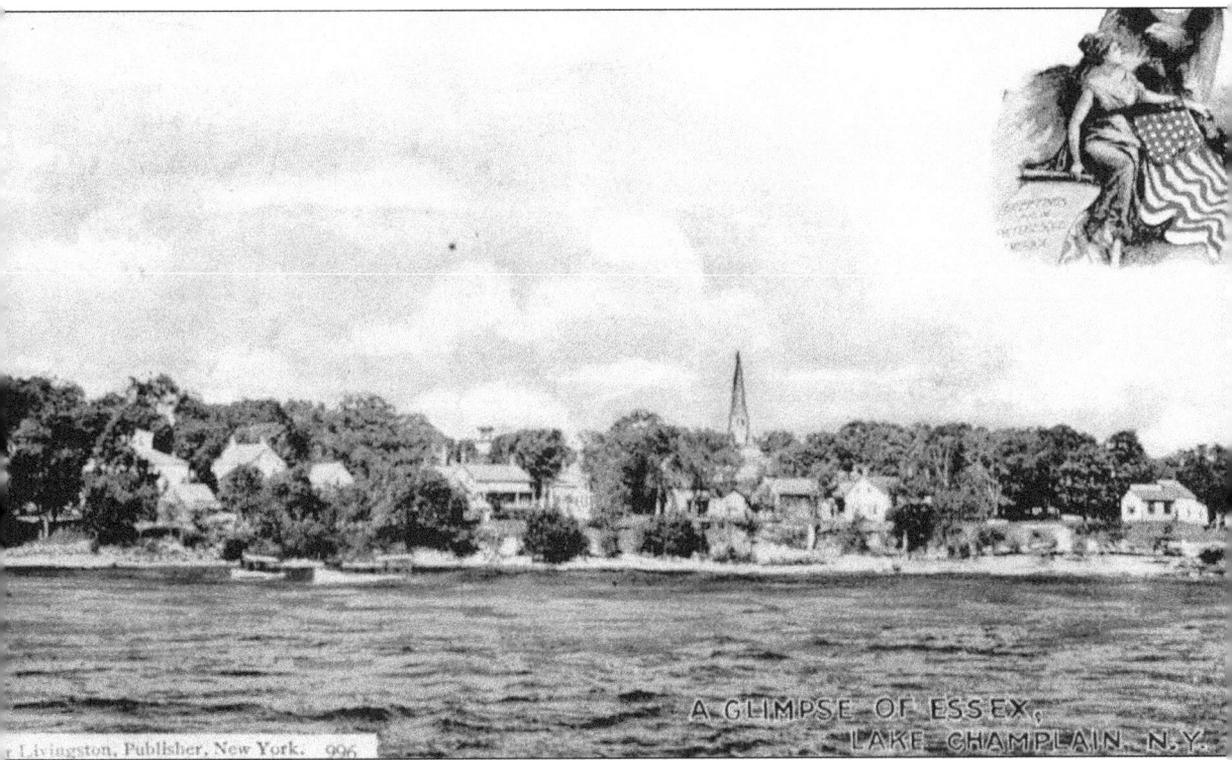

A GLIMPSE OF ESSEX, LAKE CHAMPLAIN, N.Y.

Livingston, Publisher, New York. 996

Essex has one of the finest and most intact collections of Federal and Greek Revival architecture in rural New York State, and the village has sought to preserve their heritage since 1969. Until the railroads came in the 1840s, Essex had a maritime economy connected to Lake Champlain and the Champlain Canal. A shipping port, ferry service, and boatbuilding stimulated the growth of the village. The village of Essex, in its entirety, was placed on the National Register of Historic Places in 1975. One of the oldest settlements in the state, it was founded by William Gilliland in 1765. Over two dozen early-1800s buildings are included on a walking tour of the village. One of the most impressive buildings in the village is the c. 1853 Greystone. It is a splendid Greek Revival house overlooking Lake Champlain and was the home of Belden Noble. Made of smoothly dressed limestone blocks, it is well taken care of and restored by today's owner.

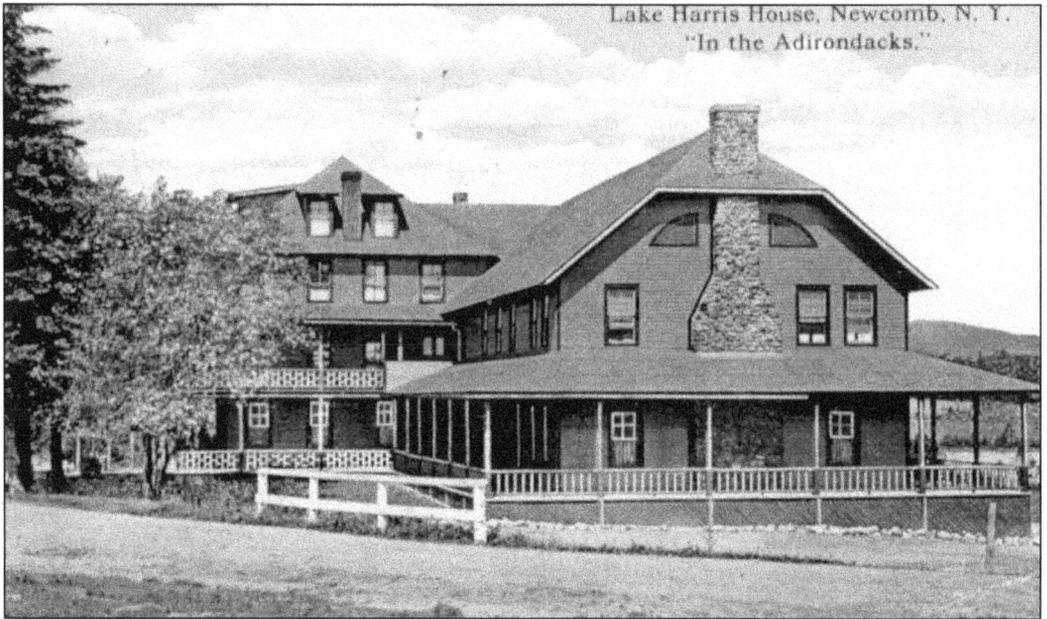

Newcomb boasts a good view of the Adirondacks' highest peaks, and it is close to the source of New York's mighty Hudson River. Nearby, the Marcy Trail, Indian Pass, and the Roosevelt Monument add to Newcomb's list of attractions. The Santanoni Preserve, with a historic great camp complex owned by the people of New York State, sits on the shores of Newcomb Lake. The Lake Harris House was once an important stopping place at Newcomb.

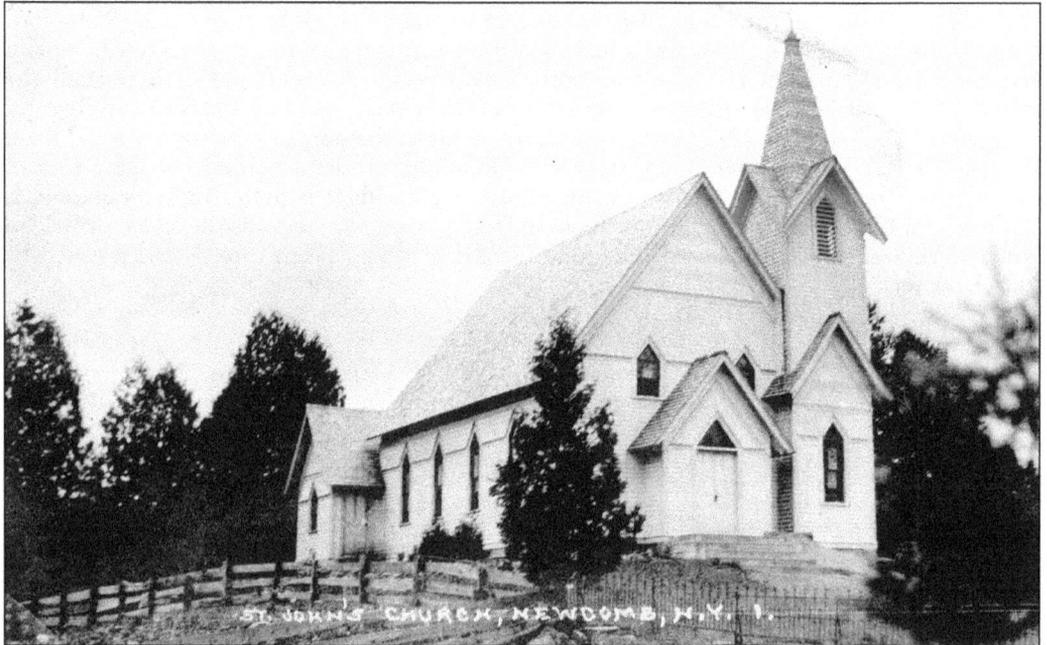

St. John's Catholic Church in Newcomb was built in 1896 and remodeled in the 1940s and 1950s. It was closed in 1963, and the congregation moved to St. Teresa's Church, which was moved to Newcomb when the mining village of Tahawus was moved to make room for additional mining.

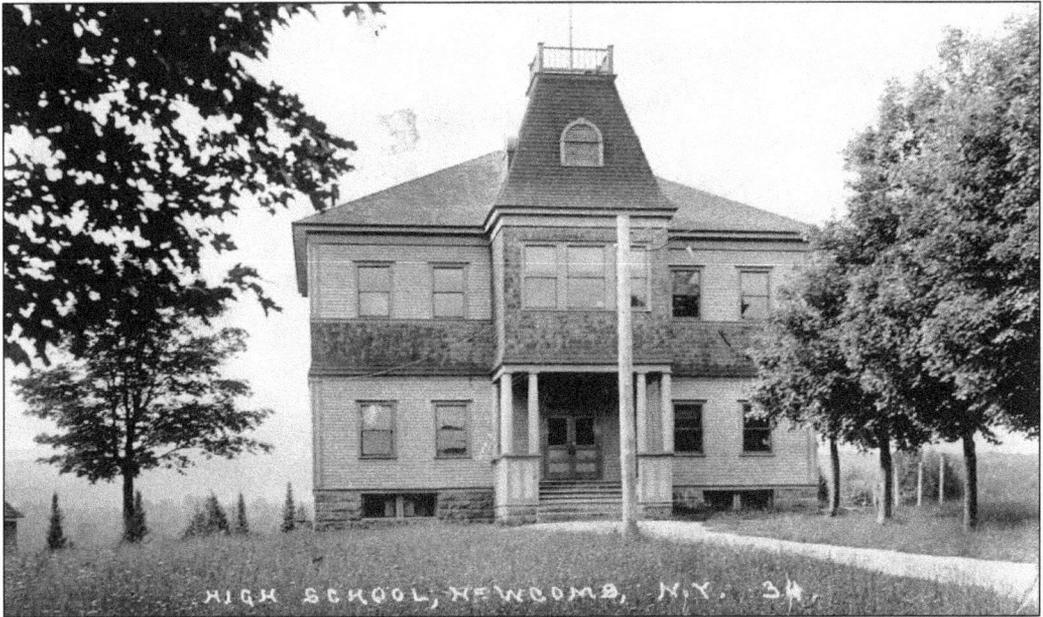

The 80-student Newcomb Free School, shown here, was built in 1912 to replace the 1908 Union Free School. It burned down in 1947 and was replaced by today's school in less than a year after the fire. One of the smallest schools in the state, Newcomb has the finest Adirondack school curriculum to be found anywhere.

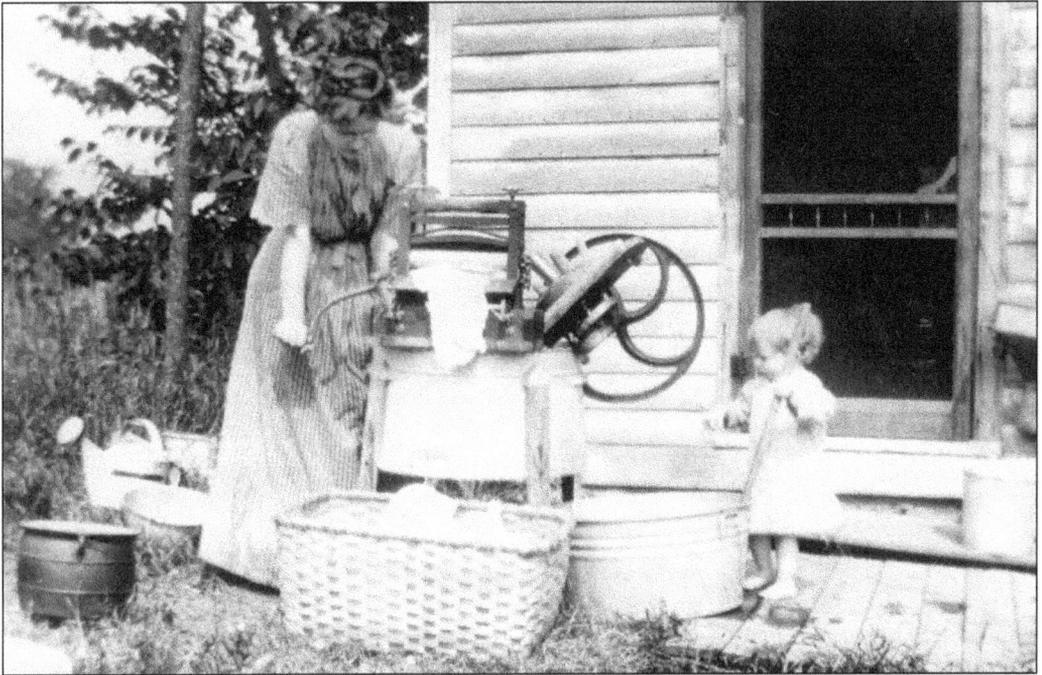

Washday in the Adirondacks in the 20th century was not an easy task. It was before the days of inside plumbing and laundromats. Tubs of water had to be filled on the stove by bucket loads from the outside well. A good fire was needed to heat the water. Clothes had to be wrung through a hand-cranked wringer and then hung by clothes pins on a rope line to dry.

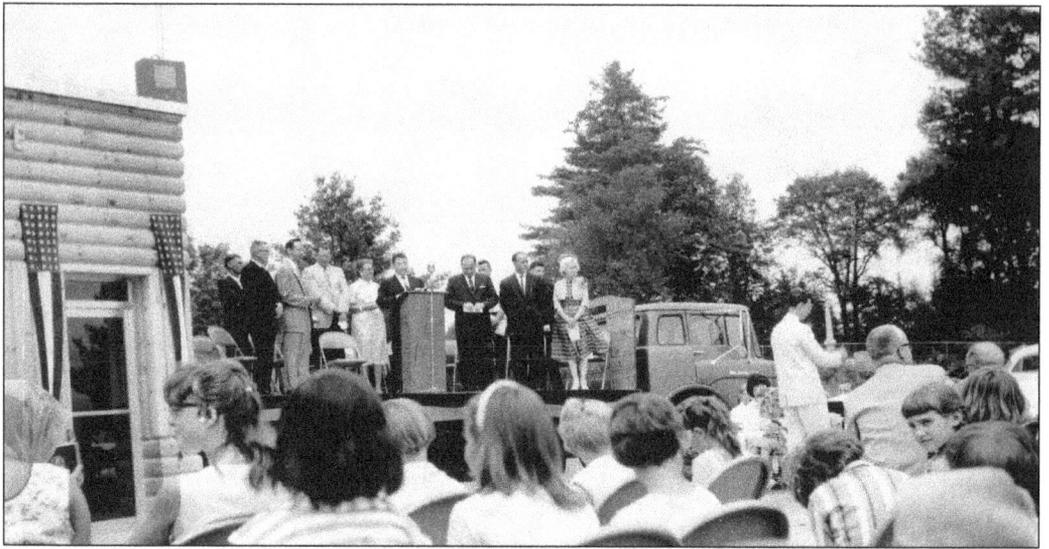

The new post office at Speculator's four corners was dedicated on the northeast corner on July 29, 1961. You might say that it was a traveling post office; it had been on each of the four corners since its beginning in the 1850s. Present at the dedication were U.S. Rep. Sam Stratton, Mayor Harry Wilber, Supervisor Charles Wickes, Postmistress Amy Early, school principal Don Williams, Mr. and Mrs. Charles Johns, Eagle Scout Bruce Knapp, Rev. Harold Kaulfuss, Rev. Robert Smith, and Lions Club president John Zeiser.

The Lake Pleasant Central School at Speculator has served the community well for 73 years. The time came for a new school, and the year 2002 marks the opening of a new $6 million building on East Road. The school includes students from kindergarten through ninth grade. High school students are tuitioned to neighboring schools. The location of an excellent school plant in the heart of the Adirondacks is a good setting for a balance of learning and playing.

County jails were as much a necessity in the early Adirondack days as they are today, yet they were somewhat unique when it comes to our usual expectations of the local lockups. When the rough-cut stone 1839 Hamilton County Jail was inspected in 1931, it was decided to leave the cell doors unlocked at night because of the danger of fire. One of the early jail keepers, who was also an Adirondack guide, made the prisoners go moose hunting with him to help provide food for their keep.

The "new" Hamilton County Courthouse at Lake Pleasant was built in 1929 to replace a 75-year-old building. Now, 73 years later, it is still in use and will likely be so for years to come. It has seen its share of high-profile cases over the years, including the controversial Garrow case, which tested client-lawyer confidentially.

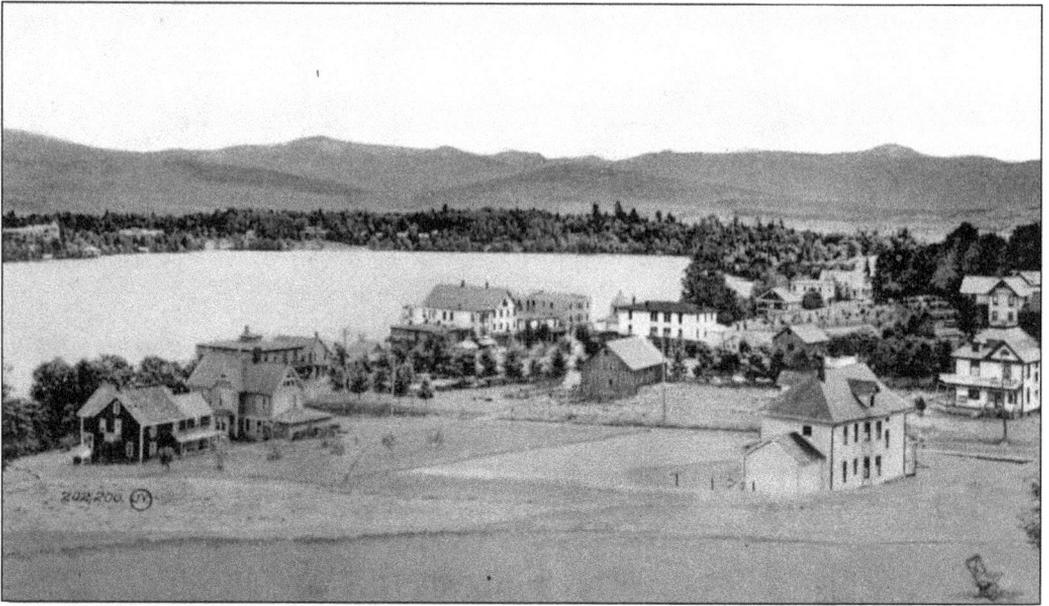

Lake Placid has gained worldwide fame as the site of the 1932 and 1980 Winter Olympics. The Winter Olympic Museum can be visited at the Olympic Center. Excursions to Lake Placid have been popular since the early-1900s excursion trains and continue with the renewal of the excursion railroad between Lake Placid and Saranac Lake today. It has become a year-round tourist destination with accommodations from rustic to elegant.

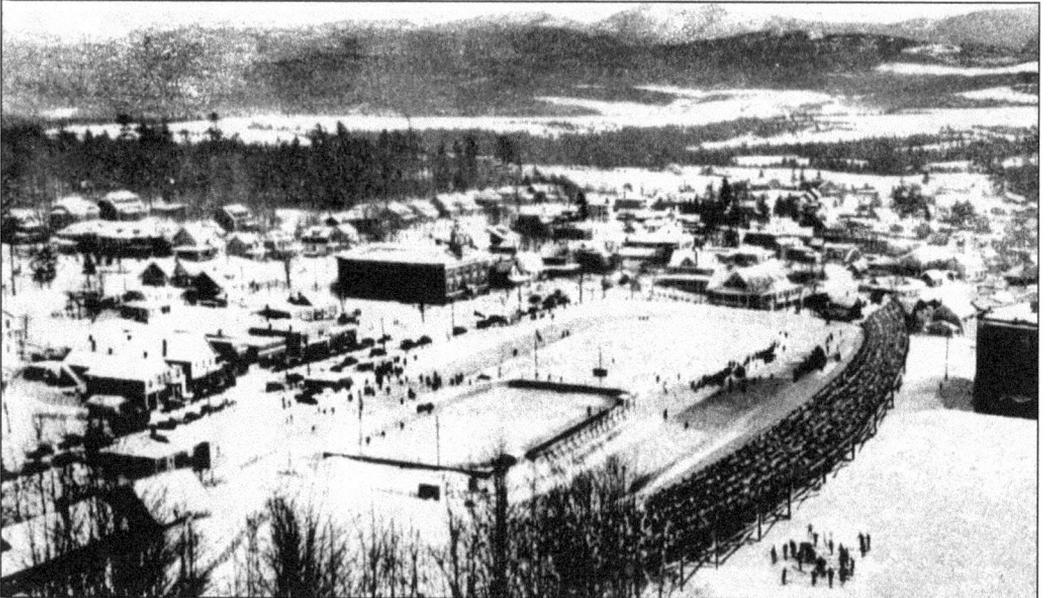

The first Winter Olympics were held in 1924 in France; the second, in Switzerland. The third Winter Olympics came to the Adirondacks in 1932. Lake Placid had become a center for winter sports, and facilities were developed for Olympic competition, including the skating rink shown here. Nature played a role in the 1932 Olympics, bringing much needed snow just before opening day.

Nineteen-year-old Sonja Henie of Norway won the figure skating gold medal at the 1932 Olympics after winning the same medal at the 1928 event. She went on to win again in 1936 and became a U.S. citizen in 1941. Her professional skating career and films made her one of the 10 wealthiest women in America. She died of leukemia in 1969.

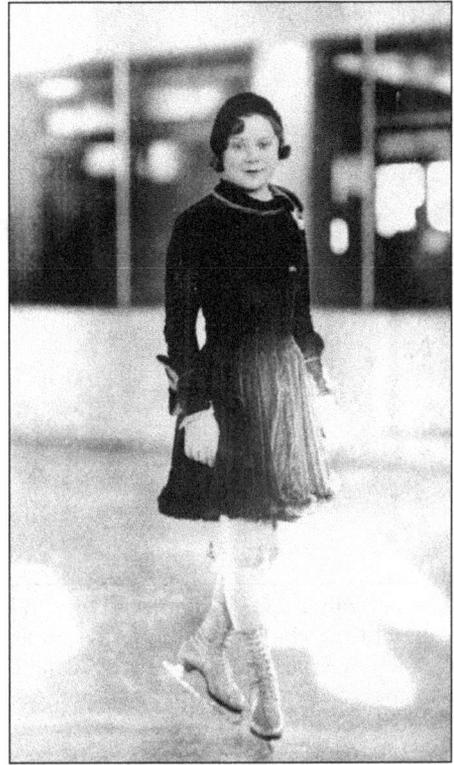

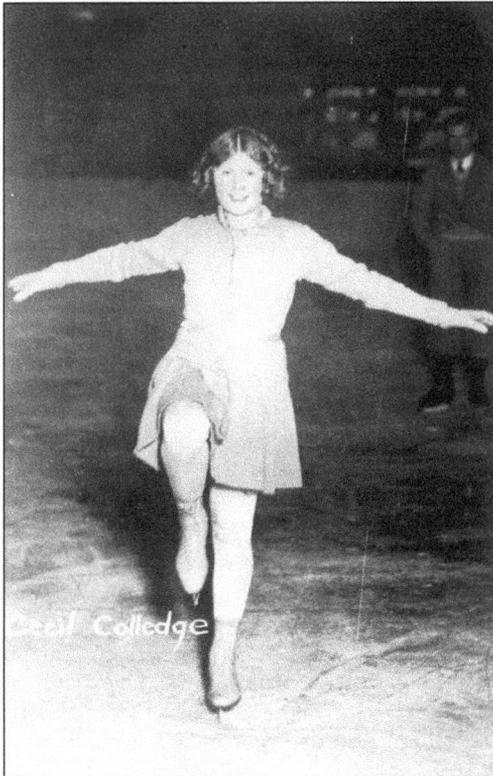

Cecil Colledge of Great Britain was one of three 11-year-olds who competed in figure skating in the 1932 Olympics at Lake Placid. Figure skating requires performing compulsory figures, which take years of practice to perfect, and a freestyle program that can be as different as the skater cares to risk. It is difficult for the younger skaters to do well.

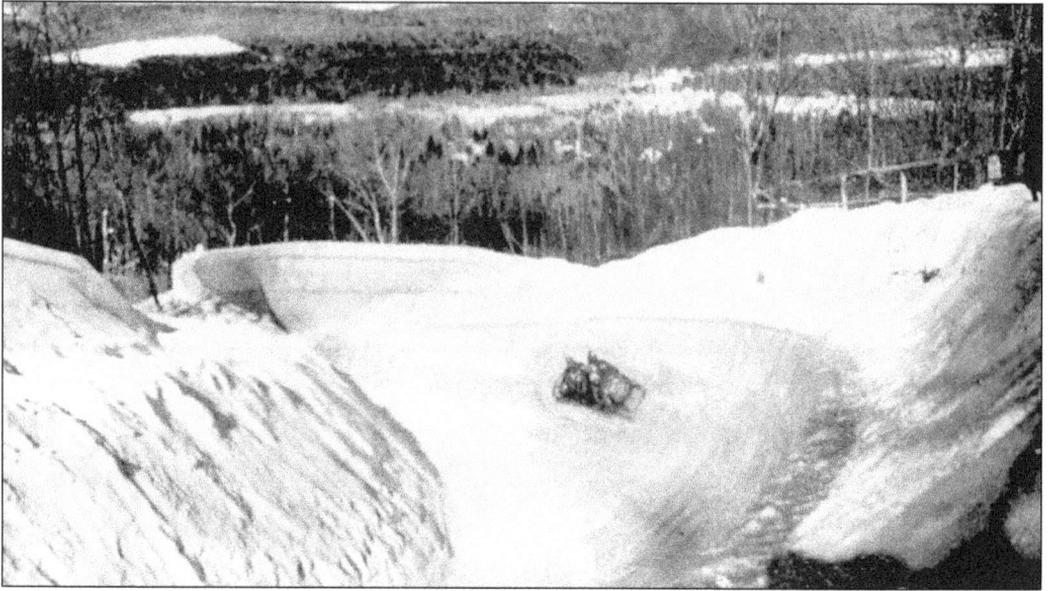

The bob run at Lake Placid was built on Mount Van Hoevenberg for the 1932 Olympics. At the competition, the United States dominated bobsledding. They won the two-man and four-man bobsled events. The site was rebuilt and improved for the 1980 Olympic games; refrigeration was included to extend the seasonal use of the run. It is open for rides by the public at times throughout the year.

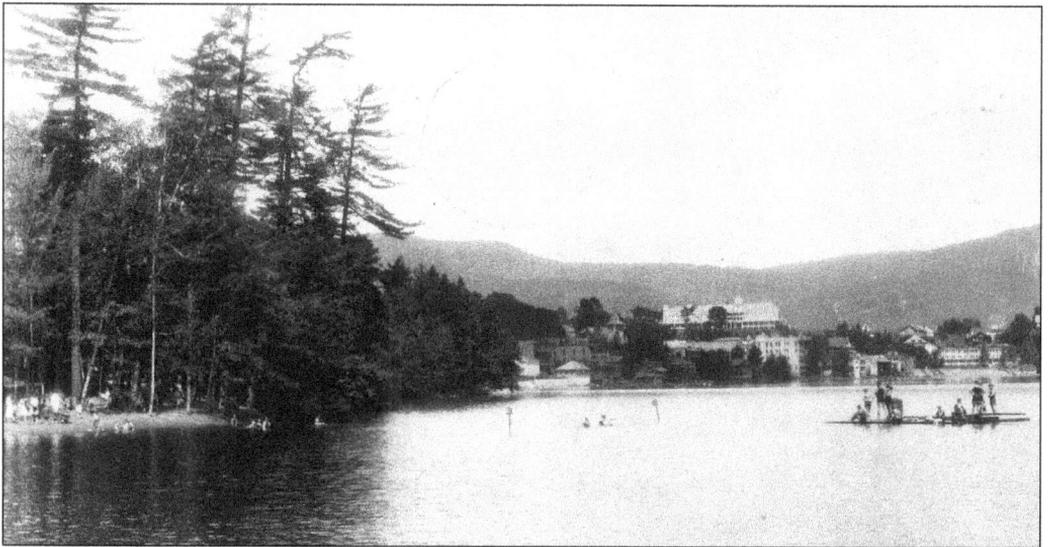

Beaches in the Adirondacks have been attracting visitors from the earliest days. The writer of this early postcard had traveled from Burlington, Vermont, to swim at the Lake Placid beach. Swimming out to a floating dock has always been a challenge on the Adirondack lakes. Is that the large Stevens House on Signal Hill in the distance?

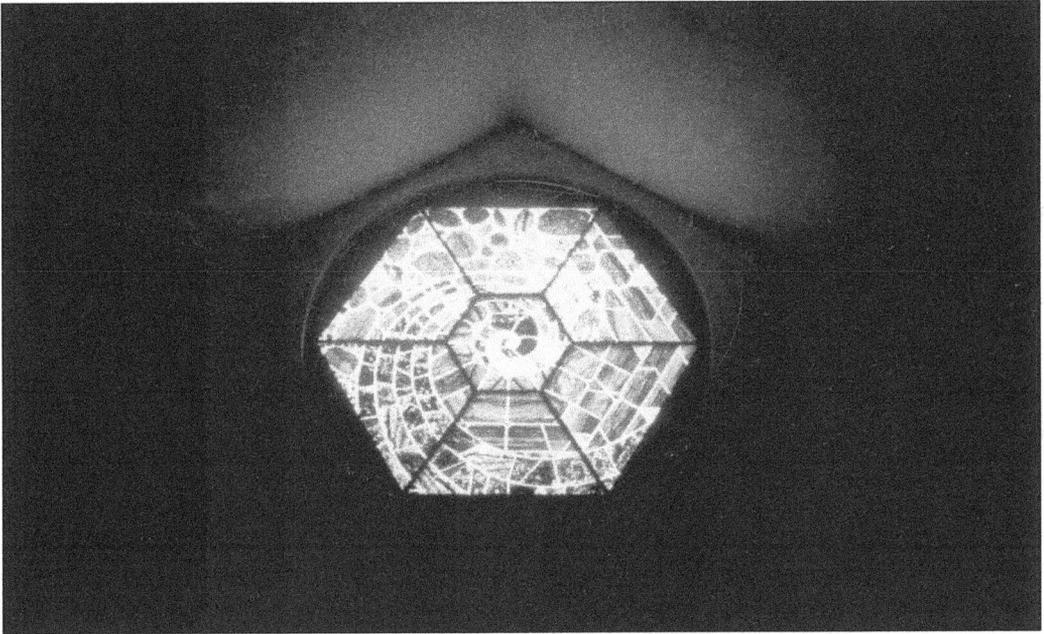

The "colored glass" window shown in this church with the light shining through is actually a window made of Adirondack rocks and minerals. The thin-sliced rocks were made with a diamond-tipped saw blade in a technique developed by the late Vincent Schaefer. The artistic rock window, symbolizing the circle of life, is in St. John's Church at North Creek.

The chapel at Dr. Edward L. Trudeau's Tuberculosis Sanatorium at Saranac Lake is still standing. The property is now owned and used by a management corporation, but the chapel is preserved and kept open for weddings and other events. The chapel was an important part of seeking a tuberculosis cure in the health-giving Adirondacks.

Adirondack camp builder William W. Durant had St. William's on Long Point at Raquette Lake built in 1890 for his workmen and support staff. It was a Catholic parish church until 1939, when it became a retreat house for Franciscan Friars. Since 1992, it has become a nondenominational church and is being restored and put to use for special programs and retreats for the general public.

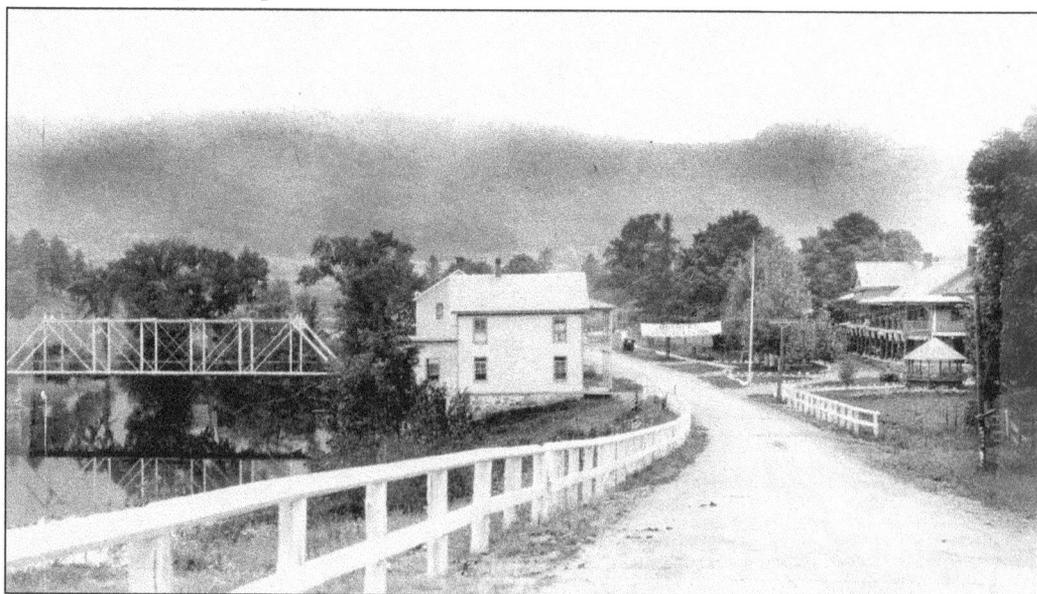

The banner across the road on the entrance to Wells in front of the big building reads, "Moshers Adirondack Inn." The building on the left was called the Mission. The Pilgrim Holiness Church held tent meetings in Wells in 1907, whereupon they organized and purchased the building. They installed an organ and used the building for their church until the 1930s. The old bridge across the Sacandaga River can be seen behind the building. This 1883 bridge was replaced by the present bridge in 1939.

Beverly Buyce Williams sits on the porch of the home where she was born and raised. Purchased by the Wells Historical Society, the old house is slated to become the Wells Historical Museum. It is located in the center of the hamlet and is being restored to house artifacts and the archives of the town of Wells. The town was settled by the Wells and Whitman families from Long Island in the 1790s. Many of the Adirondack settlements are developing local museums to preserve the past.

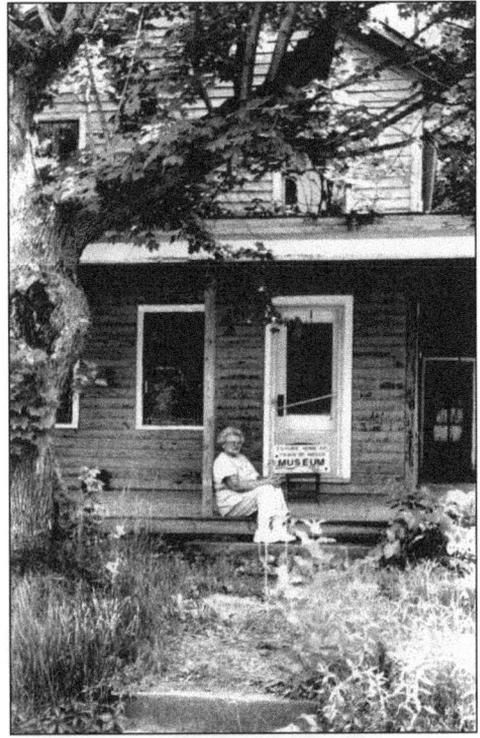

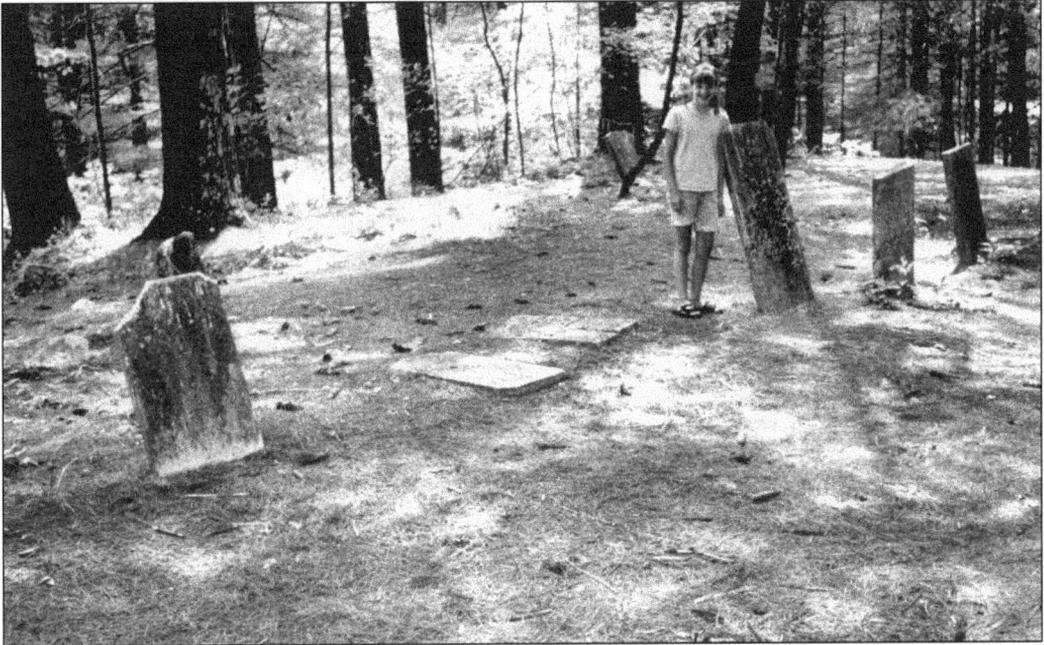

Family graveyards scattered throughout the Adirondack woodlands are facing destruction by weather and vandals. The Whitman graveyard, on a pine-covered hillside overlooking Lake Algonquin, dates back to the Revolutionary War. One gravestone, "Isaiah Whitman, Soldier of the Revolution," has been stolen for sale as a collectible. Jennifer Williams is shown here researching the names and dates of her ancestors.

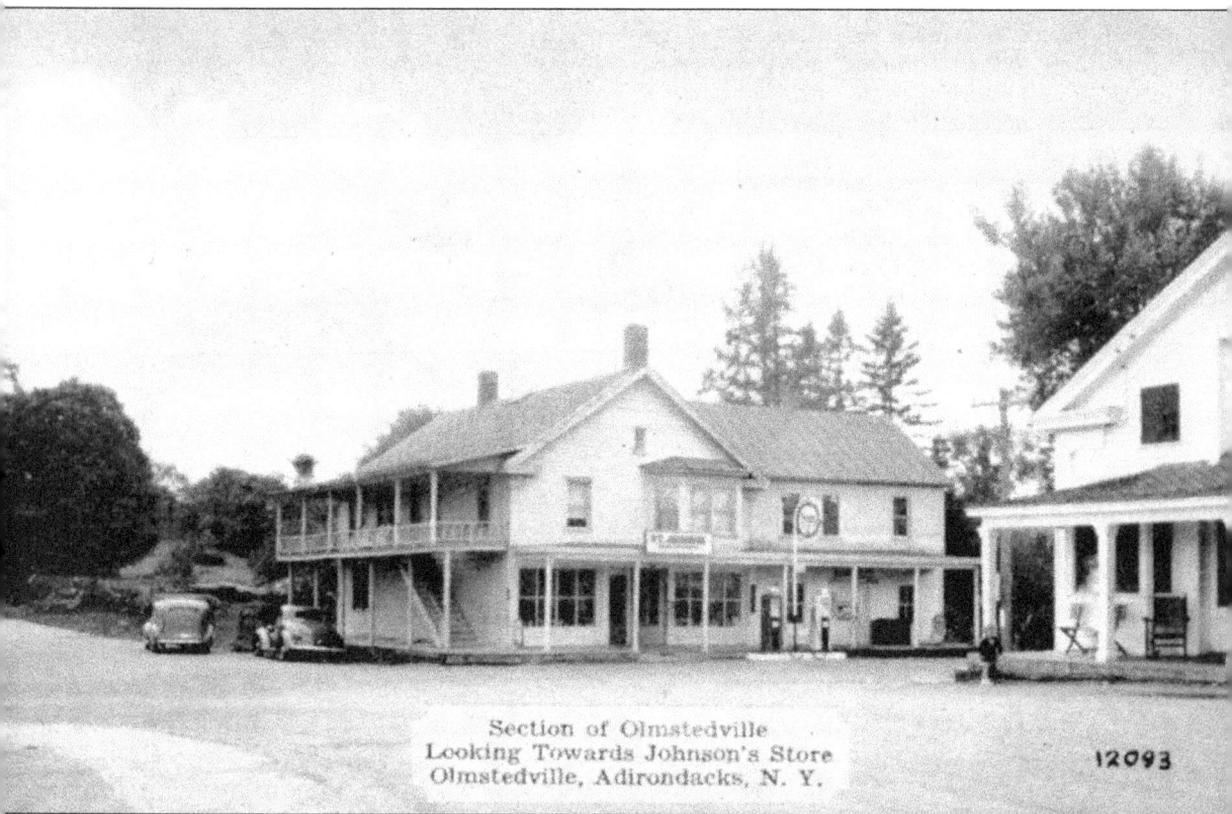

Section of Olmstedville
Looking Towards Johnson's Store
Olmstedville, Adirondacks, N. Y.

12093

Many Adirondack settlements owe their existence to the tanning industry. Entrepreneurs saw the hemlock trees and seized the opportunity to make some money tanning the animal hides. One typical settlement of this type is Olmstedville in Essex County. Founded in the early 1800s, it supported eight tanneries by 1860. The name of the town came from the owner of one of the original tanneries. According to Barbara McMartin's splendid book on the tanneries influence in the Adirondacks, *Hides, Hemlocks, and Adirondack History,* the tanning representatives went to the New York City docks and offered work to the immigrants. The women were offered jobs in the boardinghouses, and the men were offered jobs in the tanneries. She also found that most of the eight tanners in town were Irish. The tanning industry depended on a good supply of hemlock bark for the extract to cure the hides, and when the trees were depleted, the tanners left the Adirondacks. Nearby Minerva and Pottersville also supported several tanneries in the 1800s. After the tanners left Olmstedville, the village continued to thrive as an Adirondack community. By the time this photograph was taken, automobiles had come on the scene and gas pumps had sprouted in front of Johnson's General Store.

Five

HOTELS AND INNS

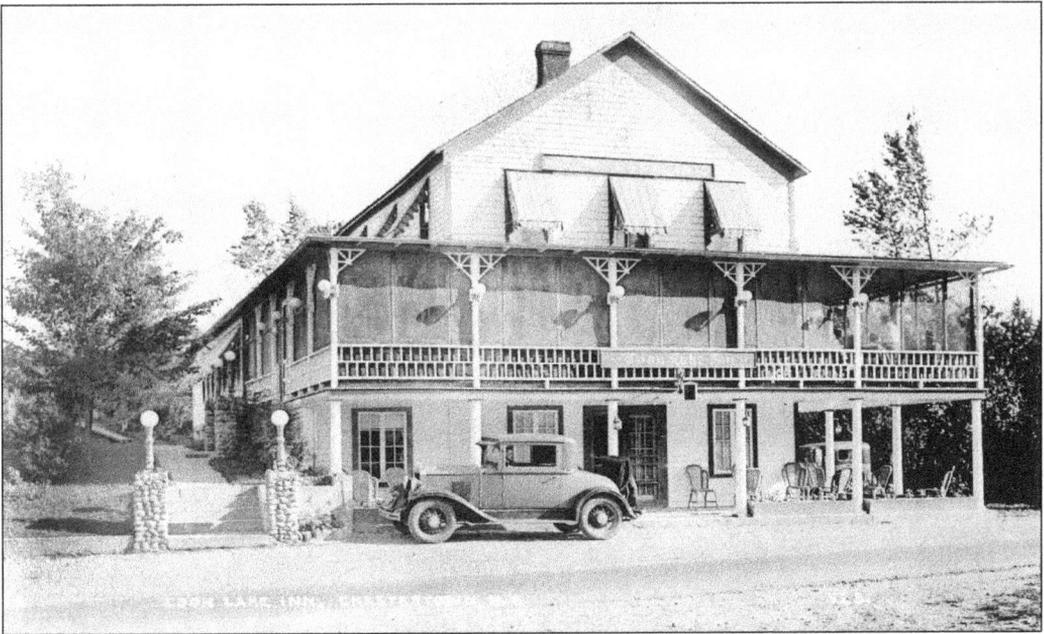

Loon Lake, on old Route 9 between Warrensburgh and Schroon Lake, was once the site of the Loon Lake Colony Resort. The 50-acre resort was advertised "for the younger set." It included the inn, a dancing pavilion, a bar and grill, tennis courts, boat landing, hardball courts, cottages, and cabins. Note the early automobile parked by the Loon Lake Inn; the author's father ran a nearby garage for the new automobile traffic in the 1930s.

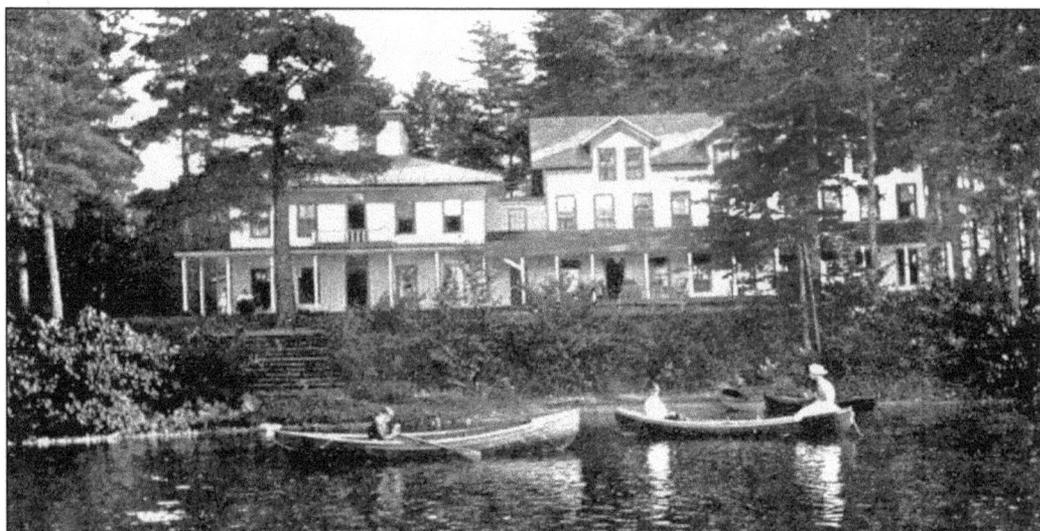

Staying at a resort hotel such as the Lake Brantingham Inn in the early 1900s meant making use of one of the hand-crafted guide boats found on the beaches of most Adirondack hotels. The stable craft was easy to row and could easily hold three people. They were developed for the Adirondacks to use on the lakes much like a rowboat and up the mountain streams like a canoe. They could be carried over the portages between the waterways and held passengers, packs, and game.

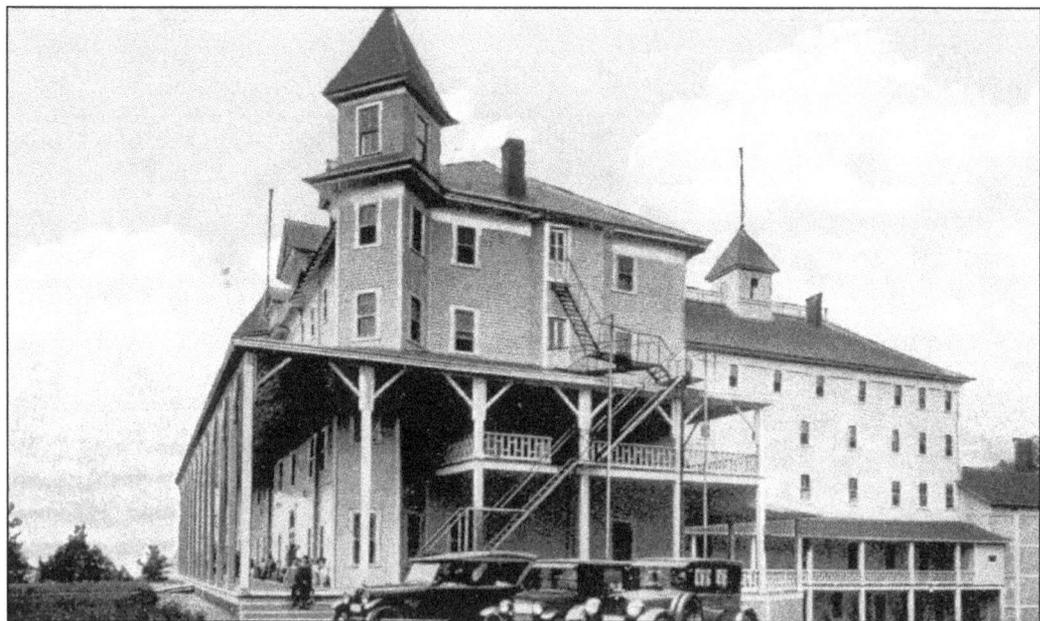

Long Lake had one of the many Adirondack establishments using the name Sagamore. The 200-guest hotel could be seen just west of the Route 30 bridge. Native American Adirondack pioneer Mitchell Sabattis purchased the original hotel lands and sold them to William Dornburgh and Edmund Butler Jr. in 1881 to build the hotel. The $7,000 hotel was opened in 1883, burned in 1889, rebuilt for 200 guests, and used until it was closed and torn down in 1960. It offered telegraph and daily mail and provided space for the town hall.

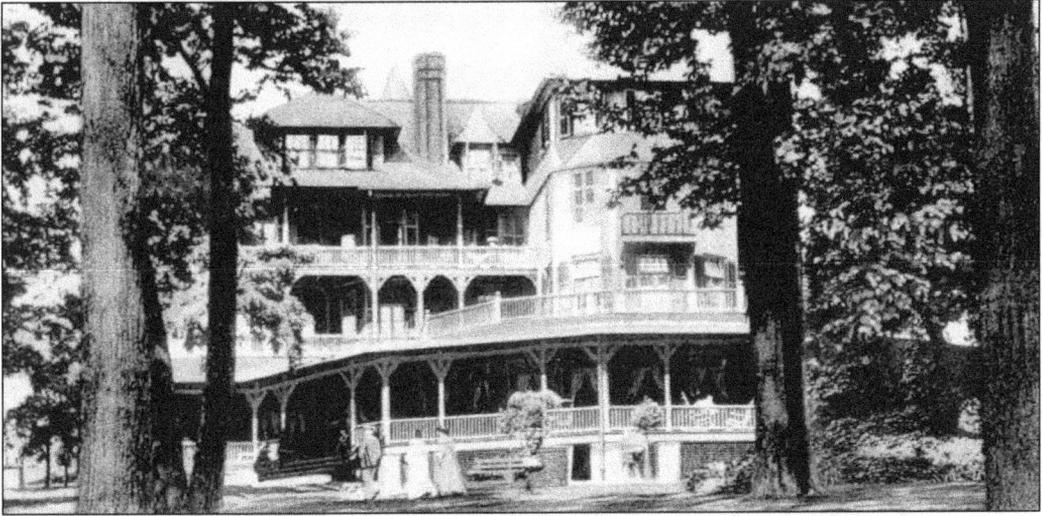

Sagamore is a term taken from a Native American word for "the oldest and highest in rank," used by James Fenimore Cooper in *The Last of the Mohicans*. Theodore Roosevelt used it to name his Long Island home, and it was used throughout the Adirondacks to name hotels. Lake George had two of the Sagamores. One was a four-story hotel in the village. The other, at Bolton Landing on Lake George, is the popular Sagamore Resort, built in 1883 and remodeled in 1930 to be used for conventions to the 1950s. In 1981, it was given new life and accommodations, and it is now a classic resort.

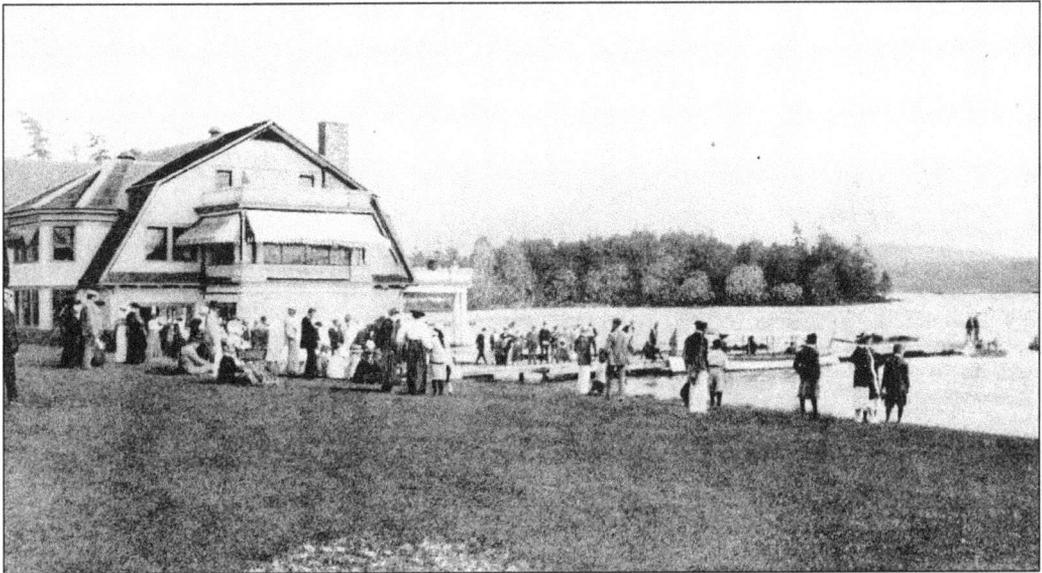

Paul Smith's Hotel was the playground of American presidents, millionaires, show people, and thousands of travelers. The hotel burned down in 1930, and other buildings followed. The store building was torn down once the property became Paul Smith's College for hotel management and forestry. The college has been expanded today. It has a state-of-the-art library and has become a four-year college.

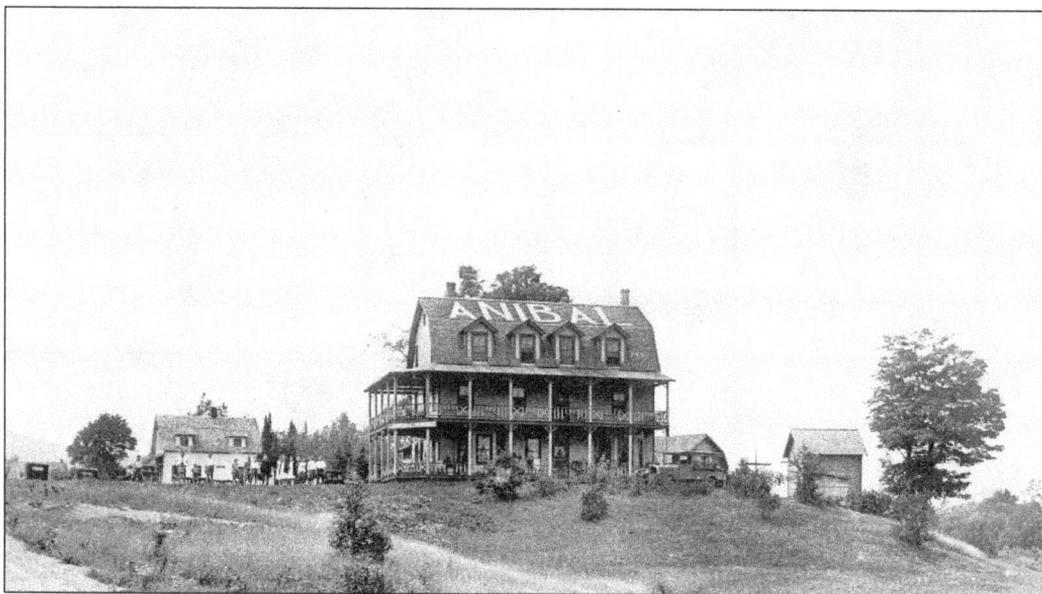

The Anibal House at Piseco was a well-known fishing and hunting lodge operated by Leon Anibal. His father, Capt. Sam Anibal, assisted in the operation of the hotel and was the last surviving veteran of the Civil War in Hamilton County. Built in 1910 by Truman Lawrence, it was the Anibal House from c. 1925 to 1946, when it became Haskell's Hotel. It was destroyed by fire in 1978.

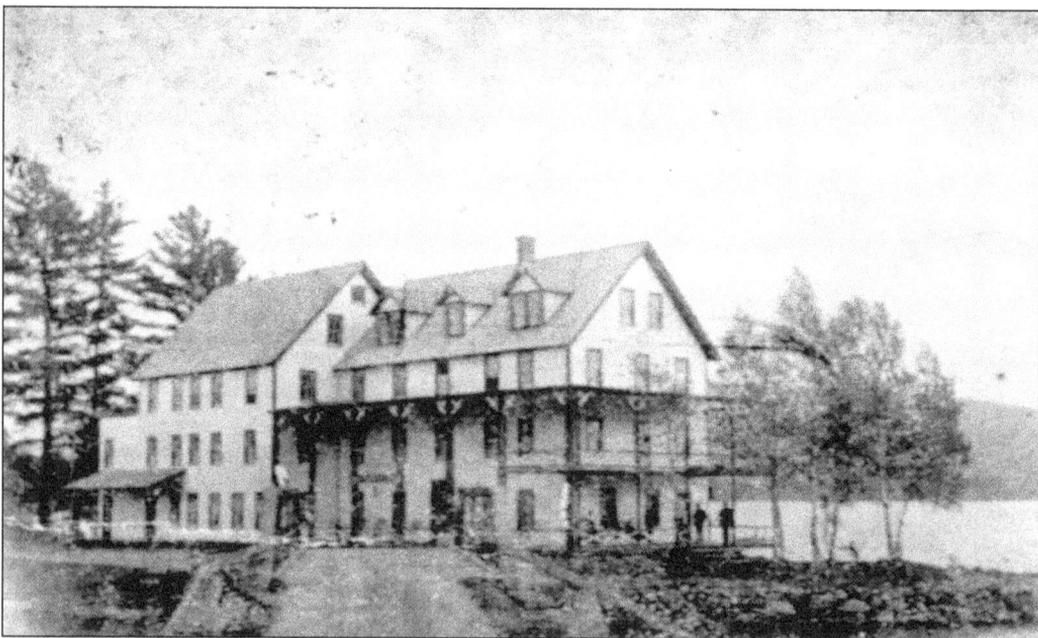

In this early-1900s postcard of the Osborne Inn at Speculator (built in 1901 by Will and Nora Osborne), the writer mentions it is the first place the stage stops. The inn was demolished in the late 1960s, and the property was divided into a private lakefront and part of the Speculator Beach. The inn once served as the training camp residence for some of our nation's famous boxers.

At one time, the Schroon Manor Hotel on Schroon Lake was known as "Heaven on Earth." Visitors came from throughout the nation to enjoy the golf course, tennis courts, hardball courts, Ping-Pong tables, badminton, shuffleboard, baseball, and basketball, as well as the watersports, horseback riding, and skating. Today, the buildings are gone and the property is being developed for a state campground. All that remains of the resort is the crumbling amphitheater where opera star Robert Merrill and comedian Red Skeleton got their starts.

Minnowbrook on Blue Mountain Lake was first constructed in 1915 and opened for business during the warm season. In 1944, it became an executive retreat for the Hollingshead Corporation. It burned in 1947 and was rebuilt in the Durant rustic log style. In 1953, Minnowbrook became a conference center for Syracuse University. Sparks on the roof destroyed the main lodge again in 1988, but it was rebuilt by Syracuse University and is operating today for conferences and retreats.

71

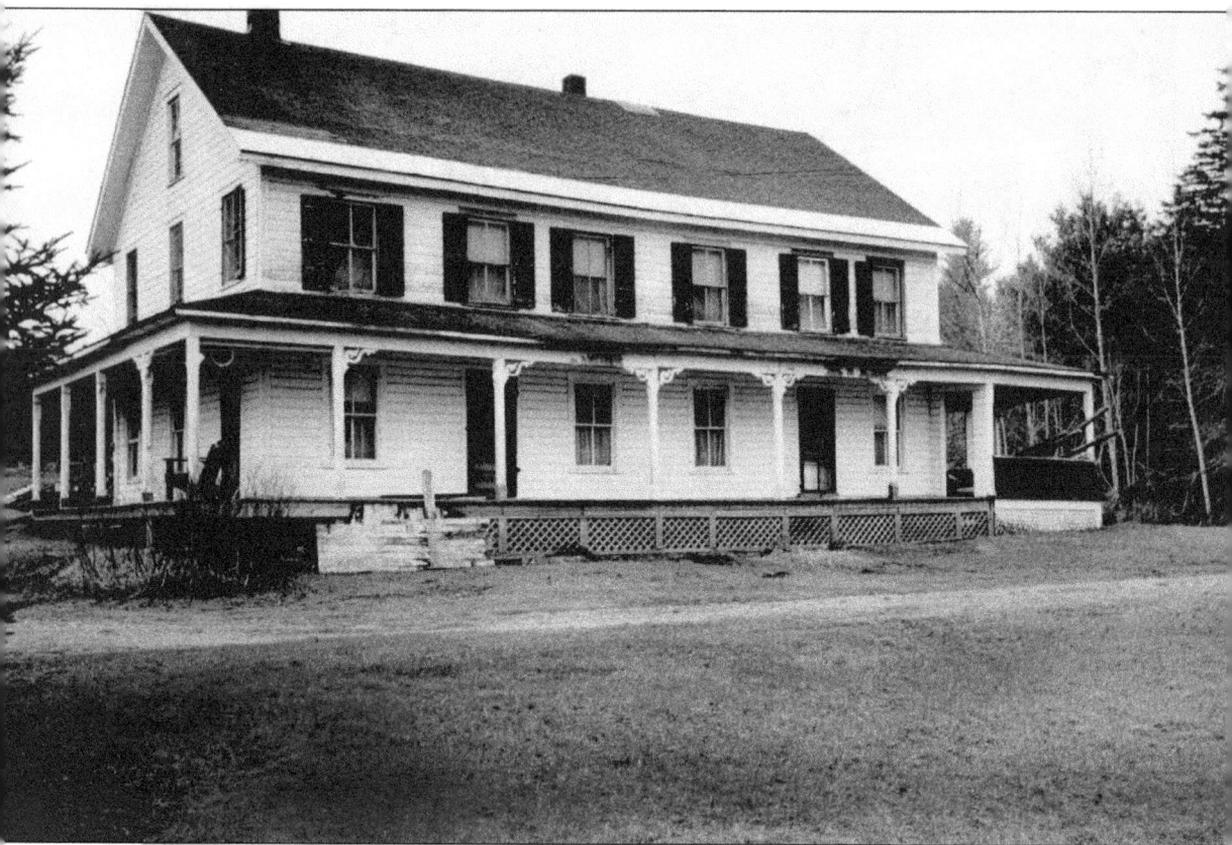

The tanning and lumbering industries at Griffin, first settled by farmers in the 1830s, ended in the 1890s. Henry J. Girard bought some of the land from the Morgan Lumber Company (later International Paper Company) and operated a hotel, dairy, and maple sugar bush for many years. The Morgan boardinghouse was used for the hotel and was later used for the Griffin Gorge Hunting Camp by Frank Girard, Henry Girard's son. The building used for a camp today is the last remnant of the once thriving village of 300 permanent residents and 200 lumberjacks. The lumbermen came to the Griffin area of the Adirondacks in the 1860s to cut the giant trees, and the tanners followed in the 1870s to get the hemlock bark for tanning hides. After the industries left the community, the land was purchased by John G. Hosley and Halsey Richards. The buildings were dismantled or moved to build homes and barns in the community of Wells or on the surrounding farms. Henry Van Avery, who was born in Griffin when it was called Moons Mills after the sawmill owner, remembered the days when the logs floating to market on the East Branch of the Sacandaga would shoot high in the air as they went through the flume.

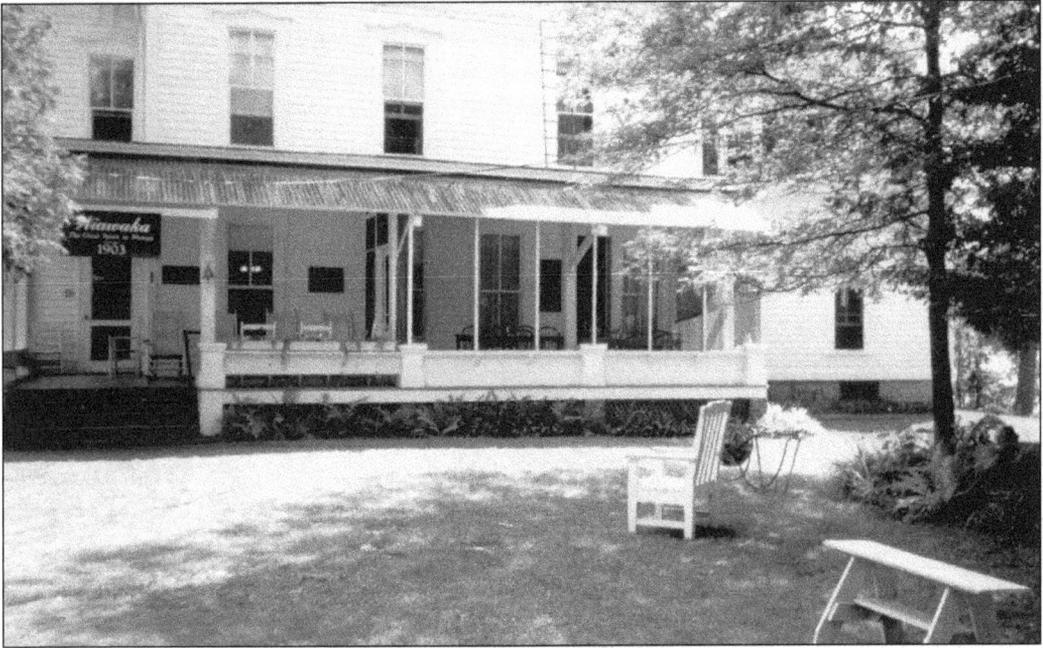

Wiawaka, "the eternal spirit of women," is a holiday house built for women at the head of beautiful Lake George. It was opened in 1903 to provide affordable vacations in the Adirondacks for the working women from the Troy textile factories. Today, with 55 guest rooms, it welcomes adults of both sexes.

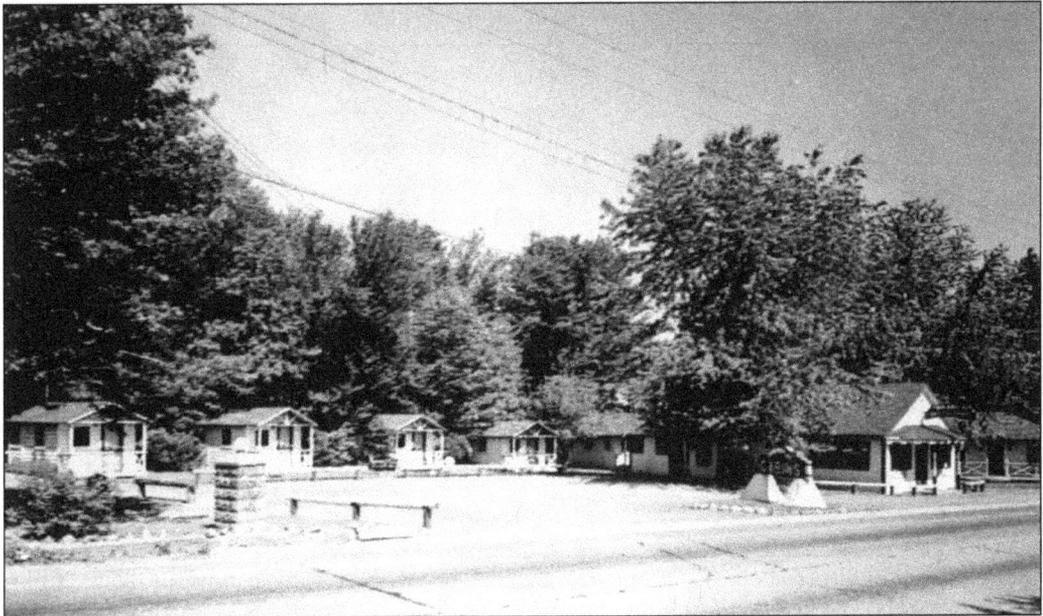

Rustic cabins gave way to those with better facilities when more Americans got automobiles and took to the roads. In the 1950s, you could stay at such cabin colonies as these "ultra modern" Twin Maples Cabins, north of Lake George Village. It also offered, as did many of the cabin businesses, a dining room and a gift shop.

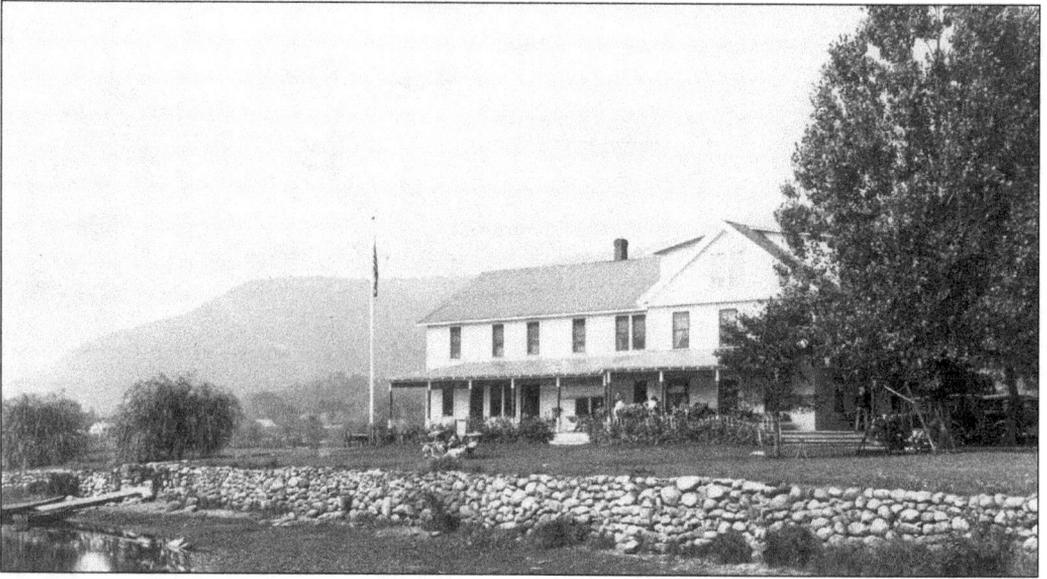

Tourist homes or large Adirondack houses were open for travelers and sportsmen when the influx of visitors searched for places to stay. George Morrison's boardinghouse, shown in this 1936 photograph, on Lake Algonquin provided lodging for those who chose to vacation in the Adirondacks. The large boardinghouse was taken down several years ago and was replaced with a private home.

Clubs also provided accommodations for those who wished to vacation in New York's mountains. The Irondequoit Club, operated by the Piseco Company, was organized in 1892 by New Jersey men who had discovered the good hunting and fishing in the Adirondacks. Part of the building came from an old 1850s building. Today, the club is open for guests, with nine rooms, three cabins, and a tenting ground, along with a private beach, tennis courts, a restaurant, and canoes.

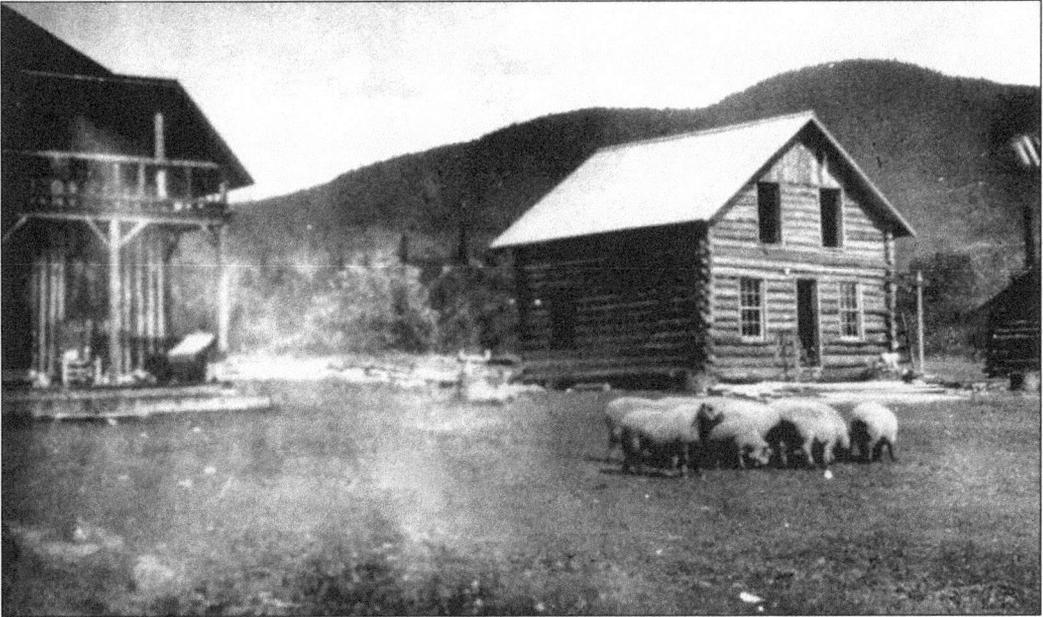

The lumbered-off lands at the end of the West River Road near Wells became the Whitehouse Resort sometime before the 20th century. The "Whitehouse" was an Adirondack farmhouse located on a dirt road some 10 miles back in the woods. It served as a lodge and cottages business during the summer and the hunting season. The cottage shown here was built by Lee Fountain. Lee and his wife, Ott, operated the resort for some 25 years, and since 1961, it has been part of the Adirondack Forest Preserve owned by the state.

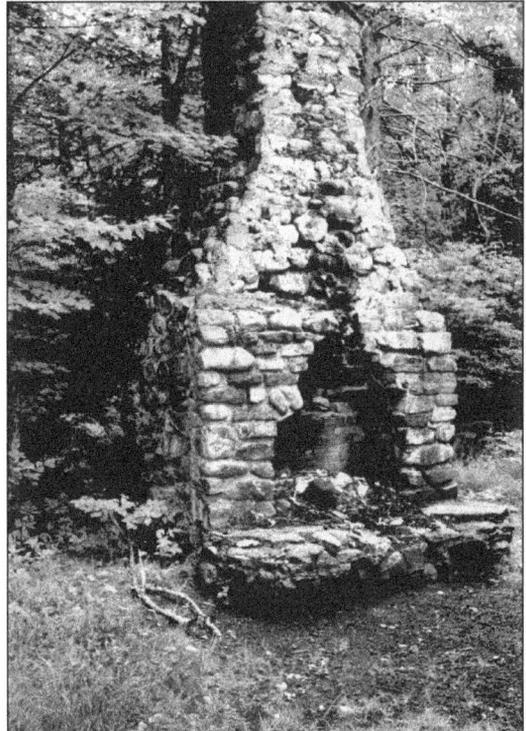

Larry Fountain, Lee and Ott Fountain's son, operated a boys' camp for 50 boys at the Whitehouse during the second quarter of the 20th century. The camp consisted of a cottage and four cabins on the West Branch of the Sacandaga River along with a recreation hall and a mess hall. Now that the land has joined the Forest Preserve, all that is left are the chimneys. Determinations are under way on whether to preserve the historic chimneys or remove them from the property.

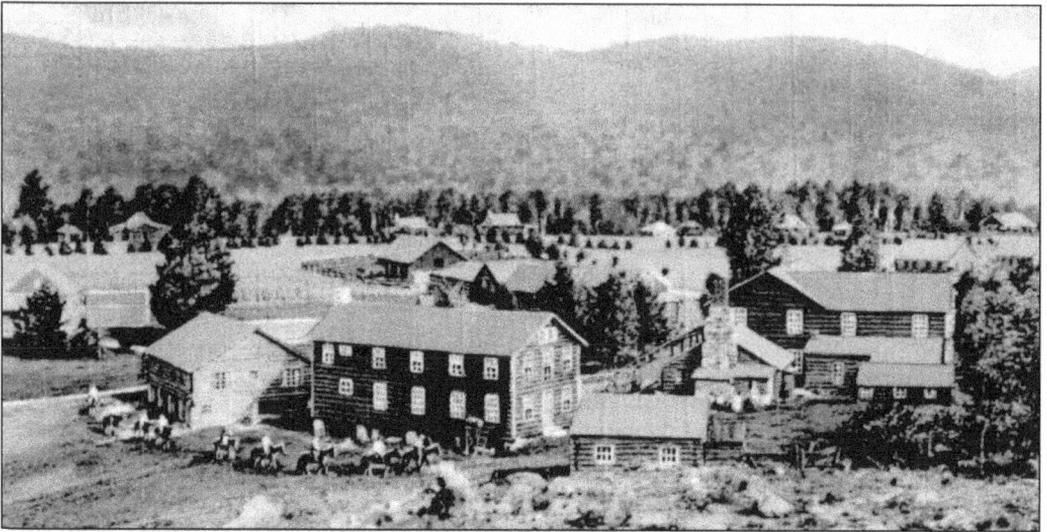

Warren County in the Adirondacks was known as the "Capital of Dude Ranch Country" in the 1940s, when it had more dude ranches than any other section of the East. Dude ranches, with such names as Thousand Acres, Sun Canyon, Rocking Ridge, and Hidden Valley, brought the Old West to the East. They offered horses, real cowboys, good ranch food, country music, and rodeos, along with vacation accommodations. About a half-dozen dude ranches still operate in the Adirondacks today.

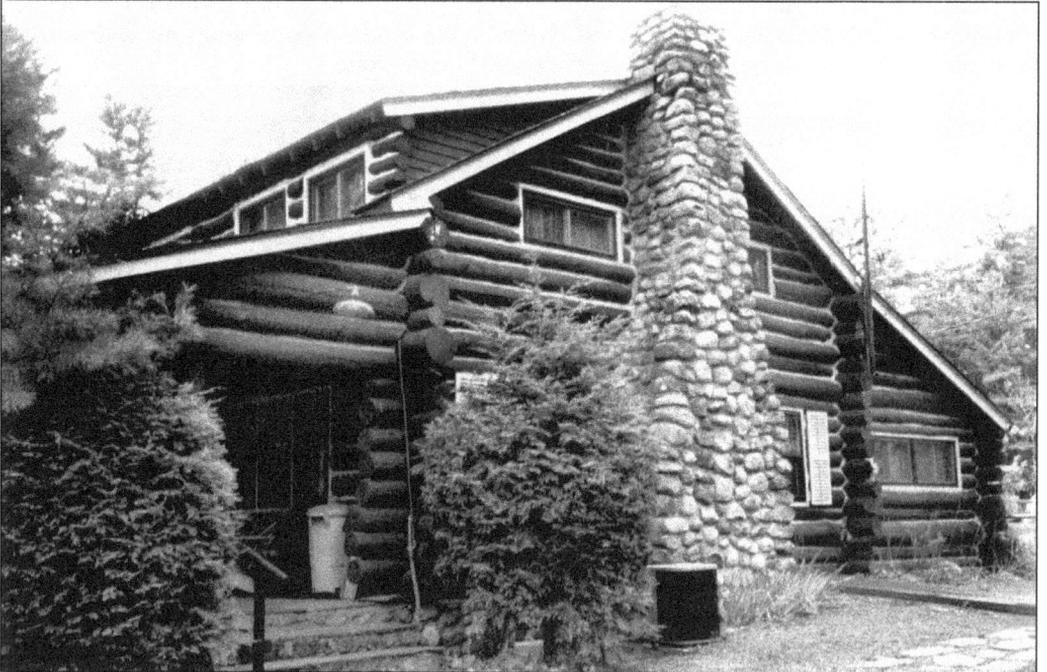

Log cabins were the structure of choice by the earliest Adirondack settlers, and the tradition has continued to this day. Warren County may have the largest number of log cabins within its borders of any county in the Adirondacks; many of the cabins in the county were built as part of the popular dude ranch business. Earl Woodward, dude ranch entrepreneur, built this cabin and many others as part of his dude ranch enterprise.

One of the oldest inns in the Adirondacks is the early-1800s Deers Head Inn at Elizabethtown. It has been well cared for over the years and still thrives as a classic regional establishment for dining and lodging. Oral history talks of a 42-point mounted deer head taken near Paul Smiths in the 1890s that may have hung at the inn and may account for the name.

Those who drive through Long Lake on today's Adirondack Trail (Route 30) pass the stately Hotel Adirondack, still doing business on the south shore of Long Lake near the town beach. Built in the early 1900s, it has reached its 100th birthday. Originally owned by Patrick Moynehan (lumberman, road builder, and owner of Raquette Falls Land Company and Raquette Lake Supply Company), it has passed through a change of ownership over the years. In the early years, it advertised accommodations for 75 people at $25 per week.

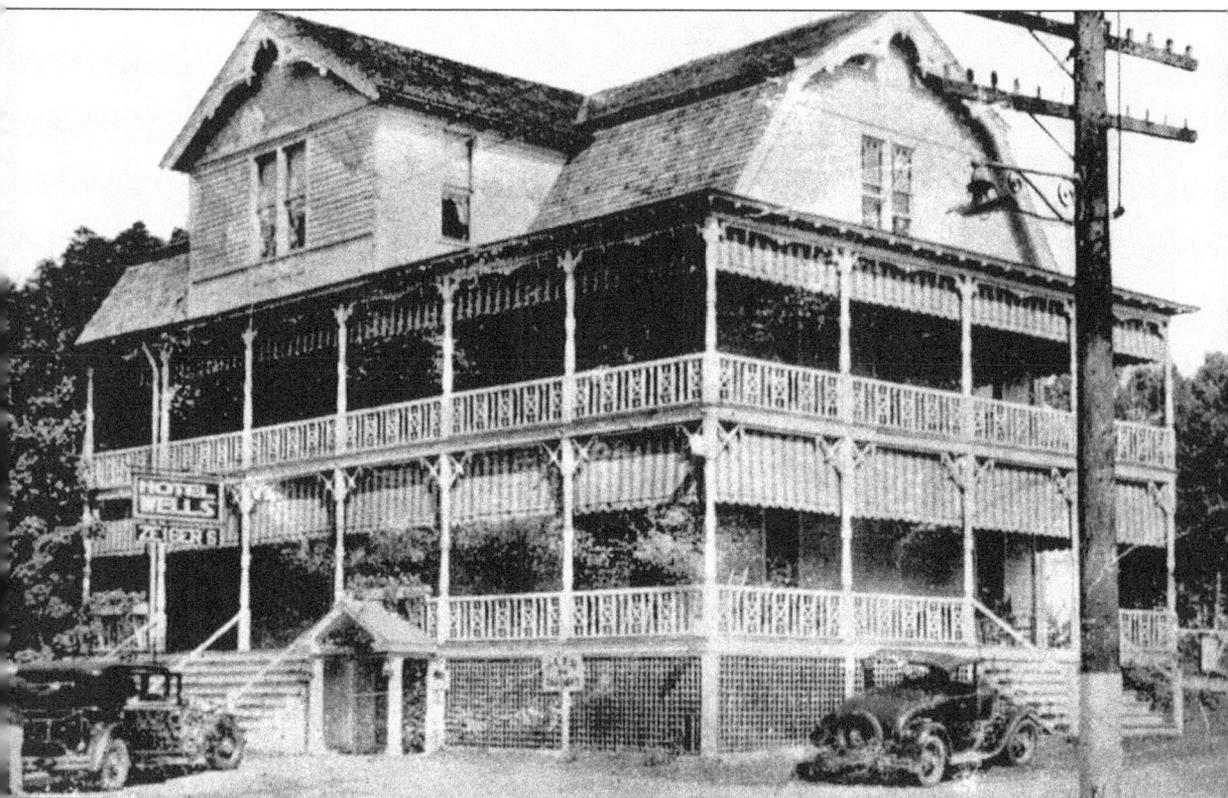

Not many early Adirondack hotels have survived the devastating fires or wrecking balls that destroyed most of them, but Hunt's Hotel in the historic hamlet of Wells can still be seen along the Adirondack Trail (Route 30). Built in 1899 by Martin and John Hosley, it was originally known as the Hosley House. It was operated without a bar, and rooms were $2 a day. It has changed hands over the years and has been known as Zeiser's Hotel Wells and Riley's House. During the Adirondack heyday, it was a good stopping off place for the Northville–Lake Pleasant stage line to get a meal and to change horses. Adirondack vacationers could board a train and make connections to the Fonda, Johnstown, and Gloversville Railroad and get up to the Northville station by 10:00 a.m. The horse-drawn stage would leave for Lake Pleasant around 11:00. It would stop at the hotel for lunch and to change the horses. It would finally reach Lake Pleasant at 6:00 p.m. The return trip was put off until the next day. When automobiles entered the scene, the trip from Northville to Lake Pleasant and back could be made in less than half a day.

Six

FAMOUS ADIRONDACKERS, GUIDES, AND SPORTS

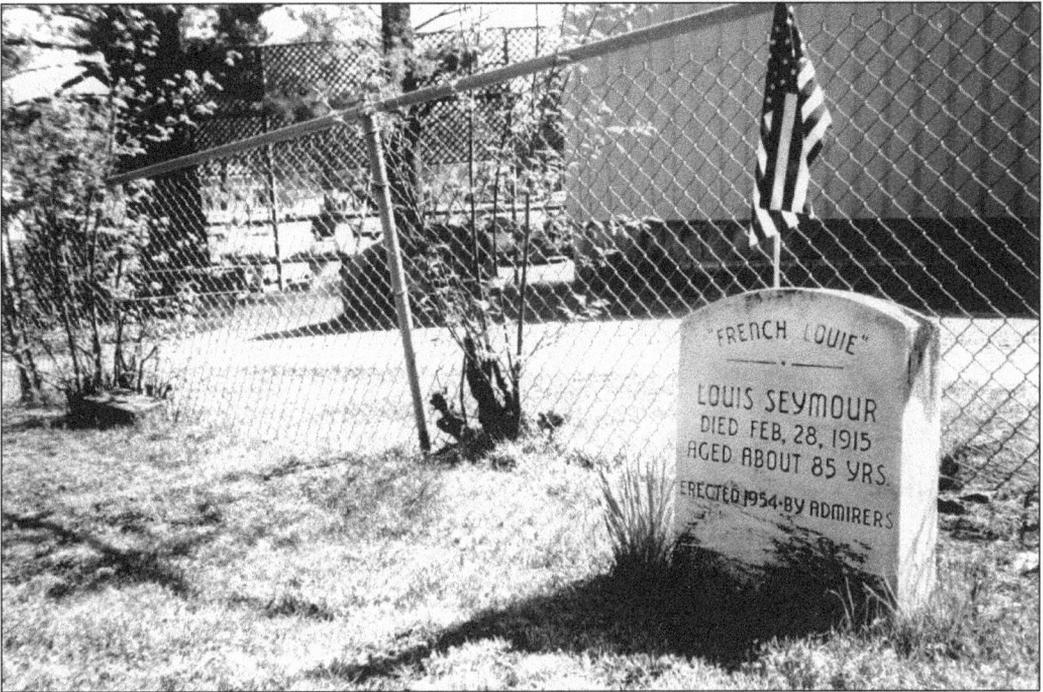

When French Louie died of Bright's disease in 1915, the local school was closed in honor of the old Adirondack guide so the children of the school in Speculator could attend his funeral. They put balsam twigs in his casket and lined the streets with evergreens from the church to the cemetery. In 1954, the schoolchildren raised enough money for the tombstone, shown here, in the Speculator graveyard. His fireplace still stands in the woods at West Canada Lake, and the "French Louie Trail" was recently designated and marked in the Perkins Clearing country.

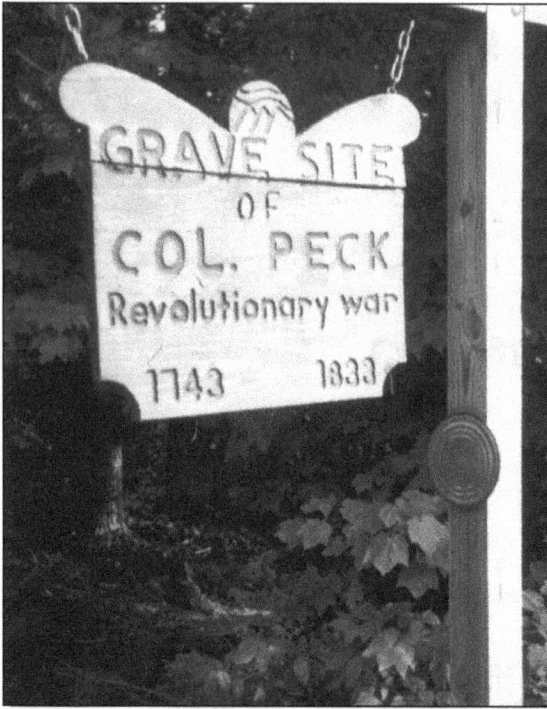

The grave site of Col. Loring Peck, his wife, and his son is on the back side of Lake Pleasant. Peck was Hamilton County's Revolutionary War hero. His three sons followed in his footsteps, and all served in the War of 1812. His son William held a commission, George was a surgeon, and Richard went on after the war to become the first county judge in Hamilton County.

Dime novelist Ned Buntline, promoter of the Buffalo Bill shows, went to the Adirondacks in 1850. He loved the Adirondacks and did his writing from his cabin near Blue Mountain Lake. He married his Adirondack housekeeper, who later died in childbirth. Buntline buried his wife and child under a nearby pine tree. In 1891, the constant desecration of her grave caused millionaire William W. Durant to rebury them in the Blue Mountain Lake Cemetery with the monument that can be seen there today.

There is a brass plate in the grass at the Oakwood-Morningside Cemetery at Syracuse that marks the burial site of Robert Garrow Sr., who died in 1978. His passing marked the closing of a dark chapter in Adirondack history; he was the subject of a large manhunt in July and August 1973. Celebrations were canceled, roads were blocked, and cars and camps were searched to find Garrow, who murdered four and raped seven. He was caught, tried, and convicted.

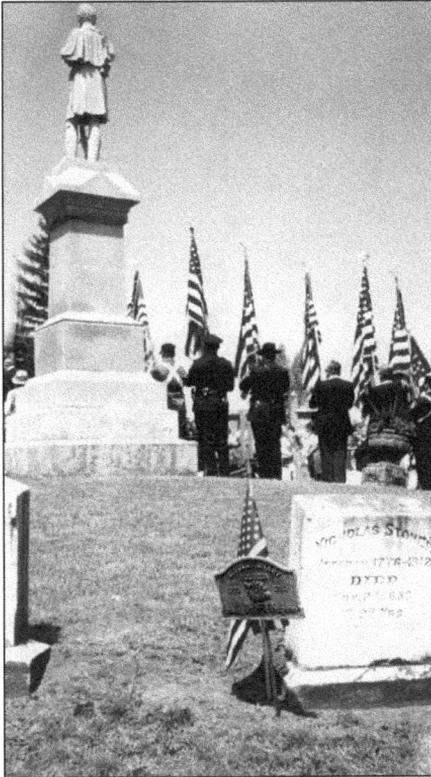

Nicholas Stoner, Fulton County's folk hero and veteran of the Revolutionary War and the War of 1812, lies in the soldiers' circle at Gloversville's Prospect Hill Cemetery. His remains were removed from the old Kingsborough Cemetery to place him with the other veterans. One of the early county historians maintained that they moved Stoner's wife by mistake and she is buried with the soldiers. Stoner was also one of the first Adirondack guides.

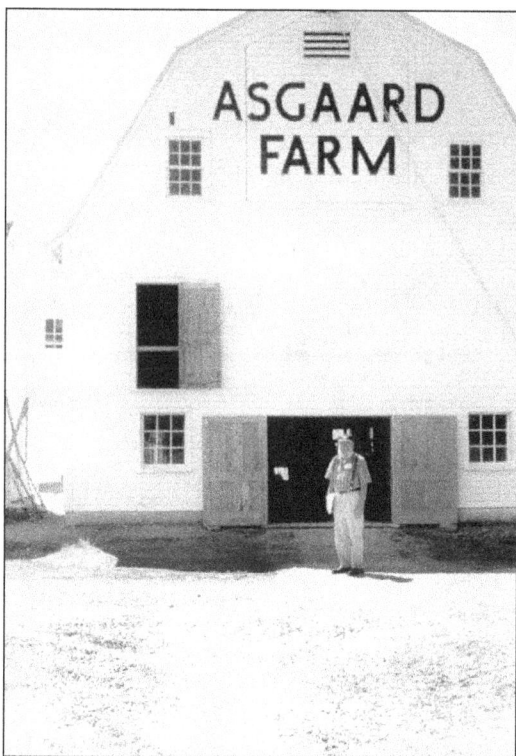

Artist Rockwell Kent named his Adirondack farm Asgaard (farm of the gods), located at Ausable Forks. Kent raised his family and 40 cows at his farm, which was built in 1928. He had a log studio in a grove of pines where he created his paintings, which can be seen today at the gallery located in the State University at Plattsburgh. The privately owned farm is well cared for and is being restored today.

Elmer Patterson of Lake Pleasant was a spruce gum picker. Before the days of manufactured chewing gum, the pitch from the spruce trees was chewed for "healthy gums and teeth." Patterson, with his partner Bion Page, would take a two-week trip into the Adirondack winter woods, sleeping in a spruce-lined bed in the snow, with temperatures below zero, often keeping the fire going all night, to pick spruce gum. After spending hours cleaning the gum, they earned $10 per day. Elmer also supplied the land for the Speculator Methodist Church for $100.

82

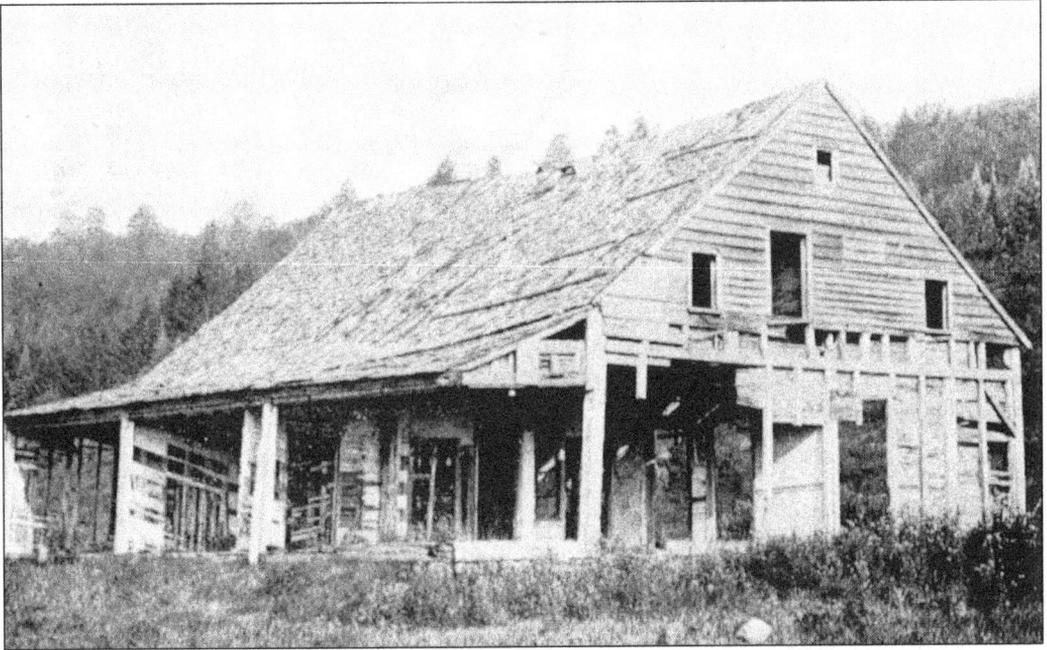

One of the earliest sportsmen in the Adirondacks was Nat Foster, who lived at Salisbury in the early 1800s. He later moved to the old Herreshoff House near Old Forge in the Brown's Tract. Foster was an excellent shot and had a trapline of 300 traps. His biographer, A.L. Byron-Curtiss, claimed that Foster was the Natty Bumpo in Cooper's tales. A celebration of Nat Foster Days has been held over the years in his home country to keep his memory alive.

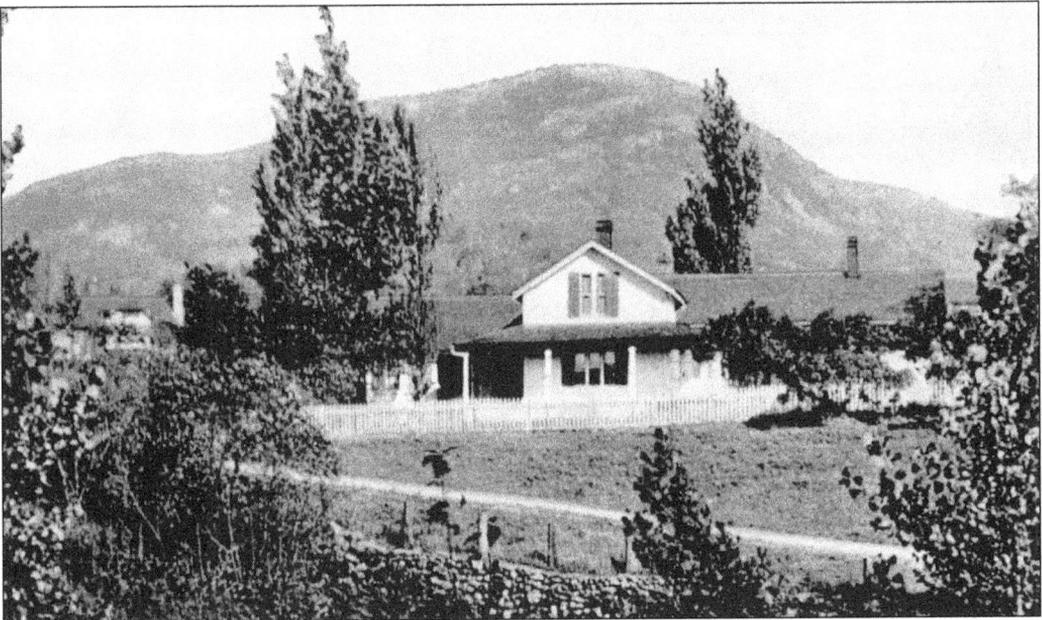

Renowned author Robert Louis Stevenson spent some time in the Adirondacks. He, along with many others, contracted tuberculosis in the 1880s and came to the mountains in search of a cure. He did some writing while there, and his cottage contains a large collection of Stevenson memorabilia and is open to the public at Saranac Lake.

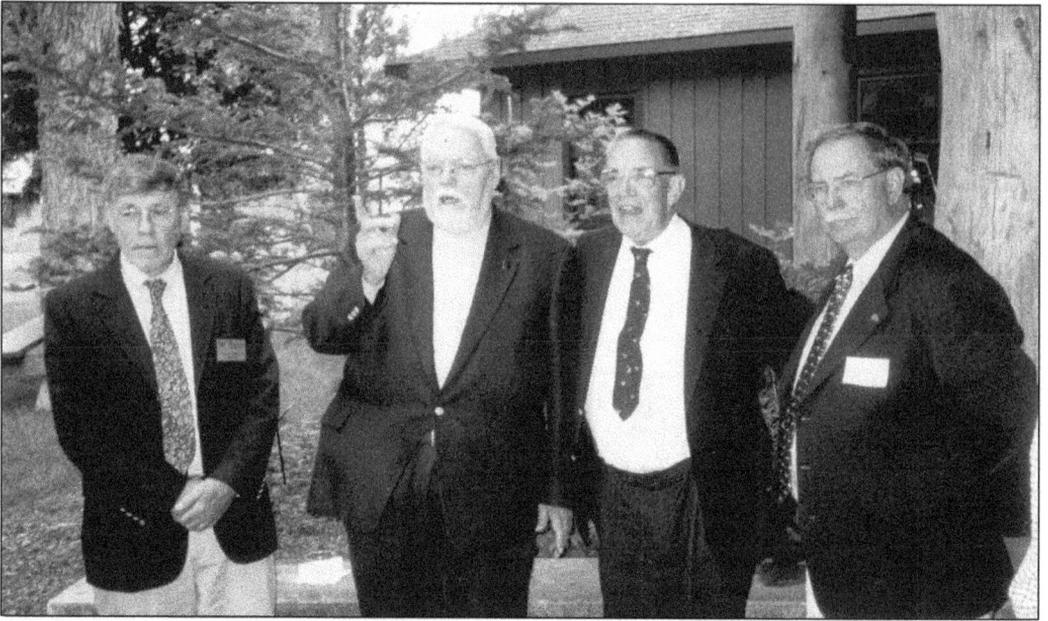

The Adirondacks have been blessed with those who cared about them over the years and served to make those decisions that protected our fragile, forested mountains. Those gathered here represent that corps of leaders who have provided wise guidance for many years. They are, from left to right, John Collins, former Adirondack Park Agency (APA) chairman and now Adirondack Museum director; Herman (Woody) Cole, former APA chairman and the 1980 Olympics chairman; Arthur Savage, former APA member and longtime Adirondack advocate; and Richard LeFebvre, present APA chairman.

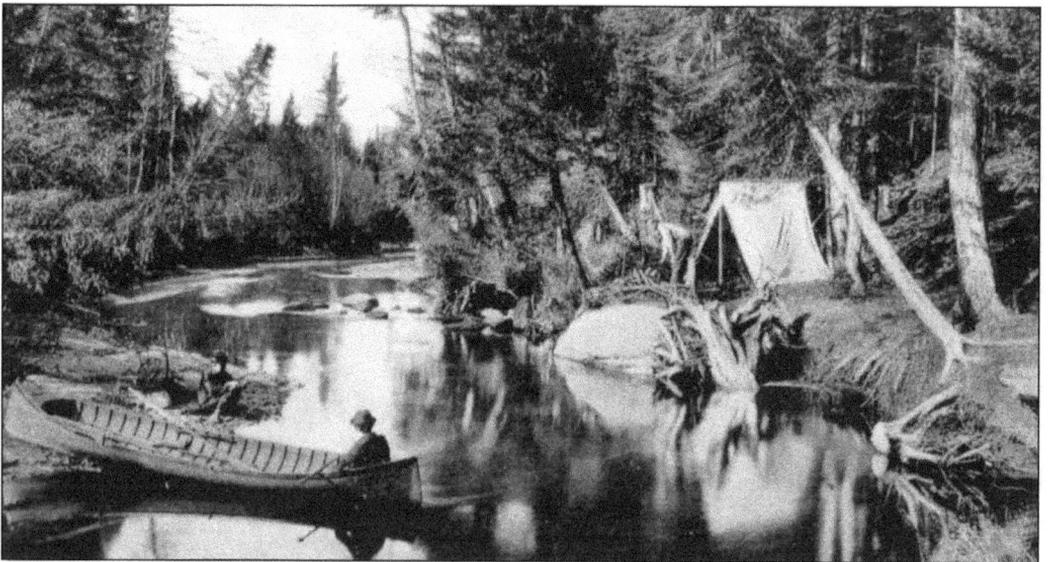

The Adirondack guides had many skills that were useful in camp. They not only rowed the boat and guided the client, but they set up the tent, did the cooking and cleanup, cut the wood, and kept the campfire going. They also had to guide the client safely to the deer, fish, or hiking destination. Guiding dropped off with the influx of automobiles and after World War II, but it is making a resurgence today.

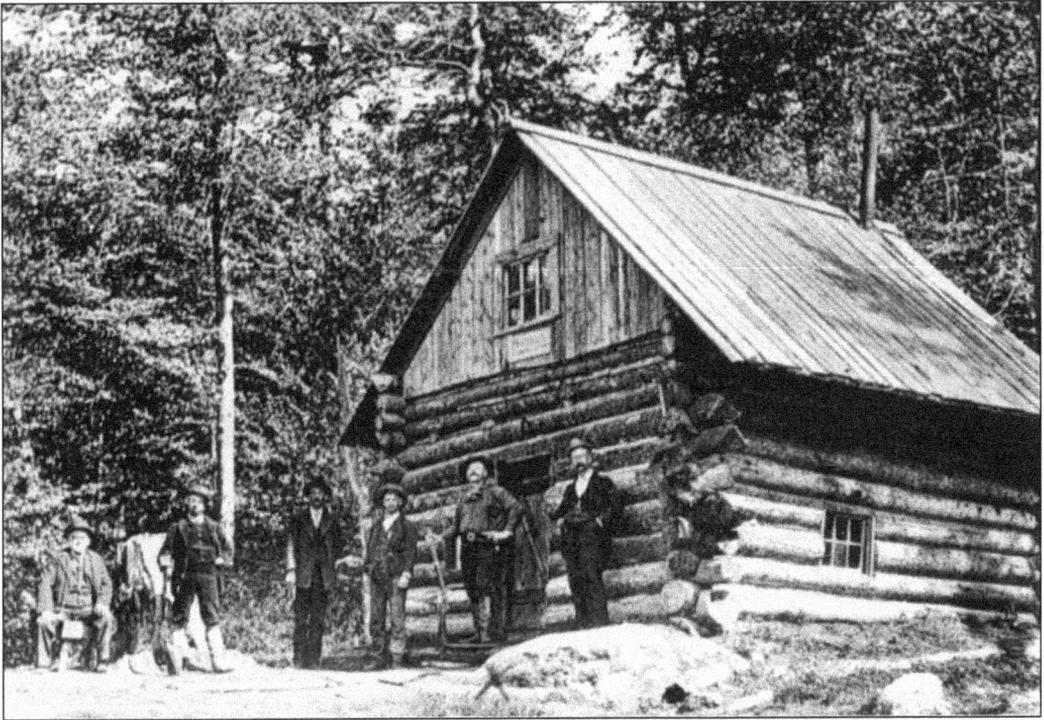

"Greenhorns," those who had never hunted before, were often initiated to the ways of the woods at the old Adirondack hunting camps. On a deer drive, when large numbers of hunters walked through the woods to drive the deer to another hunter on watch or to the water, the inexperienced were often left behind, sitting on a watch in the woods long after the hunt was over. If they missed a shot at a white-tailed deer, they got their own shirttail cut off.

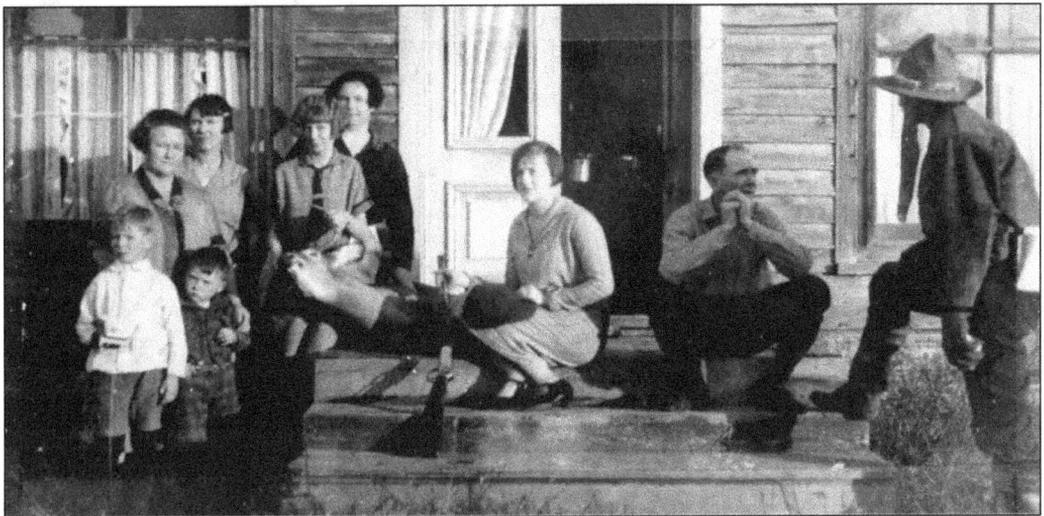

The entire family turned out when the annual hunt came to a successful conclusion. In the Adirondacks, most families depended on taking a white-tailed deer each year to help feed the growing family. Venison could be canned, made into mincemeat and dried pemmican, and packed in salt brine. Hides were tanned into leather and used for clothing.

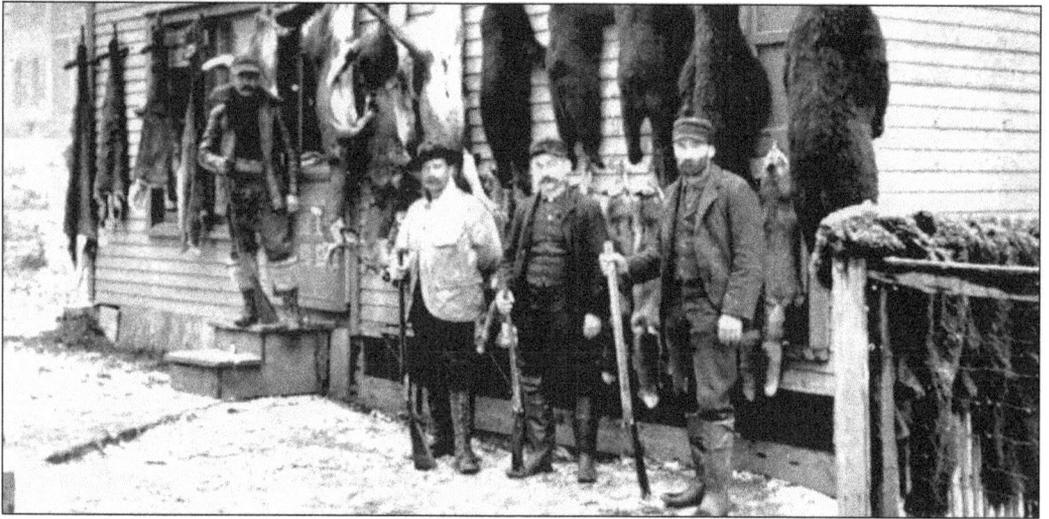

Much of the Adirondack economy during the 1900s depended on hunting and its associated attributes. Hunting parties came from far and wide, stayed in the local hotels and hunting camps, ate in the local restaurants, traveled on the stage, train, and bus lines, and hired the local guides. Leather dealers and taxidermists benefitted from the hunting season. The settlers also depended on the products of the Adirondack forest to feed their families and raise some cash money.

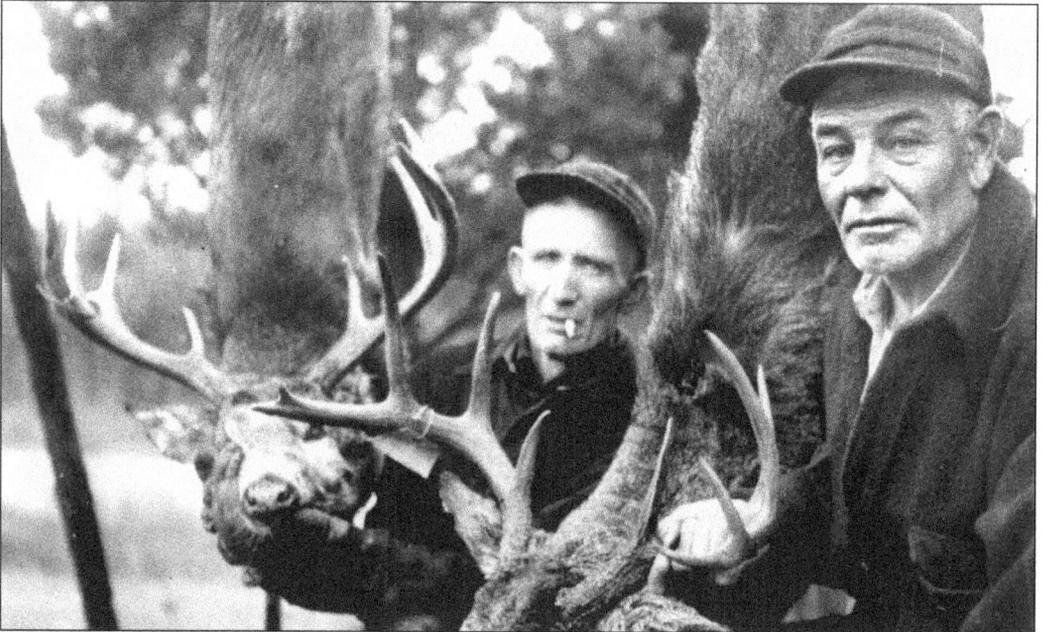

The guides at the Whitehouse Hunting Preserve, Jim Craig and Pat Conway, were the subject of a 1940s folk song written and sung by Pete Craig of Wells. Part of the long, 14-verse song provides a good description of an Adirondack guide: "There was one guide we all loved to be with, He was rugged; he wore a slouched hat, And all stories were topped round the fireside, By the West River Guide they called Pat. And that old guide that owned that whole valley, He would tell tales no one could believe, But he grinned as he left us in wonder, A' wiping his face on his sleeve!"

The tradition of hunting was important in the Adirondacks, and it was passed down from father to son in each generation. The hunting camp became part of that tradition, and hunters returned to the same camp year after year. Most had their rules to keep the hunting trip safe for all the hunters and to train the greenhorns. The rules were strictly enforced at the successful Whitehouse Hunting Preserve supervised by Ed Richards. In some 25 years, they had no accidents.

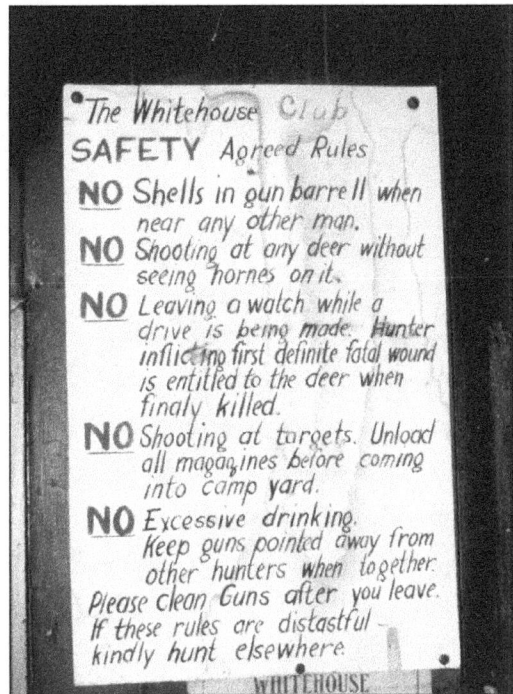

The Whitehouse Club
SAFETY Agreed Rules
NO Shells in gun barrell when near any other man.
NO Shooting at any deer without seeing hornes on it.
NO Leaving a watch while a drive is being made. Hunter inflicting first definite fatal wound is entitled to the deer when finaly killed.
NO Shooting at targets. Unload all magazines before coming into camp yard.
NO Excessive drinking. Keep guns pointed away from other hunters when together.
Please clean Guns after you leave. If these rules are distastful kindly hunt elsewhere.
WHITEHOUSE

Adirondack guides became part of the hunting tradition, and each hunting party had their favorite guide. There should be a song written, "Ode to the Unknown Guide," in honor of those hundreds of guides who opened the Adirondacks for thousands. Old photographs and stories come to surface about the anonymous guides. This unnamed guide is in his guide boat somewhere near Saranac Lake; it may be Sanford McKenzie of Lake Placid or another of the pre–World War II guides.

The 30,000 miles of streams and rivers and the 3,000 lakes in today's Adirondacks still provide that privacy and solitude sought by many since the first intrusion of the forested mountains. An old guide floating on an Adirondack pond, surrounded by the lush Adirondack vegetation and rolling hillsides, with his Buyce guide boat, his Adirondack pack basket, and a bamboo fishing pole, can fish away the hours much like those who came before him. The wide guide boats provide stability on the Adirondack waters when the wind and waves arise, and a good pack

basket can carry the gear and supplies needed in the Adirondack woodlands. With the long oars, the guide can rapidly skim across the waters and, with a small paddle, can take the guide boat up a mountain stream. Most guides painted their guide boats the minute they began using them; they were green on the inside to blend in with the overhead vegetation and Prussian blue on the outside to blend in with the waters. The beautiful varnished guide boats were used mainly for recreation.

The New York State Outdoor Guides Association rechartered the defunct original 1891 Adirondack Guides Association in the Adirondack Gateway County of Fulton in 1983 with Don Williams, shown here, as its charter president. Today's guides, numbering more than 1,000, are tested and licensed by New York State to work in the Forest Preserve counties. Individual categories are licensed, including rock climbing, whitewatering, hunting, fishing, hiking, and camping.

The guides of the New York State Outdoor Guides Association follow a code of ethics for guiding and maintain a clearinghouse for employment of a guide. In 1991, the licensed guides in this photograph gathered at the dedication of the pavilion at Berkeley Green at Saranac Lake on the 100th anniversary of the original Adirondack Guides Association. The association's honorary president, State Surveyor Verplanck Colvin, told the guides at their first meeting, "With true hearts, faithful work, and kindness toward all—you cannot fail to obtain every reasonable goal you may desire."

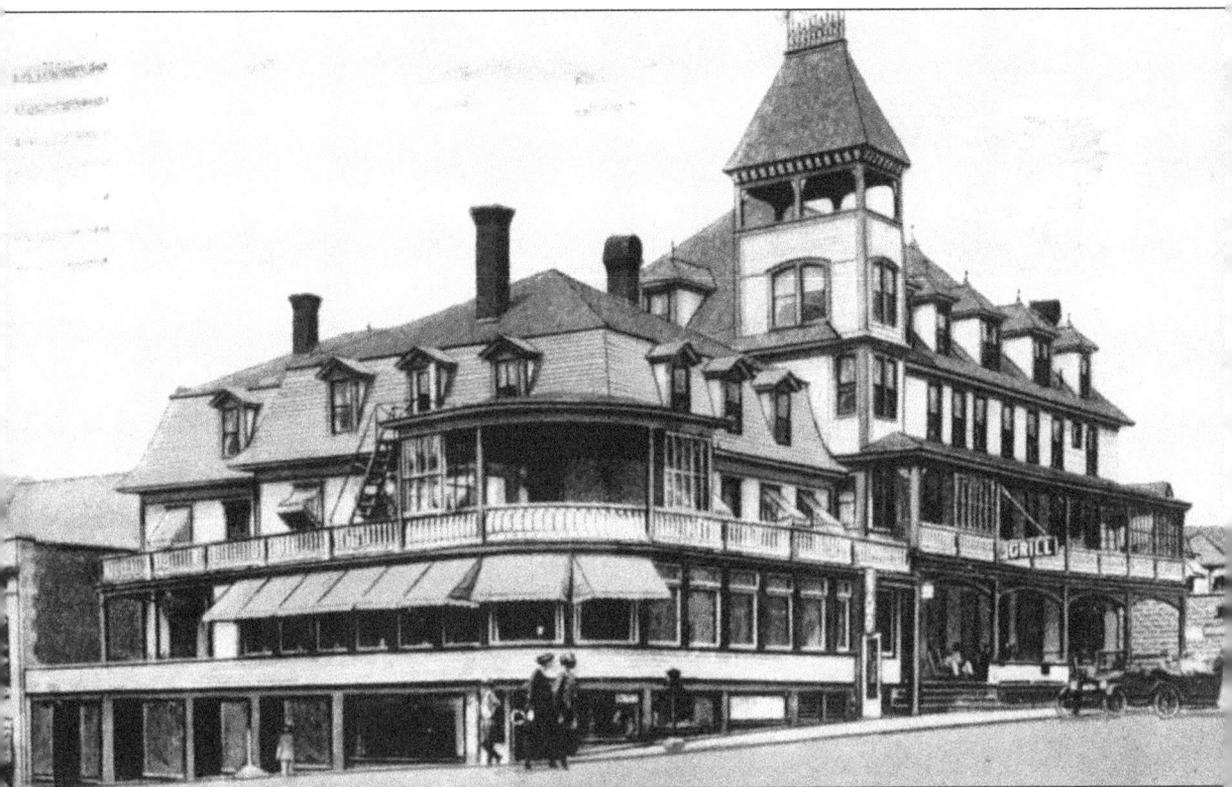

Guidebook writer S.R. Stoddard recommended the Berkeley Hotel in his early Adirondack travel books. The Delaware and Hudson Railroad booklet called Saranac Lake's Berkeley Hotel "thoroughly modern, handsomely appointed, and perfectly equipped." It was the site chosen by the Adirondack guides for their first meeting in June 1891. By 1918, guiding had reached a high level of success, and the state introduced a volunteer licensing program to guarantee the public competent guides. By 1923, licensing became mandatory, and it continues to this day. The 1918 bill passed by the legislature was not intended to stop anyone from guiding; it was simply "to provide a directory of competent guides and to place that directory in the hands of the largest possible number of users of the State's Forest Preserve." The voluntary registration did not work because only a limited number of the "independent minded" guides applied. When it was made mandatory, within a year more than 1,000 guides were registered to guide and required to follow the rules established by the state. The state issued distinguishing badges, which have changed from time to time over the years and have become highly collectible.

Noah John Rondeau was *the* Adirondack hermit for the 20th century. Dissatisfied with his life, he left home in 1898 and, in 1902, started going to the mountains. By the winter of 1929–1930, he was staying in the woods. He settled on the Cold River, 19 miles from civilization, and created his Cold River City, population one. Hikers often visited Rondeau at his little city, but in 1940, he reported that he was alone all year except for 10 days. Often misunderstood, he was highly intelligent and was a serious reader of the classics and the Bible. Rondeau played violin music that brought the deer out of the woods. He studied astronomy, lectured at sportsmen shows and service clubs, and once played Santa Claus at the Adirondacks' North Pole theme park. His longest continuous stay in the woods was in 1943–1944, when he stayed from May to May for 381 days. He once kept his fire going for 138 straight days during a bad winter. Rondeau is the subject of two biographies and has his own display of his house and gear at the Adirondack Museum at Blue Mountain Lake. He left the woods during the Big Blowdown of 1950 and died in a nursing home in 1967.

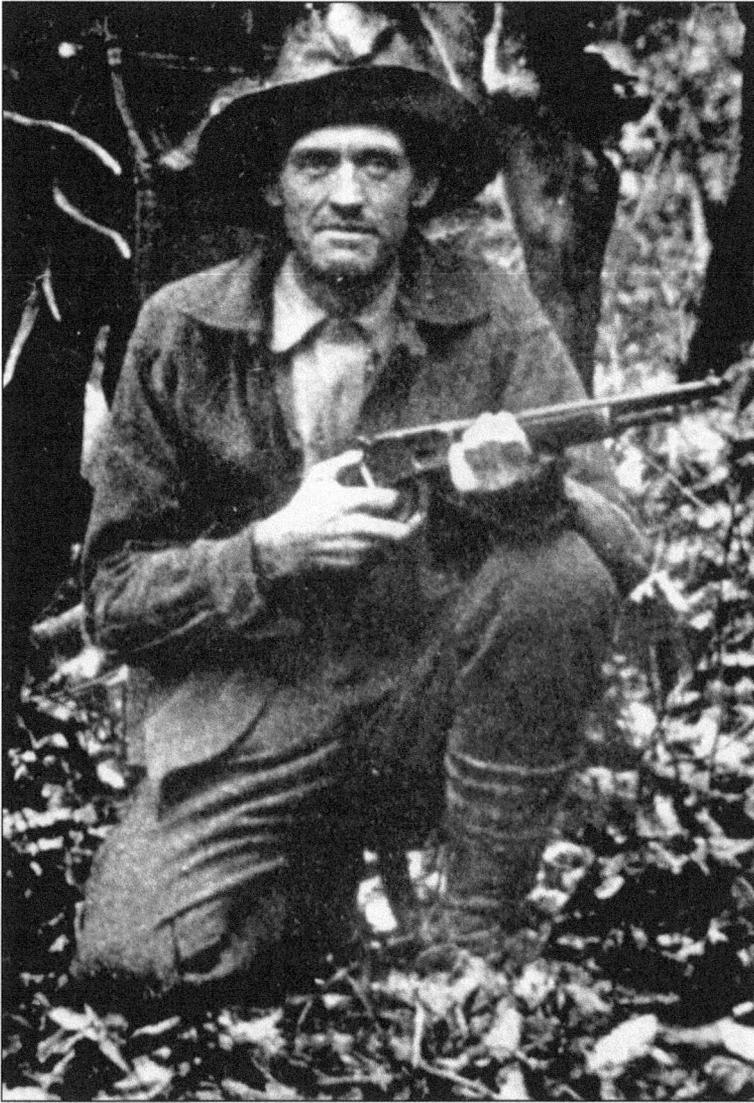

Oliver H. Whitman was a true Adirondacker. Born and raised in the Adirondack wilderness in the Adirondacks' "landlocked" Hamilton County, he learned to live off the woods. Much like other native Adirondack residents, he was an expert woodsman and a perfectionist in many of his activities. Leather dealers learned to recognize his hides because of their quality. He placed his onions in his garden in neat rows, using a board with holes in it to place the bulbs properly. Whitman also excelled at operating a water-powered lathe and, during the war, made machine parts for the General Electric Company. When automobiles became popular, he was often called upon to make a new part to replace one that had broken. It was often said that if Whitman could not make the part, you might as well throw the car away; it would be beyond repair. He made himself a set of steel teeth to use when eating the tough bear meat and made an "electrical" device to aid in healing. He was in great demand as a hunting guide and, along with his father and other family members, ran a successful hunting business. Whitman's day-to-day activities were recorded in journals kept by his father, Oliver W. Whitman, for 38 years and are the subject of a book by the author. Oliver H. Whitman's grandson Roy Early is carrying on the guiding tradition of the Whitman family and is a successful Adirondack guide.

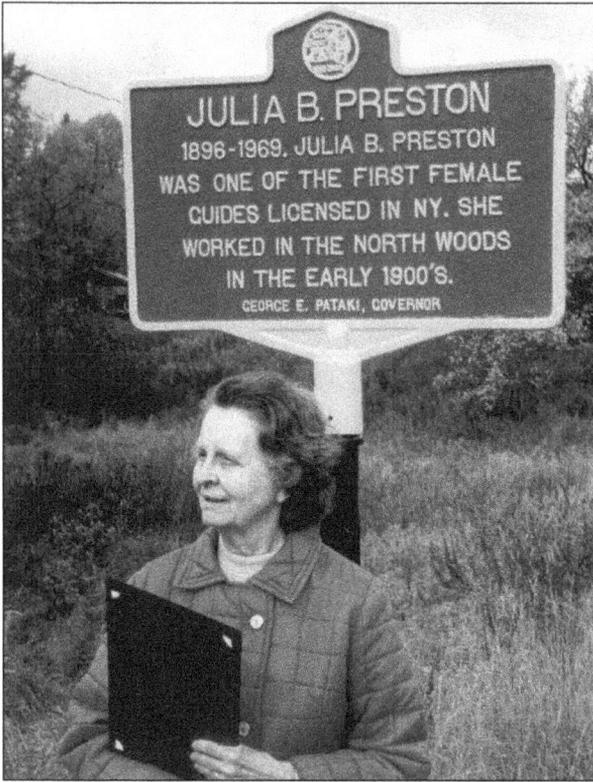

In 1914, when the New York State Conservation Department recommended a law to license "competent men" as guides, it did not know that female guide Julia Burton was already guiding with her father for $10 a day. She began hunting in 1910 at the age of 14 and became one of the first licensed female guides in the state. She passed away in 1969, and with the assistance of Audrey Preston (shown here), New York State placed a historic marker at her home site in Piseco on October 13, 1998.

Julia Burton Preston grew up in the Adirondack wilds, where her livelihood was directly connected to the wilderness. She learned to shoot, to never waste a bullet, to take animals for food and pelts, to trap, and to guide others. Her husband, Charlie Preston, was a perfect partner for her, and they lived on the Piseco Lake outlet to care for the dam, to rent boats, and to guide. When Charlie went off to fight in World War II, Julia built herself this 24- by 28-foot cabin at Piseco, where it can be seen behind the state marker today.

Once the Adirondacks were open and the men began to enjoy the outdoor pursuits, the women wanted to join in. Gertrude Atherton's Adirondack book *The Aristocrats* promoted this theme. Women found that they could enjoy fishing, hunting, and outdoor activities as much as the men did. Viola Whitman Handy is trying her luck at fishing in this Adirondack stream.

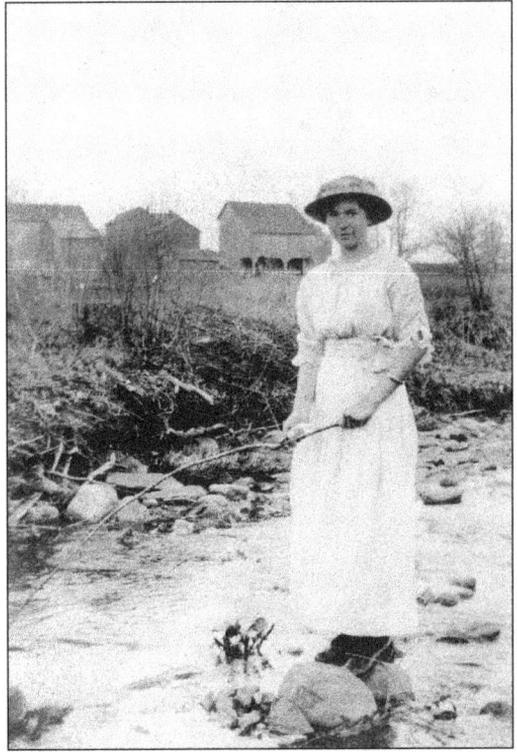

There is an old saying in the Adirondacks: "If you catch it or shoot it, you clean it!" In this view, Viola Whitman (left) and Mae Brownell have caught the fish and appear to be enjoying cleaning them and getting them ready for the frying pan. Fish were a regular part of the diets of those who lived near the Adirondack mountain streams and lakes.

Mustached Bill Smith of St. Lawrence County is easily recognized throughout the Adirondacks with his songs, stories, and crafts. Smith is one of those Adirondackers who provide a connecting bridge to the past when things were done in the old way. Bearded George Ward has devoted his life to gaining recognition of folklore and the music traditions of rural New York. He and his wife, Vaughn, have spearheaded those efforts for more than 20 years through performances, festivals, songwriting, concerts, and supporting others.

Peggy Lynne came to the Adirondacks in the late 1970s to study forestry at Paul Smith's College. With the inspiration found in the mountains, she soon became one of the leading Adirondack singer-songwriters in our country. Appearing nationally and on television documentaries, she shares the Adirondacks through her music. She has authored many songs of Adirondack women, including "Diana of the North Woods," based on a prizewinning story by the author.

The Adirondacks have their own "country" music and stories. Among those who preserve the oral history and music are, from left to right, songwriter-singer-storyteller Chris Shaw, storyteller-writer Don Williams, singer-storyteller Bill Smith, and fiddler Vic Kibler and his son Paul on the keyboards. Chris Shaw grew up at Lake George in a steamboat family but chose to be an Adirondack singer. He has appeared widely on television and on tour, including trips overseas to share Adirondack music. Don Williams was born and raised in the Adirondacks, where his Grandfather Whitman was an Adirondack guide. He has collected stories and Adirondack ephemera and has shared Adirondack stories, orally and in print, for some 50 years. Bill Smith is an Adirondack legend; he lived the stories from the past and shares a wealth of Adirondack lore and tradition. Vic Kibler is a master fiddler of international fame with a repertoire of more than 500 tunes. His son Paul plays the piano and enjoys backing up his famous father. Adirondack music and stories are shared at festivals, folk concerts, and other gatherings throughout the Adirondacks. The "Adirondack Oprey" here is in the old barn at the Caroga Lake Museum.

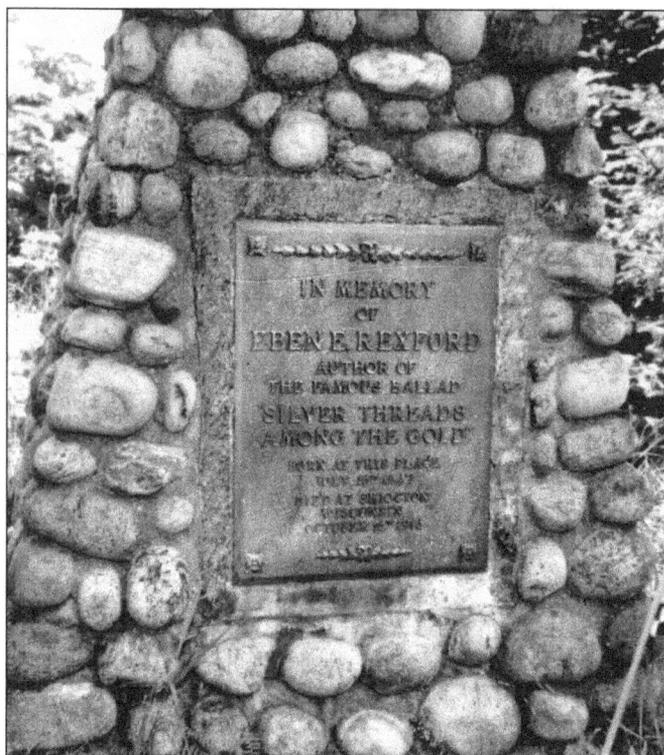

On the west side of the highway between the Weavertown corner and North Creek stands a stone cenotaph with a bronze plaque attached to the face. It is dedicated to a piece of sheet music and reads, "In memory of Eben E.R. Rexford, author of the famous ballad 'Silver Threads among the Gold.'" Rexford was born there on July 16, 1847. His ballad sold more than two million copies when published, and a million more in a 1907 revival. It is still a popular song today.

One of the most popular Adirondack music groups of our day is Quickstep. Seen here, from left to right, are Ed Lowman; John Kirk; his wife, Trish Miller; and Cedar Stanistreet. They appear at Adirondack fairs, weddings, churches, schools, and other Adirondack gatherings with their wide range of instrumental and vocal Adirondack and folk music. John and Trish have also been known to do some Adirondack clogging.

Seven

ADIRONDACK TRANSPORTATION

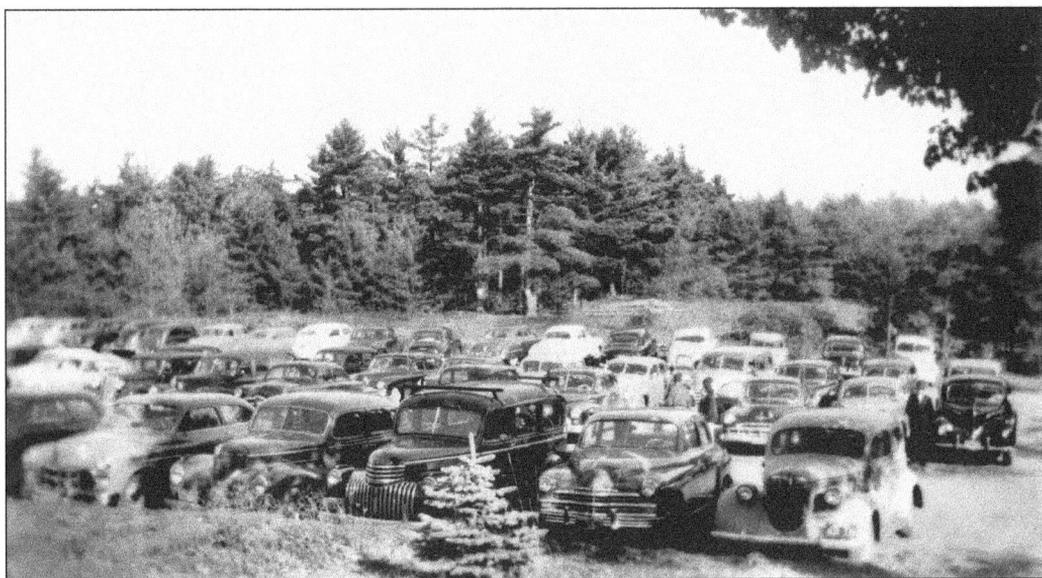

By 1930, the automobile had found the Adirondacks and was well on its way to becoming a major part of Adirondack life. The usual patterns of Adirondack access and travel would never be the same. It was now possible for the American public to have easy access to the people's park, the Adirondacks, for touring, for vacation trips, for weekend getaways, for overnight jaunts, and for roadside camping. Adirondack residents also gained access to the surrounding cities for shopping trips through the invention of the automobile. The automobile was here to stay.

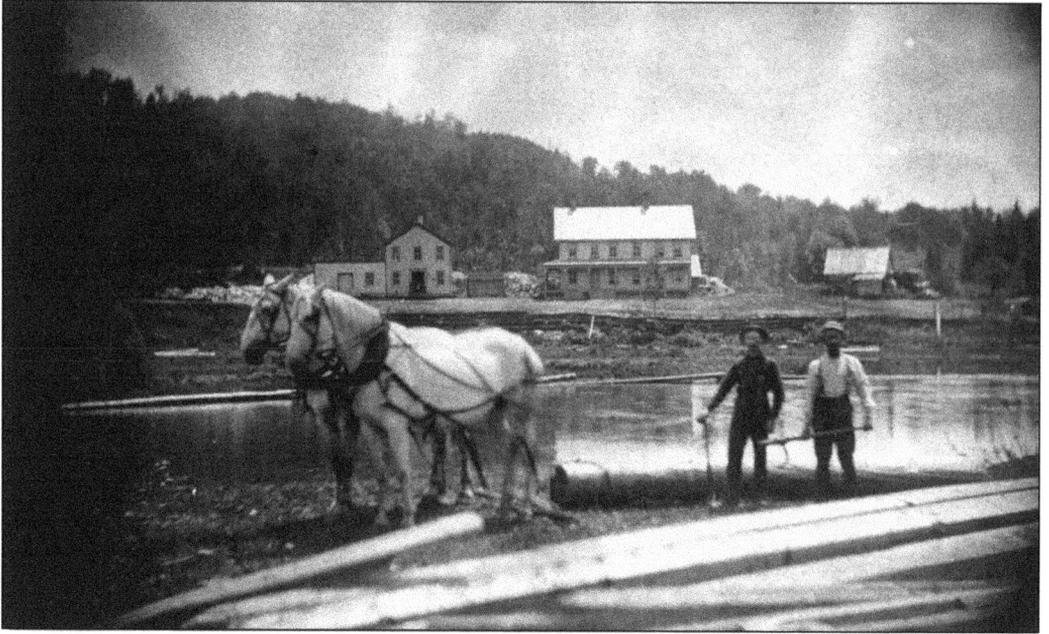

Horses played an important role in the settling of the Adirondacks, and their usefulness continued through the first half of the 20th century. They were in great demand by the loggers to transport logs to the mill or to the riverbanks to float them to the mills. They are still used today where less damage is desired on a woodland logging job. In the background is the old Morgan Lumber Company (later the International Paper Company) boardinghouse, which still stands at Griffin today.

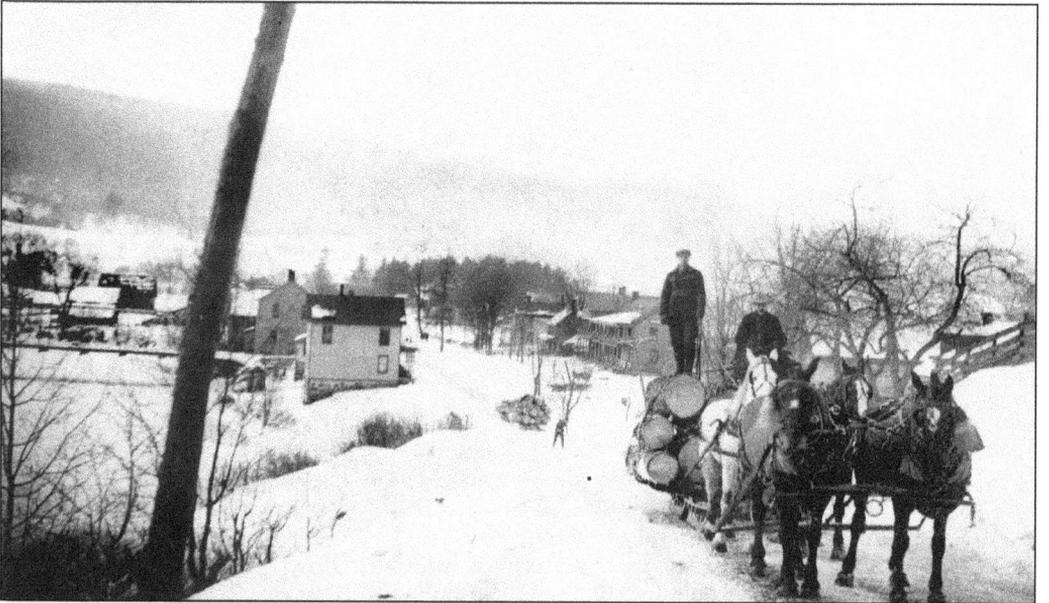

Wintertime was the best time to pull logs out of the woods and to transport them on sleighs. The heavy load shown here is double-teamed for more pulling power. When the horses slid on ice and fell, it sometimes took hours to get the harnesses untangled and back on the horses. It was a problem no longer faced when log trucks were put to use.

Before trucks gained widespread use, Adirondackers had to depend on the old freight wagons to deliver their goods. They ran on wheels in the summer weather and used runners on the snow in the winter. This freight wagon, once driven by the father of the author's wife (shown here), has found its way to the Adirondack Museum at Blue Mountain Lake. When the summer camps began to multiply around the Adirondack lakes, furniture and household goods had to be transported. Heavy items, such as pianos, were often transported by sleigh wagon across the frozen ice of the lake.

Times changed in the Adirondacks when the automobile arrived, and the left section of the building shown here evolved from the blacksmith shop for the stagecoach horses to a carport for the family's new car. It was conveniently located across from the hotel in Wells, where the stage had a stopover.

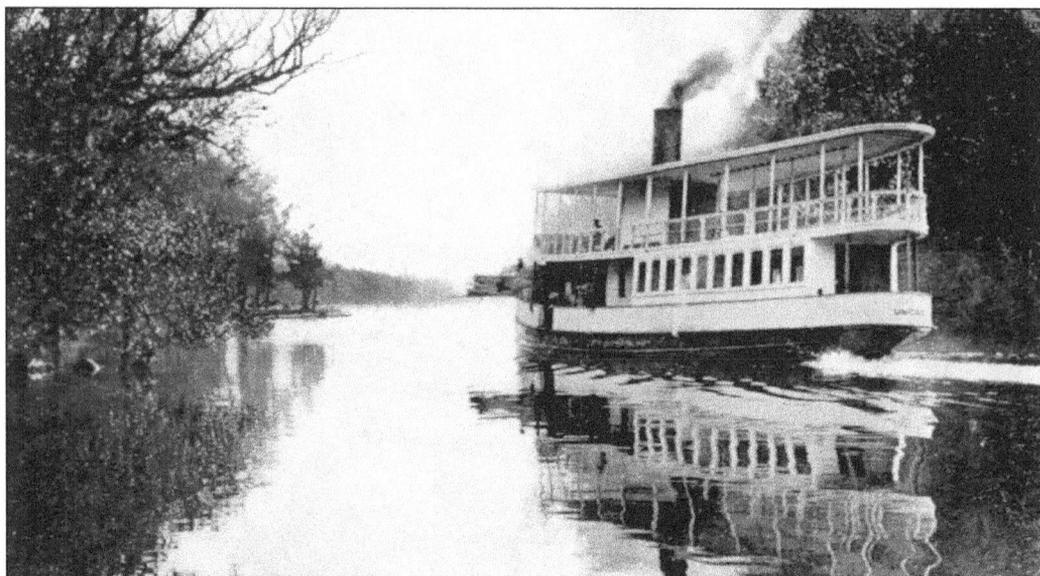

Transportation by steamboat on the Adirondack lakes has a long history. Water transportation was easier than building roads through the mountainous terrain. Today, the new *Uncas* and *Clearwater* provide scenic cruises on the Fulton Chain of Lakes, leaving from the Old Forge docks and going through four of the lakes. The automobile took much of the business away from the steamboat business up and down the Adirondack lakes.

Others who lost business to the automobile were the sleigh and wagon makers. Charles Whitman, a Wells blacksmith, made the iron parts for this old cutter, and the Oliver Whitman family brought the wood pieces out of the Adirondack forest to cut into runners, box, and seat. It provided horse-drawn transportation to town until better roads allowed the use of automobiles.

The Riverside station, at Riparius on the Upper Hudson River, has been restored and is a stopover on the train trip from the North Creek station. A nearby red caboose is open for refreshments for the traveling public. The Adirondack Railroad reached Riverside in 1870, and the station was built in 1914. It became the most profitable station on the line.

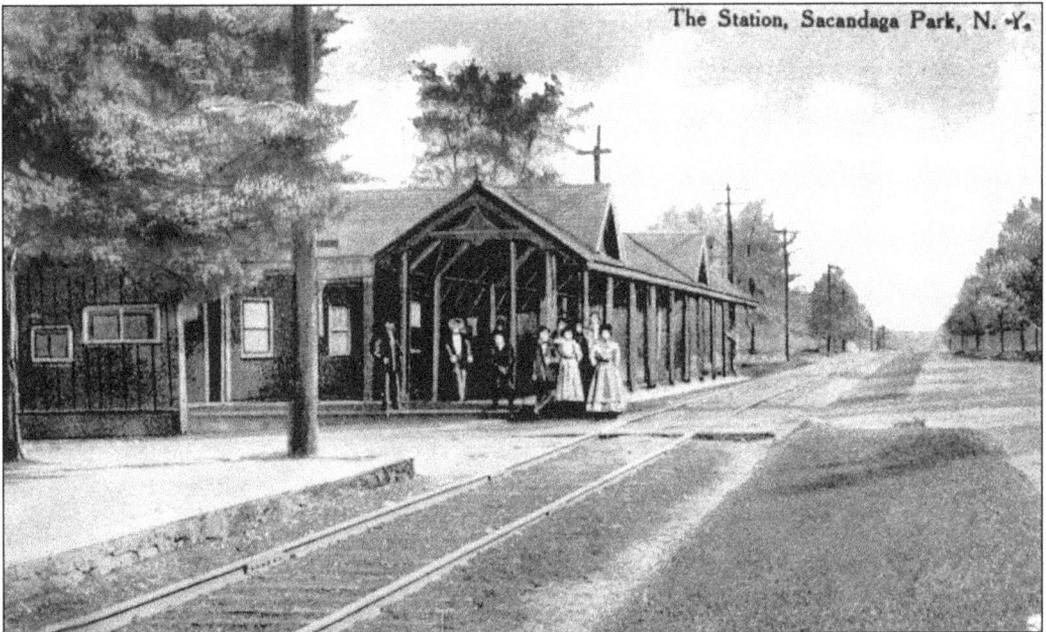

The Fonda, Johnstown, and Gloversville Railroad took thousands to enjoy the recreation at Sacandaga Amusement Park from 1875 to 1930, when the Sacandaga Reservoir flooded the park. During the 1940s, the station was used for an early game room with pinball machines, games of chance, and refreshments. The station has remained there over the years and is now slated for renovation and a new use.

Walt Weaver of Northville worked for the Fonda, Johnstown, and Gloversville Railroad from an early age. At age 15, he was delivering freight from the depot with his horse and sleigh in winter and by wagon in summer. The Northville depot, built in 1875, was located across the bridge from the village and was the last stop on the railroad coming into the Adirondacks.

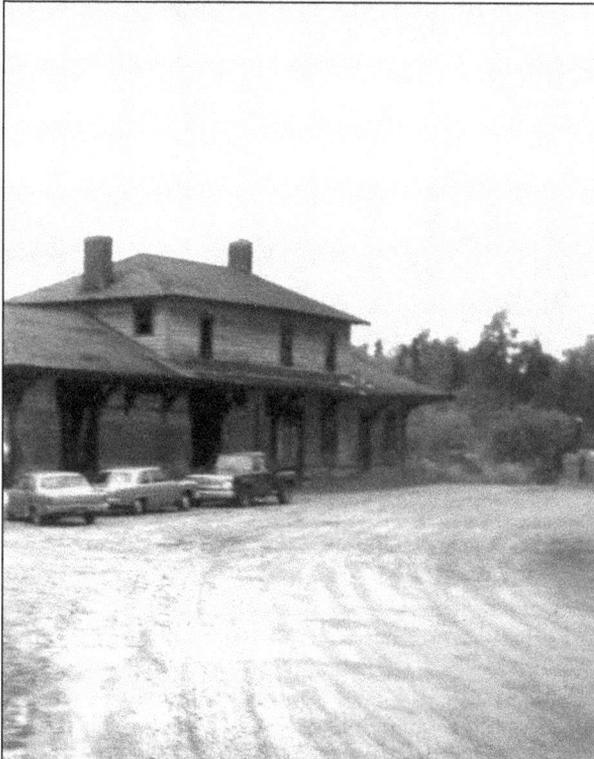

Dr. William Seward Webb built the first rail line through the Adirondacks in 1892. Trains could now go from New York City to Montreal. They passed through the Adirondack communities of Thendora, Big Moose, Beaver River, Brandreth, Horse Shoe, Tupper Lake, Floodwood, Mount Arab, Lake Clear Junction, Saranac Lake, Ray Brook, and Lake Placid. The line also had a station deep in the woods at Sabattis (shown here). It was unwisely torn down just when the rail line was being restored.

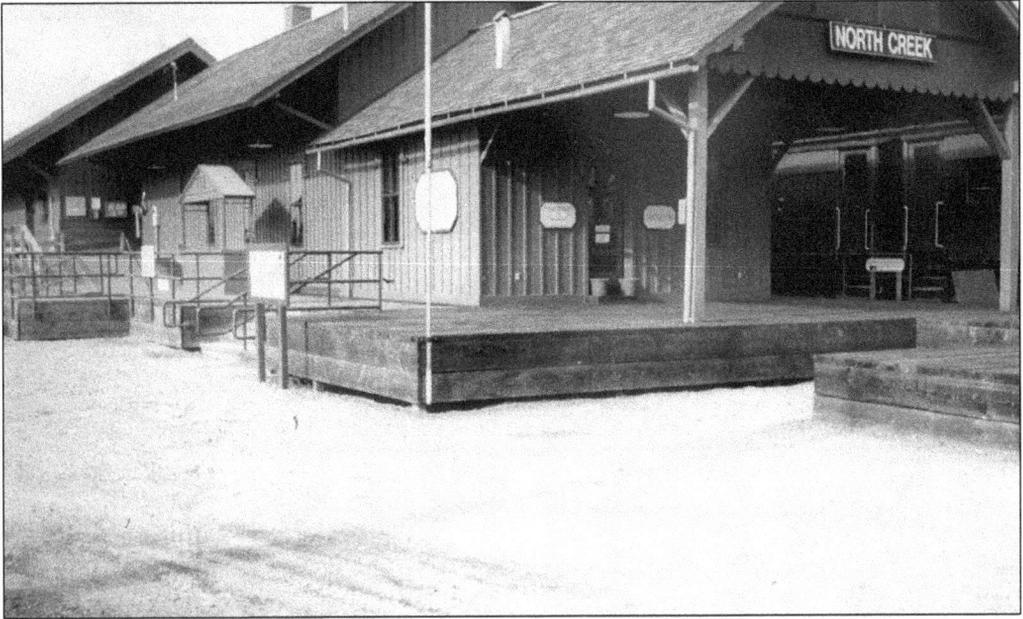

The North Creek station has been restored and reopened, and the train is running from North Creek to the Riverside station once again. The station was used by Vice Pres. Theodore Roosevelt on the night he learned that Pres. William McKinley had died from an assassin's bullet. Roosevelt was on an Adirondack vacation at the time.

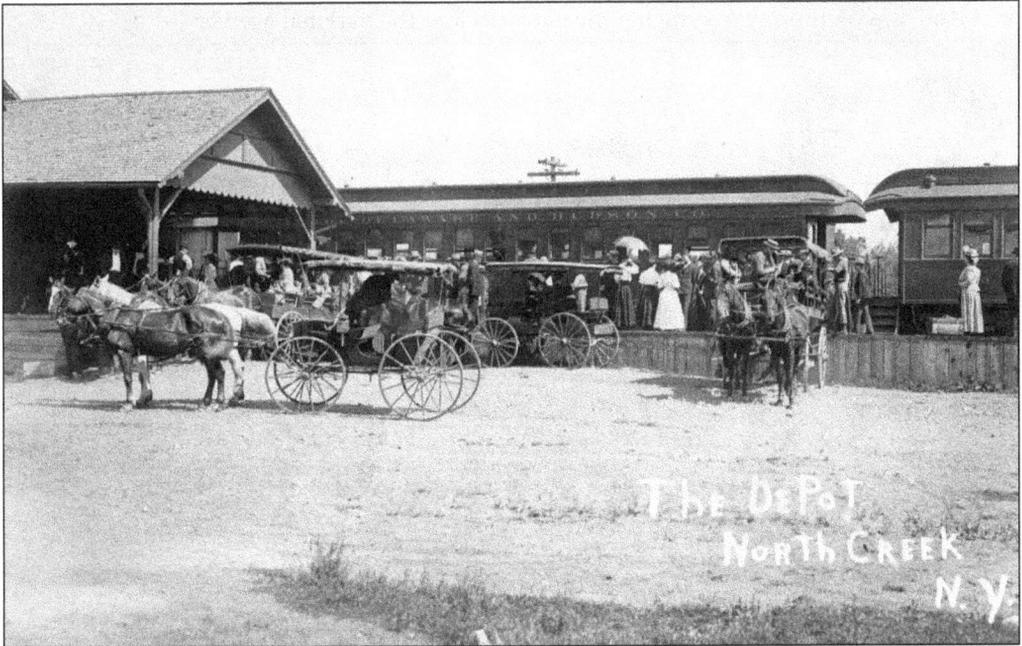

When Theodore Roosevelt reached the North Creek station on September 14, 1901, dawn was breaking. He was met by William Loeb, his private secretary, who gave him a telegram from John Hay, secretary of state, announcing the death of the president. A special train came to this historic station to take the new president to Buffalo for the oath of office.

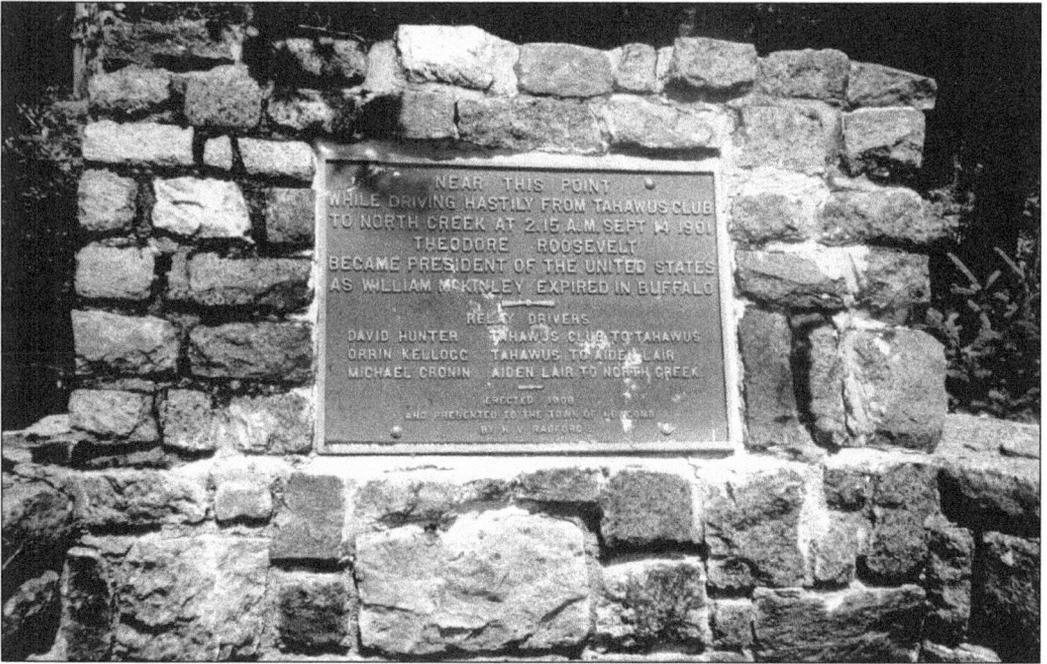

A special Theodore Roosevelt plaque can be found along the highway between Minerva and Newcomb on Route 28N, the Roosevelt-Marcy Trail. It marks the location where Vice President Roosevelt, who was hiking in the Adirondacks, became president on the death of President McKinley. It was at 2:15 a.m., September 14, 1901, when our "conservationist president" was on his way to bringing the outdoors into the national agenda.

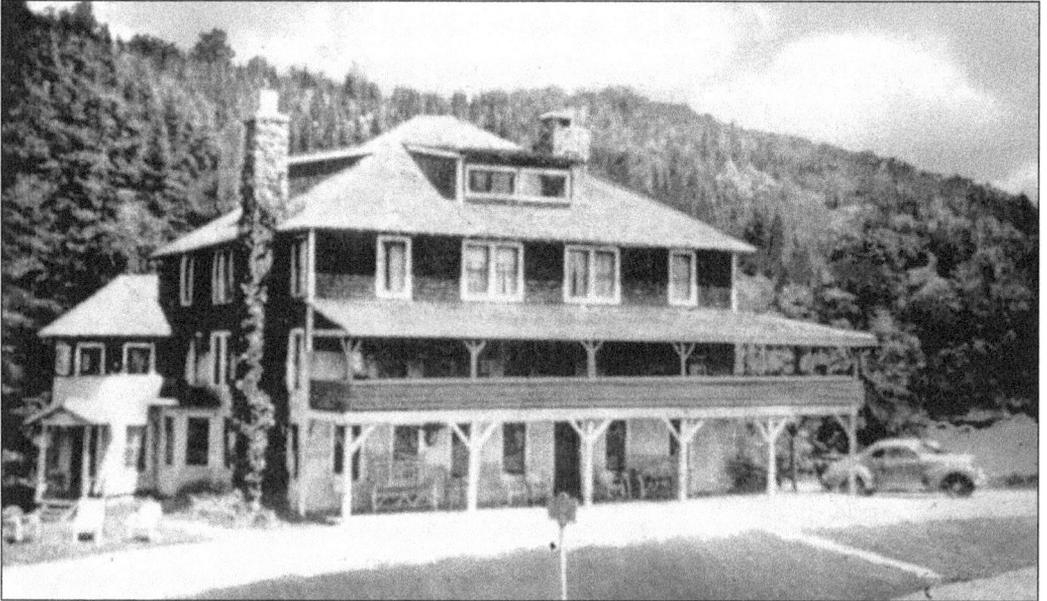

Aiden Lair was a horse-changing stopover for Theodore Roosevelt on his night ride from Mount Marcy to the North Creek station when he became president. Mike Cronin, with two horses, took Roosevelt on the final stage of his journey in record time on the darkest night of the year. The fearless outdoorsman simply told Cronin to "push ahead."

106

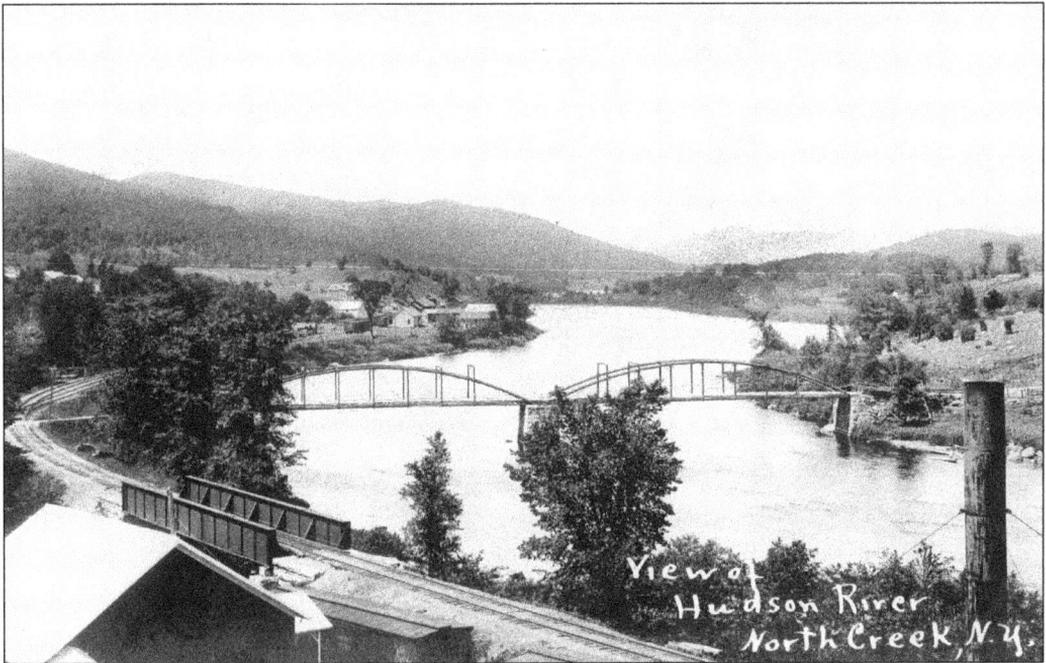

The upper reaches of the Hudson River can be seen at North Creek along with the tracks of the Adirondack Railroad (later the Delaware and Hudson). In addition to transporting summer passengers and freight, trains brought city folks to the ski center at North Creek. Garnet for the world market could also be shipped out from the world's largest garnet mine at North Creek.

Dogsleds provide a traditional form of transportation during Adirondack winters. Trained dogs compete in races and provide rides during the winter on some of the Adirondack lakes, including Mirror Lake at Lake Placid Village and Lake George. Races have been held for more than 30 years in the Saranac Lake–Tupper Lake area.

Adirondack guide boats, the unique crafts that traverse the Adirondack lakes and streams, were the workhorses of the Adirondacks. Made by skilled boatbuilders, they still attract hundreds to regattas, races, and shows today. Boats made by the top builders of the past are almost priceless on today's market, and they are the subjects of many articles and books.

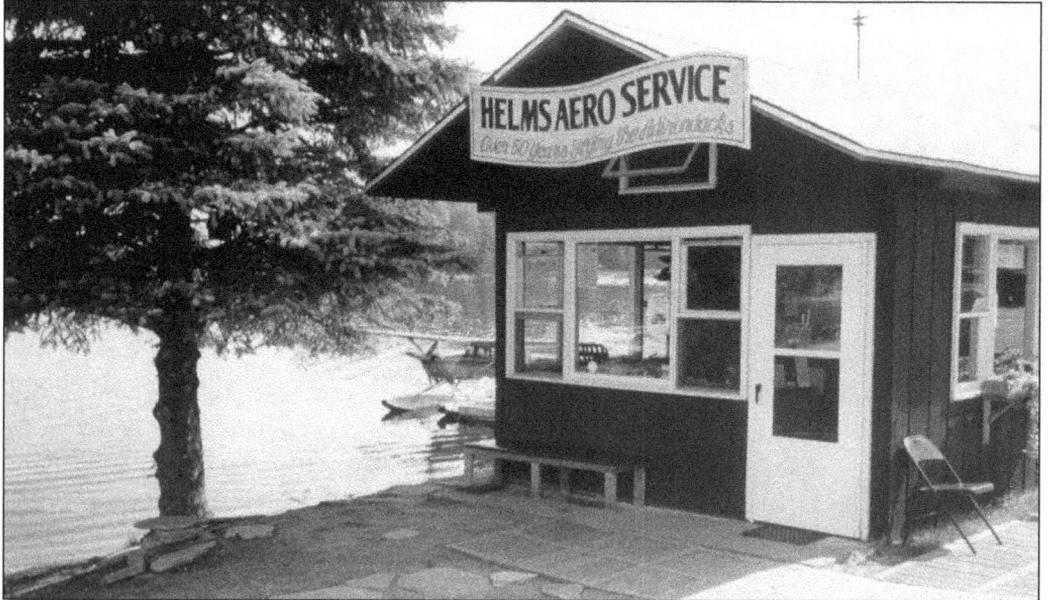

Float planes have served the Adirondacks since the early days of aviation, and the service continues today. Pilots—including Clyde Elliot of Speculator, flying minister Frank Reed, the Helms service at Long Lake, the Birds Seaplane Service at Inlet, and Payne's on Seventh Lake—have served the Adirondacks well over the years. Pilots were often called to help with search and rescue and during the bad fire seasons.

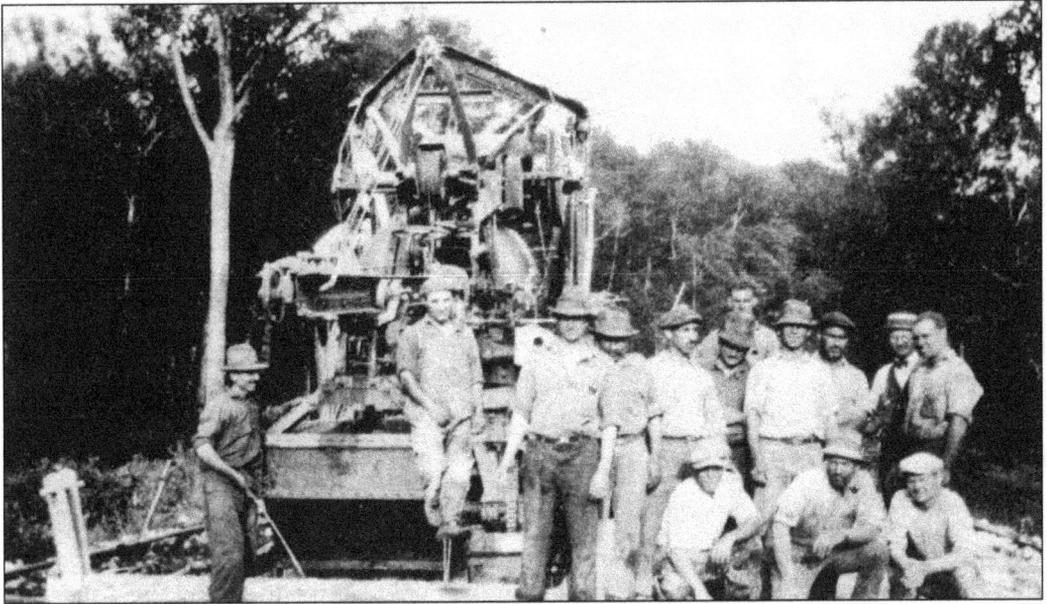

With the advent of the automobile, road building became a big industry. Working on the roads was, and is, a major job for the Adirondack residents. Each county and town has the road crews who build and repair roads. The old machine in the photograph with its crew of about a dozen men laid the concrete roadways.

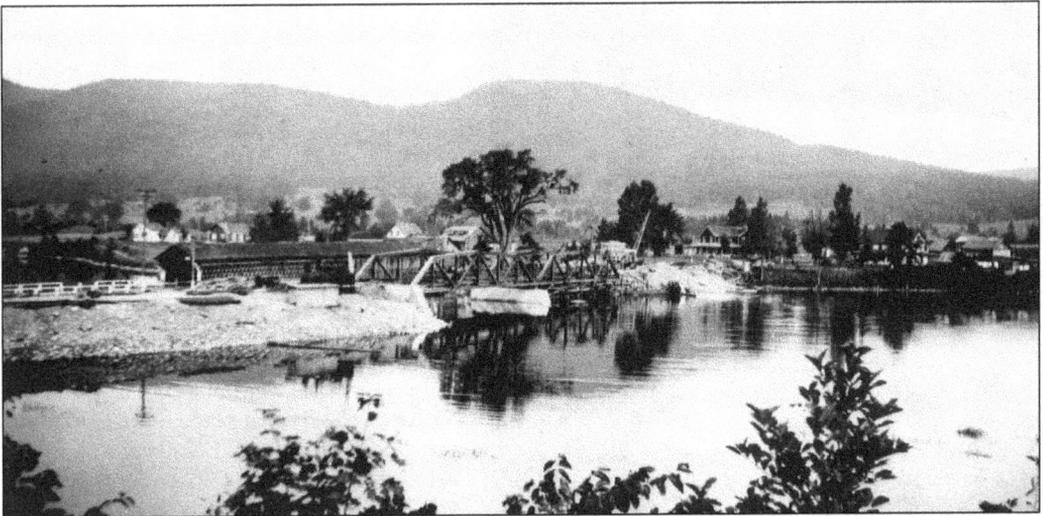

Old wooden bridges gave way to new steel structures once the automobile came on the scene. The wooden bridge on Route 30, the Adirondack Trail, was declared unsafe for cars in 1928 and was soon replaced with the steel bridge used today. Both bridges can be seen in this c. 1930 photograph before the old bridge was dismantled.

Wooden guardrails were common along the Adirondack roadways in the early 1900s. In the days of horse transportation, they served to keep the horses on the roads and the wandering animals off the roads. Automobiles called for stronger guardrails, and wood was replaced with concrete posts and cables.

Another guardrail found its way along the Adirondack highways to keep the cars on the road. Large boulders, often a by-product of the clearing of the route for a new road, were placed along the roadway to serve in place of man-made guardrails. They could easily stop a runaway automobile. When a proposal was made a few years ago to replace the boulders along Route 8 in the town of Thurman, Warren County, the public outcry protected them, and the historic rocks remain today.

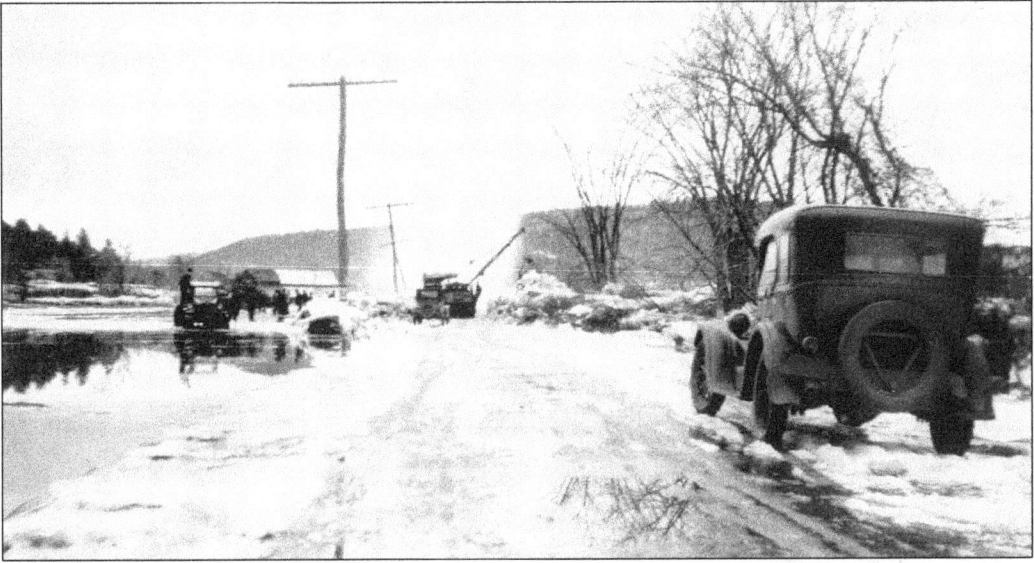

When an early thaw came to the Adirondacks, the roadways were often flooded by misdirected water. Ice dams diverted the water from the rivers and sent it along with huge ice chunks onto the surrounding roads and land. When roads are blocked, maintenance crews must be called in to get the traffic moving again. The blockage here was on a north-south route, the Adirondack Trail.

Sometimes, the winter roads in the Adirondacks become slippery, and vehicles have trouble holding the road. In the winter of 1933, the load of steel girders for the bridge between Route 30 and Route 8 over the Sacandaga River north of Wells went off the road near the old spring hole below Wells Village. It took a crane to reload the heavy beams.

When slaves were escaping from the South on their way to Canada for freedom, the Underground Railroad was established through the Adirondacks. One of the stations where slaves hid was in the old 1847 store at Edinburgh. Oral history tells of slaves hidden in the post office, which was once located at the store in this building.

A hidden room was recently discovered with a secret entrance under one of the counters and behind the shelves of the old store. It provided a safe haven for the slaves to sleep overnight and to get fed on their journey. Note the opening behind the shelves. A door could be closed and locked from the inside with hand-wrought hooks. The room could not be detected from the outside.

Eight

ANIMALS, PLACES, AND PASTIMES

The types of animals in the Adirondacks include the wild, the tame, those who provide transportation, and those who provide food. The goat can be all four of these. Having a family goat was as common in the Adirondacks as having a family dog during the 20th century. Healthy goat milk and goat cheese were staples in the diet of the families. It was the job of the young to keep the height-seeking goats off the roof of the family car.

Providing food for the domestic animals in the Adirondacks was a never-ending task. Getting the hay in for the winter involved using horses to pull the mowing machines and hay wagons. The hay had to be thrown up on the wagons with pitchforks and unloaded in the barns. It took all family members and hired help to get the job done. Riding on the hay load was fun for all.

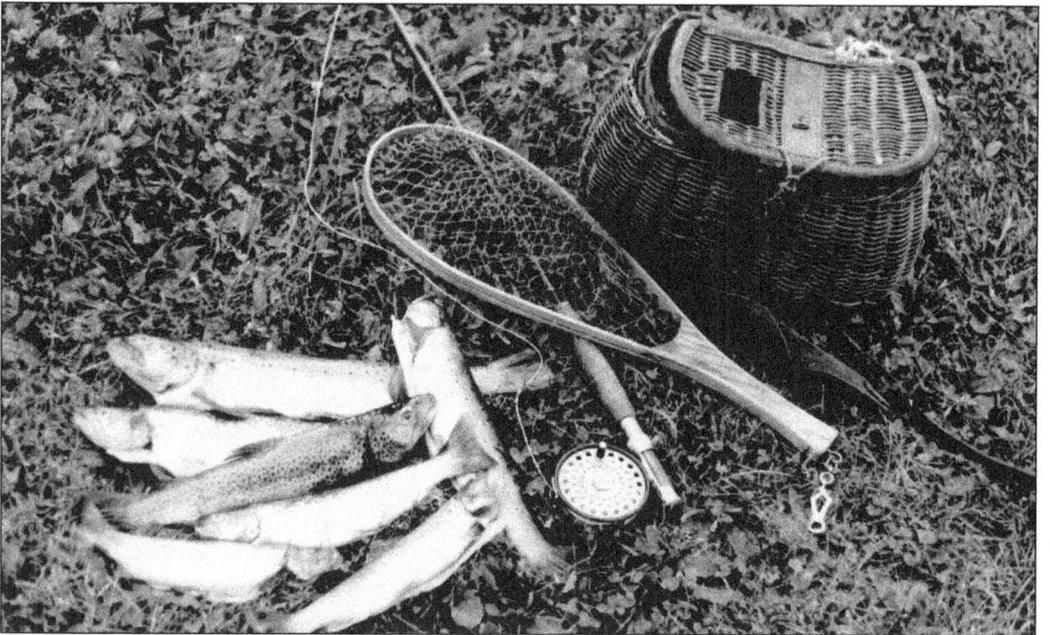

Anglers have been taking trout from the Adirondack waters since they first found the mountain lakes and streams. During the Great Depression, some Adirondack families kept from starving by fishing. Fishing today brings extra dollars to the Adirondack economy and provides recreation for thousands, young and old alike. Native trout can still be found in Adirondack waters, and record-size fish can be found in the record books.

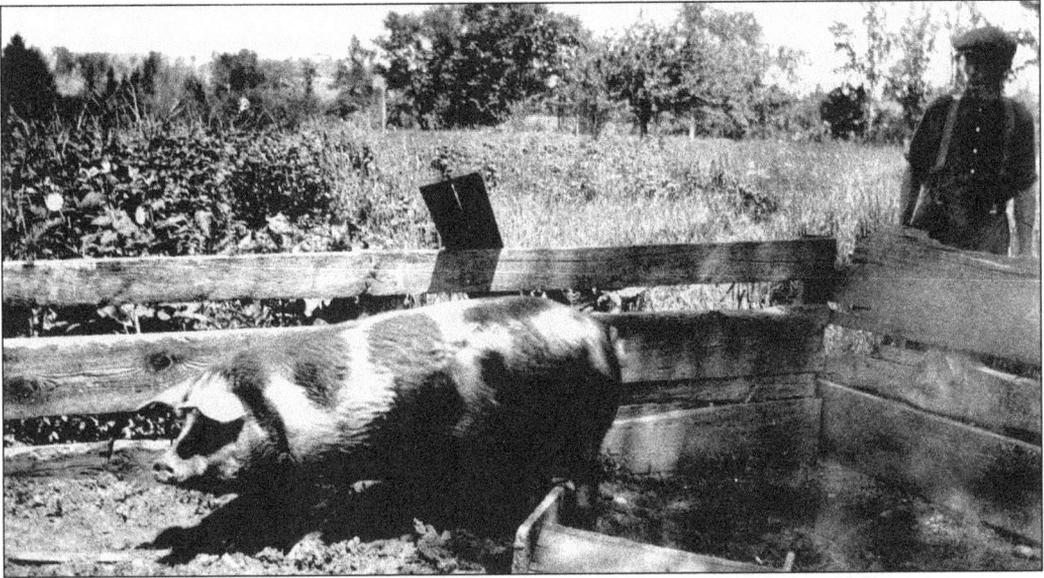

Pigs were important to the survival of those who lived in the Adirondacks. Along with venison, pork was a vital part of the family's diet. Pork was used to make mincemeat, to supply lard for cooking, and to make head cheese, sausage, and salt pork. Preserving the pork was labor intensive. The legs, tongue, and tail had to be pickled; the head cheese meat had to be ground and pressed by a jack under the house; salt pork had to age in earthenware crocks; ham and bacon had to be smoked in the smokehouse; and the pork rind had to be dried and fried.

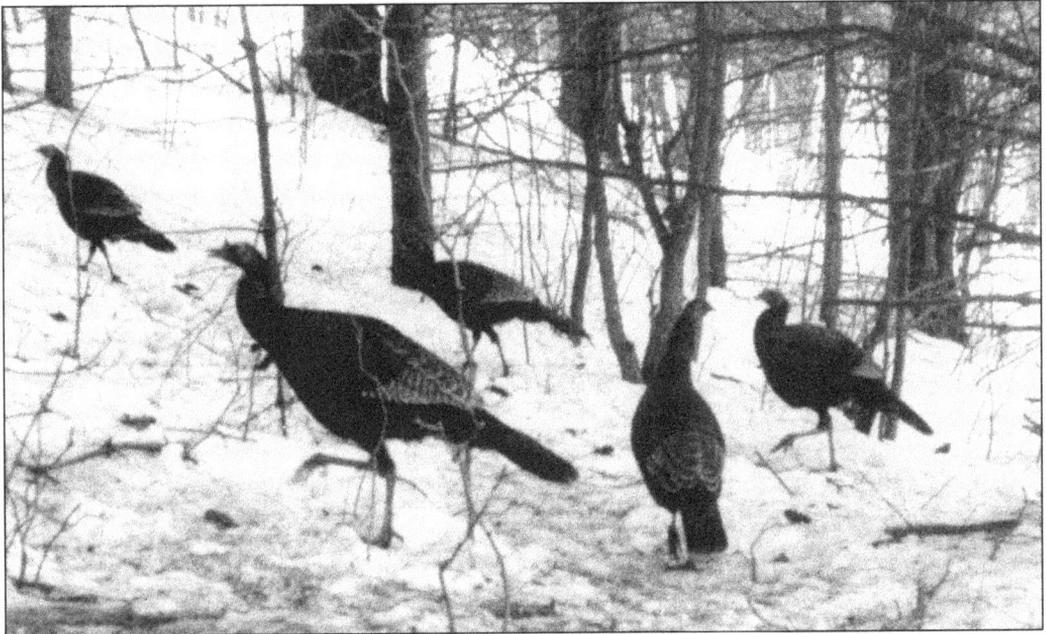

Wild turkeys have been making a big comeback in Adirondack country during the past 10 years after being extirpated for a couple of centuries. Adirondack turkeys can grow to a height of four feet on the abandoned farmlands being reclaimed by the growing forest. The tough birds survive the Adirondack winters, sleeping on the tree branches and searching out the open waters. Turkeys enjoy the large area of forested Adirondacks where they can roam relatively undisturbed.

Adirondack panthers have been known as mountain lions, cougars, pumas, panthers, and catamounts. Beginning in the 1860s, they were killed for the $20 bounty, but they are now protected by state and federal law. Some wildcats have maintained a residence in the Adirondacks over the years, but the reintroduction of the lynx in 1989 has not been successful.

Nighttime visitors often come to the Adirondack camps, campsites, and homes. Raccoons search out the garbage pails and dumps to find food for themselves and their families. Attics of camps and barns are their homes of choice when offspring are due. It is an impossible job to evict them until they decide to move. One group of raccoons learned how to unzip the tents in the campsite once a rehabilitator showed a raccoon how to do it.

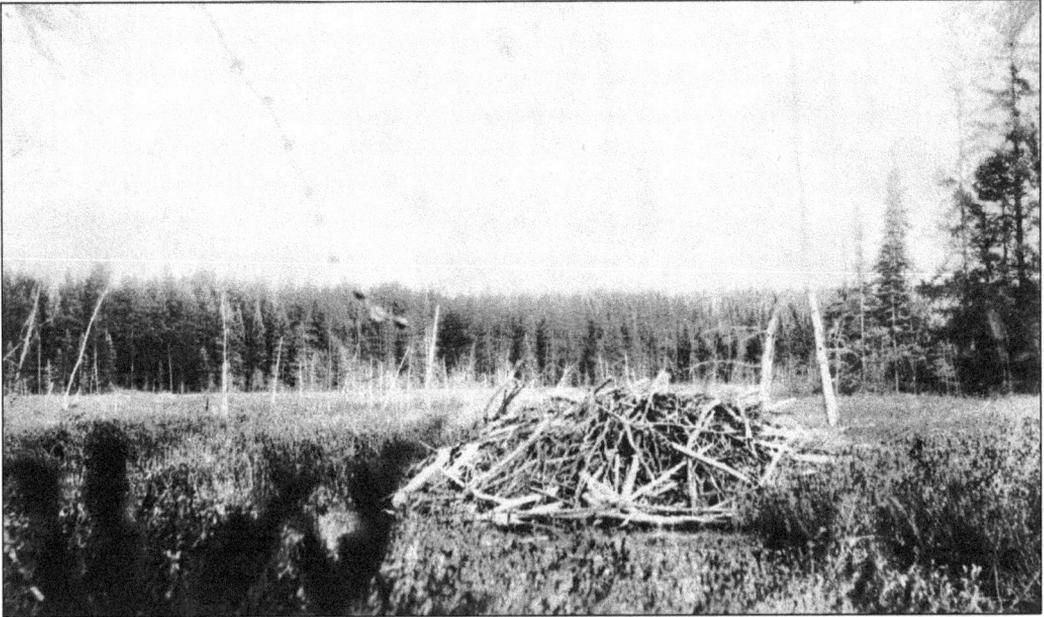

Beaver houses can be seen in the waters throughout the Adirondacks. Beaver enter their homes under the water, so they need to build dams to keep the water deep and to provide a place to store branches for winter food. Although they were once gone from the Adirondacks, they have made a successful comeback today with the introduction of beaver from other states. However, the original beaver were much larger than today's animals, and with the recent finding of big beaver in a remote forest in Michigan, it might be possible someday to reintroduce the original Adirondack beaver.

A world's record North American black bear was taken by well-known hunting guide Bob Avery near Arietta on December 1, 1962. The bear was seven feet eight inches tall and weighed 650 pounds. The bear was found four and a half miles back in the woods near the top of Moose Mountain. Bear are no longer hunted in the Adirondacks with dogs and bait.

Driving through the Adirondacks is much like a trip to a wild animal farm. Not only are the white-tailed deer seen feeding on the roadside browse, but flocks of turkeys, opossum, skunks, rabbits, and other animals often run across the roads. Watch for the herds of deer in the winter when they cross the roads like the milk cows once did.

Feeding the Adirondack white-tailed deer during the wintertime has become a subject of controversy. The deer yard up for the winter, and if the food supply is limited, a deer starvation problem ensues. Those who provide food hope to save some of the deer from hunger. Those who oppose the winter feeding say it tames the deer, makes them dependent on man, and exposes them to nearby highways, where they can get hit by a car. Currently, it is illegal to feed deer in New York State.

Another controversy arose a few years ago when it was suggested that moose should be reintroduced to the Adirondacks. The idea was rejected by those involved, but the moose decided otherwise; they came back to the climaxing Adirondacks in large numbers. The last moose had been shot in the Adirondacks in 1862 by guide Alvah Dunning, and they had been extirpated until the 1980s.

There have been those in the past who have tried to introduce or reintroduce animals to Adirondack country. Small-game farms, game preserves, and private estate attempts have featured elk, moose, beaver, and various deer species, among others. The deer and elk shown here were at Rogers Camp on Oxbow Lake. The high fence was not only to keep the animals in but to keep the hunters out. All the attempts to reintroduce elk ended in them dying or getting killed.

Jumping frog contests at the Adirondack festivals and old home days have been a longtime tradition in the Adirondacks. The contests, such as the one shown here at Sherman's Park at Caroga Lake, called attention to the plight of today's frogs in our pollution-laden habitats. Frogs are being born with mutations, with bad eyes, and with other colors. Are they trying to tell us something?

Sherman's Amusement Park had its beginnings in 1921 with a bathhouse, pavilion, and dance hall, serving the resort community that surrounded it, as well as the nearby cities. Over the years, the public beach, the little cars, the dance hall with big bands, and the midway with the merry-go-round and Ferris wheel created an enjoyable gathering place for residents and visitors to the Adirondacks.

120

Santa's Workshop, at the base of Whiteface Mountain, was designed and built in 1949 by Arto Monaco. It was one of the first theme parks in our country and still operates today. The Land of Make Believe, another theme park by Monaco, has been closed for several years and is in need of historic preservation. The Great Escape at Lake George is a popular Adirondack theme park that houses some of Monaco's creations from the Land of Make Believe.

Sherman's, on the shores of Caroga Lake, stands as witness to the days of the Adirondack amusement parks. The old carousel, lovingly restored, still makes its rounds, bringing enjoyment to young and old. The dance hall and pavilion, along with the Ferris wheel, continue today to provide an enjoyable Adirondack pastime to residents and visitors.

121

One of the most significant Adirondack organizations to come along in modern times is Adirondack Architectural Heritage (AARCH), the regional, nonprofit, historic preservation organization for the Adirondack Park. Under the leadership of Howard Kirschenbaum, seen to the right on the steps with AARCH executive director Steven Englehart, who provides technical assistance and education, the group has saved much of the Adirondack historic architecture from destruction. It has created a new appreciation and stewardship of the Adirondack past through a summer tour program of significant places, such as the 1853 Greystone (shown here), in Essex.

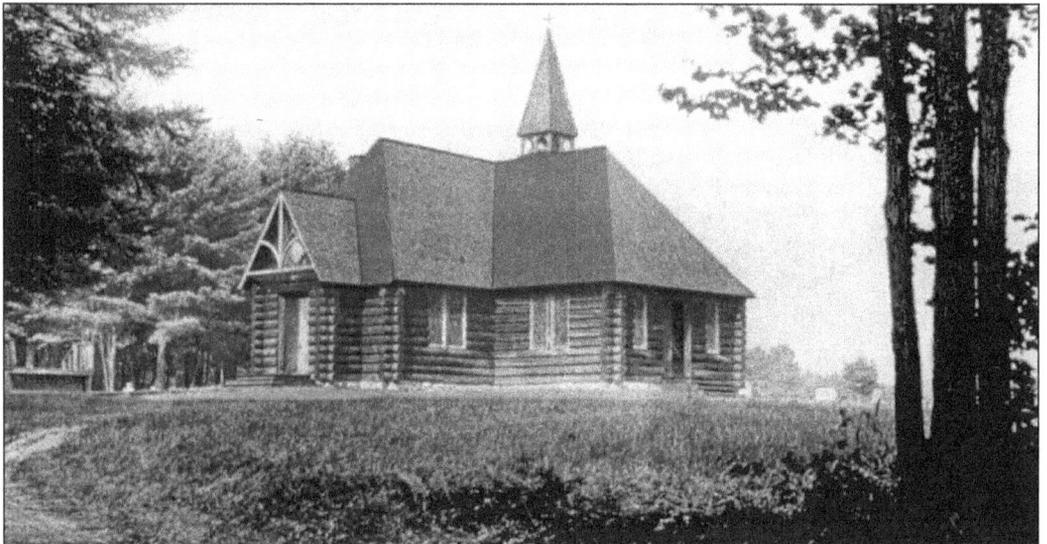

Dr. Edward L. Trudeau, who was strongly religious, saw the need to combine religious beliefs with medical help. He raised funds for the St. John's in the Wilderness church (shown here) and for the Church of St. Luke the Beloved Physician at Saranac Lake. The picturesque red-roofed chapel on the grounds of his sanatorium served those who came for help in curing tuberculous. Churches were important places in the Adirondacks wherever the people settled.

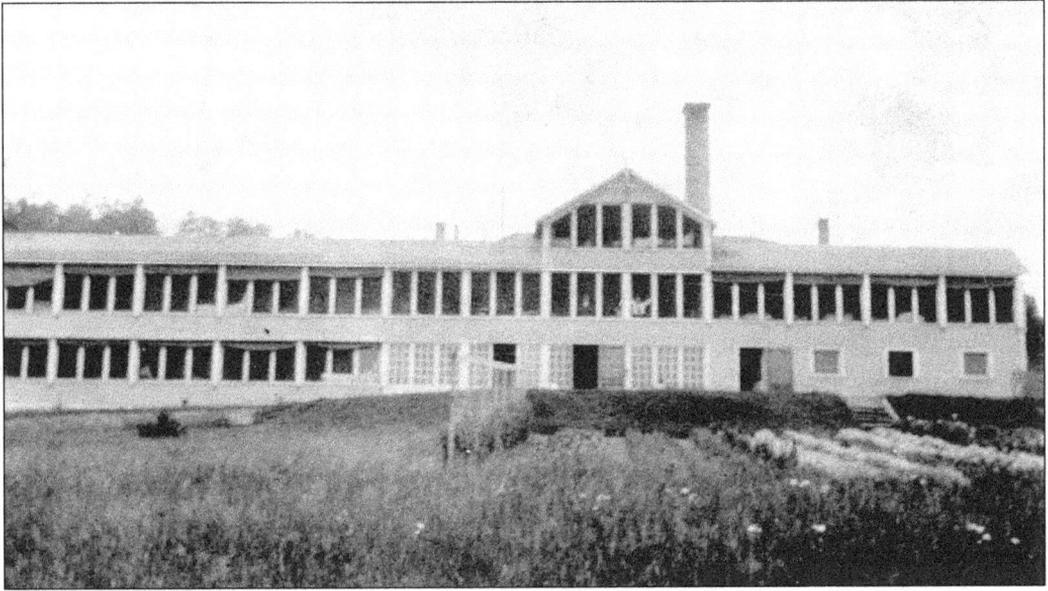

The health-giving features of the Adirondacks have been well documented over the years. Rev. W.W.H. Murray espoused the healthy Adirondacks in his 1869 book, and Dr. Edward L. Trudeau gained fame for his work with tuberculosis patients at Saranac Lake. Many came to the mountains, some in the last stages of the disease, to seek a cure at tuberculosis sanatoriums that sprang up in many Adirondack communities. This photograph shows the tuberculous hospital at Jackson Summit in the southern Adirondacks.

When tuberculous was a deadly plague in our country, sanatoriums were opened in the Adirondacks. New York State operated the Ray Brook Sanitarium for many years. During the summer weather, open tents provided fresh air while the summer breezes kept the bugs away. Fresh air was part of the cure. The Adirondack Correctional Facility is now located on the old sanitarium site.

The Adirondack Museum at Blue Mountain Lake is one of our nation's finest regional museums. Some two dozen buildings on the landscaped grounds contain the world's largest collection of Adirondackia. A schoolhouse, a fire tower, a log cabin, and a rustic beach house have been moved to the property to stand with some of the original hotel buildings, replicas, and exhibit halls. Educational programs and demonstrations are offered throughout the season (from May to October), and an extensive Adirondack gift shop and bookstore are maintained. A fine library with a vast Adirondack collection is open by appointment. The Adirondack Historical Association was formed in 1948 and, in 1953, purchased the site of the Blue Mountain House for a museum. The Museum of the Adirondacks opened on August 3, 1957. William Wessels and Harold Hochschild conceived the idea of the museum to preserve remnants of the region's heritage. Hochschild's book of Adirondack history, *Township 34*, spurred on the need for a museum. The Adirondack Museum is the kind of place that calls for a return trip, again and again.

For more than 15 years, the Adirondack Museum at Blue Mountain Lake has held a rustic furniture fair in the fall. Held on the grounds of the museum, it features 50 of the best rustic furniture makers of our time. Using native twigs, branches, and logs, the furniture makers fashion elegant furniture that can be used in any home. Demonstrations and lectures accompany the show, carrying on the Adirondack rustic furniture tradition.

The rustic furniture work of the Sampson Bog Studio of Mayfield has reached the quality of fine art and is the top in the country. Barney and Susan Bellinger and their daughter Erin have designed a unique style of Adirondack furniture, combining paintings and realia pieces from nature along with the natural twigs, logs, and branches from the mountains. Their pieces adorn many notable homes in America and appear in museums and galleries.

Peter Winter is a sculptor in wood. Carving with a chain saw, he creates creatures from the Adirondack forests. The "military bears" shown here stand on the lawn of Lanzi's-on-the-Lake Restaurant on the Great Sacandaga Lake near Mayfield. Winter is also known for his uniquely designed Adirondack rustic furniture.

We do not often think of old mines as places to visit in the Adirondacks. The MacIntyre Mine brought hundreds to the Adirondacks, beginning with the mining of iron ore in 1832. The National Lead Company took over in 1941 to mine titanium and magnetite. Some 80 million tons of rock were removed from the Sanford Pit, and the entire village of Tahawus was moved in 1961 to mine the Southern Extension Pit. The mine closed in 1966, and proposals for the future of the lands are being considered.

126

A place you may want to visit is the Olympic ski jumping complex near Lake Placid. The 1932 Olympic skiers shown here participated in a variety of Olympic skiing events, including cross-country, Nordic combined, slaloms, downhills, and ski jumping at the Intervale complex. The same site was used for the 1980 Olympics amid some controversy over the height of the 90-meter hill. It is 26 stories high with an observation deck and is used year-round for jumping.

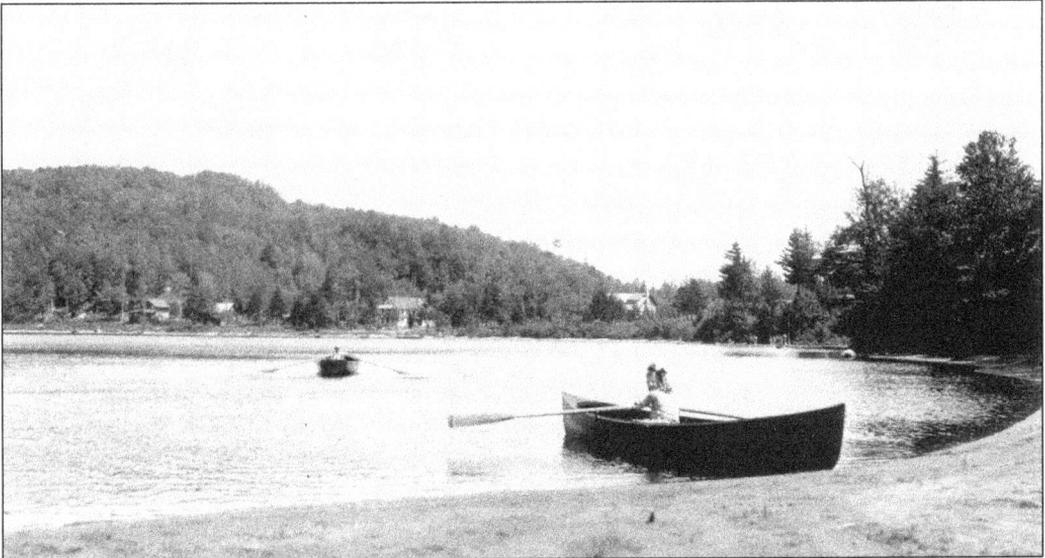

Children in the Adirondacks found themselves involved with outdoor pursuits in the woods and on the waters. It was, and is, a great place to grow up. The Adirondack guide boats were stable and easy to row with the long, efficient oars. They were safe for children, and the little girl in the photograph has rowed her guide boat across the bay at Piseco Lake.

127

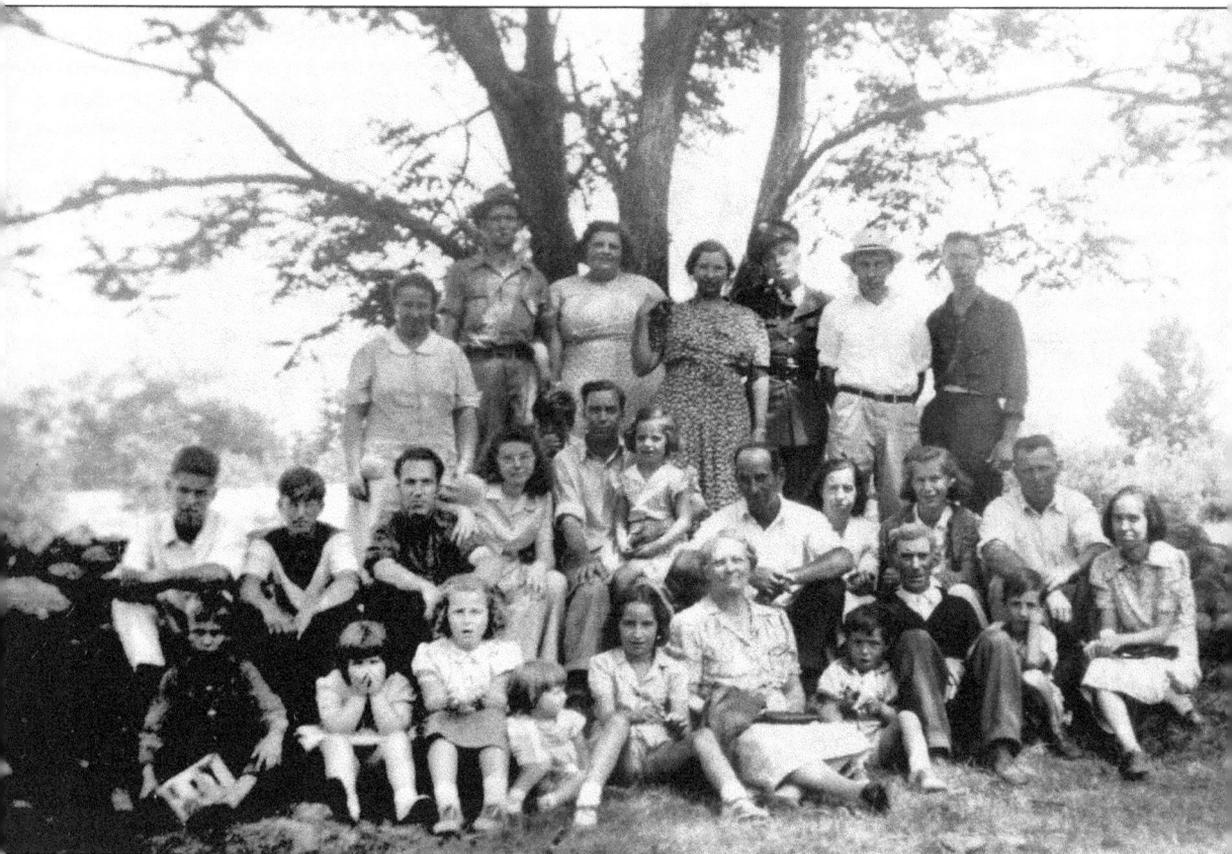

Family reunions were a way of keeping the family close in the Adirondack settlements. Many of the settlements included several generations of the same family. The Whitman family (shown here) descended from the 1790s Whitman migration from Long Island to the Adirondacks. They came to the mountains to make the money offered by the growing tanning industry. At one time, the hamlet of Wells had 58 Whitmans settled within its borders. The Adirondack Whitmans have been traced back to Englishman Rev. Abigah Whitman, who had two sons come to America in 1635. The Adirondack branch descended from Zechariah. The fourth-generation Whitman, Isaiah, came to the Adirondacks with his wife, Hannah, and their children to find a new life in the wilderness. In many ways, the Whitmans typify the American family. In this 1940 photograph, the author is the small boy on the right of the first row, leaning on the knee of his grandfather, Adirondack guide John H. Whitman.

Visit us at
arcadiapublishing.com

..